RITES OF WAY

Canadian Commentaries

Published in conjunction with the *Literary Review of Canada*, Canadian Commentaries features prominent writers exploring key issues affecting Canadians and the world. A lead essay commissioned by the *LRC* becomes the ground for responses by others, opening a place for a spectrum of views and debate.

We welcome manuscripts from Canadian authors. For further information, please contact the Series Editor:

Dr. Janice Gross Stein
Director, Munk Centre for International Studies
University of Toronto
1 Devonshire Place
Toronto, ON M5S 3K7
Canada
Phone: (416) 946-8908
Fax: (416) 946-8915
Email: j.stein@utoronto.ca

Mark Kingwell and Patrick Turmel, editors

RITES OF WAY

The Politics and Poetics of Public Space

Wilfrid Laurier University Press

WLU

We acknowledge the support of the Canada Council for the Arts for our publishing program. We acknowledge the financial support of the Government of Canada through the Book Publishing Industry Development Program for our publishing activities.

Library and Archives Canada Cataloguing in Publication

Rites of way : the politics and poetics of public space / Mark Kingwell and Patrick Turmel, editors.

(Canadian Commentaries series)
Includes bibliographical references and index.
Issued also in electronic format.
ISBN 978-1-55458-153-5

1. Public spaces. 2. Public spaces—Political aspects. 3. Public spaces—Social aspects. I. Kingwell, Mark, 1963– II. Turmel, Patrick, 1976– III. Series: Canadian Commentaries series

NA9053.S6R575 2009 307.1'216 C2009-903691-6

Library and Archives Canada Cataloguing in Publication

Rites of way [electronic resource] : the politics and poetics of public space / Mark Kingwell and Patrick Turmel, editors.

(Canadian Commentaries series)
Includes bibliographical references and index.
Electronic edited collection in PDF, ePub, and XML formats. Issued also in print format.
ISBN 978-1-55458-167-2

1. Public spaces. 2. Public spaces—Political aspects. 3. Public spaces—Social aspects. I. Kingwell, Mark, 1963– II. Turmel, Patrick, 1976– III. Series: Canadian Commentaries series

NA9053.S6R575 2009 307.1'216

Cover photograph by Lisa Klapstock: detail of *Beige Cube Chair* (from the Living Room series), 2002. Cover design by Blakeley Words+Pictures. Text design by C. Bonas-Taylor.

The excerpt from *Private Jokes, Public Places*, by Oren Safdie, is used with the permission of the playwright. The play was first published by Playwrights Canada Press. The excerpt from *How Insensitive*, by Russell Smith, is reprinted with the permission of the Porcupine's Quill. The novel was originally published by the Porcupine's Quill in 1994. The four excerpts from *Occasional Work and Seven Walks from the Office for Soft Architecture*, by Lisa Robertson, are reprinted with the permission of the author. The photographs on the part-opening pages—*Girl Falling* (page 1), *Synagogue, Montreal* (page 27), *Crime Scene* (page 69), and *132 Berry Road* (page 121)—are reproduced with the permission of the photographer, Robin Collyer. Robin Collyer is represented by the Susan Hobbs Gallery, Toronto.

This book is printed on FSC recycled paper and is certified Ecologo. It is made from 100% post-consumer fibre, processed chlorine free, and manufactured using biogas energy.

Printed in Canada

CONTENTS

vii Acknowledgements

ix Introduction: Rites of Way, Paths of Desire
 MARK KINGWELL AND PATRICK TURMEL

PART I

3 Masters of Chancery: The Gift of Public Space
 MARK KINGWELL

23 We Wuz Robbed
 JOE ALTERIO

PART II

29 Public Space: Lost and Found
 KEN GREENBERG

47 Architecture and Public Space
 ALBERTO PÉREZ-GÓMEZ

55 The Enduring Presence of the Phenomenon of "the Public":
Thoughts from the Arena of Architecture and Urban Design
 GEORGE BAIRD

63 *Private Jokes, Public Places*: An Excerpt
 OREN SAFDIE

PART III

71 Holistic Democracy and Physical Public Space
JOHN PARKINSON

85 Public Spaces and Subversion
FRANK CUNNINGHAM

101 Take to the Streets! Why We Need Street Festivals
to Know Our Civic Selves
SHAWN MICALLEF

113 *How Insensitive*: An Excerpt
RUSSELL SMITH

PART IV

123 Beauty Goes Public
NICK MOUNT

137 Protect the Net: The Looming Destruction of the
Global Communications Environment
RON DEIBERT

151 The City as Public Space
PATRICK TURMEL

165 ... walks from the office for soft architecture
LISA ROBERTSON

179 Contributors

183 Index

ACKNOWLEDGEMENTS

Our thanks to the contributors, whose distinctive and insightful inter-ventions have made for a book we hope will significantly advance the debate about public space. This collection is part of a series called Cana-dian Commentaries. We have certainly included Canadian voices and Canadian experiences in what follows. But the subject of public space is, like Canada's own cities and spaces, beyond restriction to a given nation, and so we also embrace work that makes connections to other sites, par-ticularly ones in the United States and Britain. Books, especially antholo-gies, are public spaces in their own conversational fashion; we hope that the experience of reading this one will be like walking along the streets of a diverse, robust, stimulating urban neighbourhood.

Thanks to Bronwyn Drainie at the *Literary Review of Canada*, who commissioned the original essay on public space which, now revised, appears here. At Wilfrid Laurier University Press we were pleased to work with Brian Henderson, Leslie Macredie, Clare Hitchens, and Rob Kohlmeier. They have made our lives easy in ways too numerous to mention.

Julien Levac transcribed the sections of the book not available in electronic form (the excerpts from Robertson, Safdie, and Smith); Matthias Piché-Perron standardized the manuscript, which, in the man-ner of the day, arrived in numerous formats and styles; and Julien Delangie compiled the extensive index. Apart from the fictional excerpts and Kingwell's lead essay, the only text that was previously published is Nick Mount's essay on public beauty, which appeared in

a slightly different form in *Queen's Quarterly*. Our thanks to Boris Castel, the editor there and a tireless champion of public discourse, for permission to use it here.

INTRODUCTION
Rites of Way, Paths of Desire

MARK KINGWELL
and PATRICK TURMEL

THE ARCHITECTURAL THEORIST CHRISTOPHER ALEXANDER, IN his monumental 1977 work *A Pattern Language*, traces what we might call the *paths of desire* that operate in buildings, walkways, towns, and cities. The "pattern language" of Alexander's thought is the new way of tracing those paths, allowing room for them, respecting the human interest in movement, solitude, complexity, stimulation, work, and rest. Though lately more appreciated by renegade computer programmers than workaday architects and urban planners, this is a language that, like the natural languages of our speech, allows individuals "to articulate and communicate an infinite variety of designs within a formal system which gives them coherence."[1]

Alexander and his colleagues examined and illustrated some 250 different aspects of this language, many of them to do with the subject of the book you hold in your hands. In particular, these thinkers were adept at plotting transitions from public to private, noting that this is never a simple or linear threshold but, often, a staggered, funnelled, or terraced series, with step-downs and in-between areas—porches, vestibules, gardens, walkways, and arcades—that complicate, stutter, and please our movement between realms. (Such thresholds are also the subject of some previous work of one of the editors, just as justice in the city has been explored by the other.)[2] But perhaps the most striking of the public-space insights in *A Pattern Language* comes at No. 94, "Sleeping in Public."

"It is a mark of success in a park, public lobby or a porch, when people come there and fall asleep," the highlighted text says, capturing the core insight of the section. "In a society which nurtures people and fosters trust, the fact that people sometimes want to sleep in public is the most natural thing in the world." Such a person may have no other place to go, in which case we regard his or her sleeping as a civic gift; or, having a place to go, a person may just "happen to like napping in the street."

The authors are under no illusions about such desires. "In our society, sleeping in public, like loitering, is thought of as an act for criminals and the destitute. In our world, when homeless people start sleeping on public benches or in public buildings, upright citizens get nervous and the police soon restore 'public order.'" There follows a long passage from Samuel Beckett's *Molloy*, in which Molloy, resting his arms and head on his bicycle handles and drifting off, is confronted by just such a policeman. The question, he says, is always the same: "What are you doing here?" The answer he gives—"Resting."—is always insufficient. It is as if, in the midst of the surrounding public's "bitter toil," such voluntary rest is "obscene," offering "a deplorable example." Indeed, Molloy sees the depth of the issue. Without better examples, ones "of courage and joy" in work, this same public "might collapse, at the end of the day, and roll on the ground."

There are many ways to approach the subject of public space: the threats posed to it by surveillance and visual pollution; the joys it offers of stimulation and excitement, anonymity and transformation; its importance to urban variety or democratic politics. But perhaps no approach is more vivid than the simple image of a policeman—the state's embodied monopoly on force—moving a sleeping person along, preventing rest and idleness, the basic human privilege of fatigue, the right not to be in circulation. It is proverbial that we are most vulnerable, and so perhaps most innocent and beautiful, when slumbering. A father observes his sleeping daughters with profound sadness and adoration; a lover looks at her dozing beloved and sees winning weakness beneath the ambition and strength of waking life. Sleep allows dreams; it knits up the ravelled sleeve of care; most basically of all, it keeps us sane. Sleep deprivation is the cheapest and crudest form of torture.

Much is contained, then, in the public injunction against sleep: the tyranny of the work ethic against idleness, of movement against rest; the presumption of a home to which sleep should properly be relegated;

the lack of trust signalled by finding a sleeping person unnatural or offensive.[3] And, as any city dweller knows, you don't even need the policeman to effect the confrontation: many public benches now come designed with anti-sleep features, slats or slopes that making reclining, and so sleeping, impossible. In a neat inversion of so-called sleeping policemen—British slang for what North Americans call speed bumps—these features are, in effect, the sleep police. You shall not rest.

Alexander's dictum on the subject is, by contrast, radical: "Keep the environment filled with ample benches, comfortable places, corners to sit on the ground, or lie in comfort in the sand.... Above all, put the places for sleeping along building edges; make seats there and perhaps even a bed alcove or two in public might be a nice touch."

• • •

WE MUST NOT SLEEP OUR WAY THROUGH THE IDEA OF PUBLIC SPACE, however, even if we believe in public sleeping. Public space is not always or only physical, nor is it always obvious where to find it. The contributions in this volume open up multiple dimensions of the concept, from architectural, political, philosophical, and technological perspectives. Throughout the book we are guided by the conviction, not pious but steely, that healthy public space offers one of the best, living parts of a just society. The paths of desire we follow in public trace and speak our convictions and needs, our interests and foibles. They are the vectors and walkways of the social, the public dimension of life at the heart of all politics.

There is historical analysis in what follows, but for the most part the contributors are more focused on the future of public space under conditions of growing urbanization and democratic confusion. The added interest offered by non-academic work—visual art, fiction, poetry, drama—acknowledges that this topic is too important to be left to theorists. These additions also make an implicit argument for the crucial role that art, not just public art, plays in a thriving public realm. (An explicit version of the argument is offered by Nick Mount in his contribution.) Lisa Klapstock's cover image, from a series called *Living Room*, is part of an ongoing engagement in her work with thresholds in the alleys and backyards of the city, while Robin Collyer's images reflect his long-maintained concern with consumption and visual corruption. (At his request, *not* included for further consumption here are his familiar photographic works in which urban signage has been blocked out.)

The text is divided into four parts. In the first is the lead essay, written by Mark Kingwell, which was circulated to all contributors as a keynote text. Though there was no requirement to do so, contributors were invited to respond to this essay. The piece sets out both basic concerns and provocative arguments about the current status of public space as a public good. Kingwell uses the contested figure of Melville's Bartleby the Scrivener to explore the challenges of intersubjectivity in both public and private. Joe Alterio's comic, "We Wuz Robbed," graphically illustrates the risks and rewards of the public, especially that most common of circulation pathways, the city street.

The three essays in the second part are by people who make a living influencing our views on and the shape of our public spaces. Ken Greenberg is an internationally known urbanist who has contributed to the design of public spaces throughout North America, Alberto Pérez-Gómez is both a theorist and a historian of architecture whose controversial views on the practice of architecture have been widely discussed, and George Baird is an architect whose influence on generations of architects in Canada and in the United States is palpable.

In his contribution, Greenberg focuses on the demise of public space in the twentieth century, and on our renewed desire today for what he conceives, controversially, to be a basic human need. According to Greenberg, public space has been attacked from all angles—economic, political, social, and cultural. More importantly, public space was corrupted by the ideas of architects and urban planners themselves. Greenberg notes the powerful intellectual movement that issued from the 1933 Congrès International d'Architecture Moderne, under the tutelage of Le Corbusier. Its ideal was that of the functional city, an ordered and efficient "machine" that too often regarded thriving public spaces as an unprogrammed nuisance.

Despite function-obsessed planners and architects, however, public spaces fill a basic human need for face-to-face encounters. Shared spaces are necessary grounds for a healthy democratic life, especially in highly diverse communities. Newly shared interests in environmentally sound living and the rising costs of energy also threaten unsustainable suburban modes of development, with their long commutes. Greenberg concludes with some concrete examples of this rebirth of public space, including the project [murmur] in Toronto, the work of another contributor of this book, Shawn Micallef, which unearths memories at various locations within the city.

Pérez-Gómez likewise takes as the point of departure the idea that cities are too often theorized as "efficient systems of circulation and consumption." This tends to undermine the proper vocation of architecture, which is the configuration of public space understood as a poetic proposition from which a collective order should emerge. Instead of simply replicating or acting on the dominant metaphoric view of cities as efficient machines or as circulatory systems, the architect should see his task as one of subversion of these dominant models and as one of creator of alternative strategies: "visions of life to reveal that which we forget, through a poetic image, at a particular moment in time, even if ephemeral."

Such places, moreover, cannot be merely the result of the egocentric imagination of an architect, nor mere novelty, the product of deranged computer virtuosity. They must refer to the natural and cultural horizons embodied in their sites. Potentially effective urban space is therefore articulated as a narrative, metaphoric projections grounded in recollection. Public space should resist easy consumption and celebrate traces of cultural continuity. It should also invite the inhabitant's intimate participation in the site, gathering a potential recovery of communal purpose and human solidarity.

Baird takes a particular interest in the kind of discourse announcing the demise of public space or the end of civil society; he identifies Kingwell's lead essay as an example. Baird does not claim there is nothing to worry about, but he wants to mitigate this widely shared negative view. He reminds us, for instance, of the vibrancy of street life around the world. Everywhere, he says, individuals seem to have an impulse to gather together "out in public." His own view of the matter, influenced by Hannah Arendt's idea of the public, is that regardless of the context in which they find themselves, human beings seem to have an enduring capacity for action. Arendt witnessed with fascination the revolt of citizens in East Berlin in 1953 and in Budapest in 1956, and came to realize that human action, and thus political resistance, always finds its space of appearance. Quoting Arendt, Baird reminds us that action and speech create a space that "can find its proper location almost anytime and anywhere." Overtly pessimistic talk about public space seems to ignore that aspect.

The excerpt from Oren Safdie's *Private Jokes, Public Spaces* dramatically illustrates how architectural ego—not to mention male aggression—can affect the creation of built forms. Public and private lines are

blurred and crossed as a young student struggles to articulate her desires in the face of critical professionals.

• • •

THE NEXT THREE ESSAYS BY, RESPECTIVELY, A POLITICAL THEORIST, A philosopher, and a writer and new-media artist address the politics of public space.

The notion of public space is often taken to be a metaphorical concept referring to the various means through which citizens can deliberate. In his contribution, John Parkinson reminds us of the democratic importance of the literal meaning of the notion. Parkinson defends a deliberative conception of democracy, according to which citizens should not only take part in the electoral process, but should also engage with one another and discuss and challenge their positions. But where are they expected to do it? According to Parkinson, the answer is in physical public space. Despite the growing importance of new media and virtual global networks, physical space is still essential to deliberative democracy.

Physical public space comes in all shapes and sizes, from libraries to parks and plazas, and also includes "the living rooms and private clubs in which groups in civil society meet." These various public places play different public roles. They can encourage encounters with strangers and diversity, or they can offer a space to make public claims or to demonstrate public anger. In all cases, it is essential for a healthy democratic society to have common spaces where citizens can gather, protest, and challenge the status quo.

Philosopher Frank Cunningham agrees with Parkinson that public spaces have the potential to be subversive of a conservative status quo, but he rejects the traditional explanation of that potential. In place of standard assessments of public-space politics, he presents two ways in which public spaces can be more evidently subversive. The first is by encouraging *Homo ludens*, a conception of a human "as a seeker of creativity, pleasure, fun and play," in the face of the hegemonic conception of a *Homo faber* and of an oppressive society dominated by a culture of work. In other words, public space forces us to conceive of an urban life that is not completely "subordinated to capitalist economic needs."

The second, related way is by cultivating what C. B. Macpherson called "trusteeship." Cunningham suggests that contemporary capitalist societies not only encourage a culture of work, but also a culture of

"possessive individualism," grounded in a strong desire to possess and consume, in self-centredness and self-interest, and in placing a high value on one's private property, thus ignoring not only others' needs, but even one's own true potential. According to Cunningham, a culture of trusteeship is necessary to undermine the norms engrained in a market society. Public space is an essential component to retrieve this culture of trusteeship. It is a space where people can learn to care about something held in common and start to develop a sense of responsibility for it.

Writer and new-media artist Shawn Micallef proposes something similar to Cunningham's idea of *Homo ludens*. Micallef calls our attention to the importance of the "liminal space" that opens up when a city decides to shut down its streets for a festival or some other public celebration. The liminal is the "in-between state on the threshold of another place" yet "firmly rooted in the physical present." Micallef uses the concept to explore what emerges during festivals, where conventions are broken, the street becomes the sidewalk, social interactions among strangers are encouraged, and new perspectives and understandings of our place in the city emerge.

During these activities, people regain control of the space, but they also start to unlearn certain behaviours imposed by social conventions, like sticking to the sidewalk or dressing in a certain way. Aptly, the excerpt from Russell Smith's novel *How Insensitive* presents a complicated experience of urban stimulus, one that is liberating but also disappointing, hovering between play and consumption. The unsatisfactory protagonists of Smith's fiction struggle with identity and purpose in the city, moving along streets and into restaurants and nightclubs, seeking a goal they only dimly perceive.

• • •

THE LAST THREE ESSAYS TOUCH ON ASPECTS OF THE QUESTIONS THAT have been neglected in the previous parts of the book. Ron Deibert and Patrick Turmel both return to the notion of public good introduced by Kingwell to deepen the discourse, while Nick Mount makes an optimistic argument for the aesthetic dimension of public space.

Mount recalls how art and beauty got disconnected in the twentieth century: from Marcel Duchamp's urinal to Damien Hirst's rotting animals, beauty is clearly not the point of much modern art. But even as beauty left the world of art, it remained strong in everyday life and in

mass culture. As Mount explains, "While high art and high theory have never been so skeptical of beauty, daily experience has never been so certain." Beauty seems to be making a slow comeback in art discourse and, to a lesser extent, in the realm of art itself. "Its most vital return," Mount argues, "hasn't been to the galleries, it's been outdoors, to the walls and streets of public space." Mount investigates the proliferation of street art, and wonders what beauty can offer beyond pleasure: consolation, empathy, perhaps even justice?

Deibert's contribution focuses on the importance of virtual public space. He argues that the global communications environment is currently under threat. This issue is closely linked to global environmental catastrophe, since the solution to the latter depends on the former: "solutions to global warming necessitate an unfettered planetary communications network through which citizens can freely exchange information and ideas." In others words, "to protect the planet, we need to protect the Net."

Threats to the public good of the Internet are various. Despite a utopian belief that the Internet would bring down authoritarian regimes that depend on a strict control of information, such regimes appear particularly good at controlling the Internet—for instance, shutting it down during elections or protests. Meanwhile, Internet service companies that used to respect a principle of "network neutrality" now play a more direct role in online realms for political or commercial reasons. The fact that the Internet is becoming a central war tool, legitimized by permissive anti-terror legislation, does not foster freedom of expression.

Deibert presents a series of resources that we can resort to in order to protect the ideals of the Net. One of these—"psiphon"—aims to protect human rights in our communication environments. As he explains, "Psiphon works by connecting friends and family members across national jurisdictions through social networks of trust and encrypted channels to allow citizens in censored jurisdictions to surf the Internet as if they were in an uncensored location over an encrypted channel." To revive the original ethos and ideals of the Internet, these and other actions are necessary. The challenges facing the global communications environments threaten a healthy global public space, more and more essential as a means to solve the various global problems we now face.

Shifting focus once more, Turmel argues that the ubiquity of urban externalities—the multiple effects of other people's actions and behaviours—is an essential part to what a city is. His contribution aims to

show that any attempt to internalize these externalities—that is, to break down the city as public space into multiple private spaces—is both impractical and undesirable. Impractical because urban externalities are a condition of the possibility of cities, and undesirable because urban externalities account for the social, cultural, and economic vitality of cities. They are what make cities great. Turmel thus wants to theorize or systematize a wide-ranging intuition in the literature on cities shared by, among others, Louis Wirth, Jane Jacobs, and Dutch architect Rem Koolhaas, who defines urban culture as a "culture of congestion." Like many other contributors to the volume, Turmel closes his contribution with a discussion of urban justice, suggesting that in a just and democratic city citizens need to gain control of urban externalities—that is, of public space.

Finally, Lisa Robertson's dreamy walks through cities real and imagined, part of her remarkable Office of Soft Architecture project, remind us of the reason we love public spaces in the first place. That is, they allow us to reflect on all aspects of our embodied consciousness.

Our hope is that this collection of interventions, some argumentative, some reflective, all political and poetic after their different fashions, will lead readers back, again and again, to the sites of ourselves.

NOTES

1 Christopher Alexander, Sara Ishikawa, and Murray Silverstein, *A Pattern Language: Towns, Buildings, Construction* (New York: Oxford University Press, 1977).

2 Mark Kingwell, *Concrete Reveries: Consciousness and the City* (Toronto: Viking, 2008); and Patrick Turmel, "La ville comme objet de la justice," in *Penser les institutions* (Quebec: Presses de l'Université Laval, forthcoming 2010).

3 For more on the tyranny of work and the subversion offered by idleness, see for example Joshua Glenn and Mark Kingwell, *The Idler's Glossary* (Emeryville, ON: Biblioasis, 2008).

PART I

MASTERS OF CHANCERY
The Gift of Public Space

MARK KINGWELL

> *But here is yet one more turn, and it is political: is it not also democracy*
> *that gives the right to irony in the public space?*
> —*Derrida,* Rogues: Two Essays on Reason *(2005)*

PUBLIC SPACE IS THE AGE'S MASTER SIGNIFIER. A LOOSE AND elastic notion that is variously deployed to defend (or attack) architecture, to decry (or celebrate) civic squares, to promote (or denounce) graffiti artists, skateboarders, jay-walkers, parkour aficionados, pie-in-the-face guerrillas, underground capture-the flag enthusiasts, flash-mob surveillance-busters, and other grid-resistant everyday anarchists. It is the unit of choice when it comes to understanding pollution, predicting political futures, thinking about citizenship, lauding creativity, and worrying about food, water, or the environment. It is either rife with corporate creep and visual pollution, or made bleak by intrusive surveillance technology, or both. It is a site of suspicion, stimulation, and transaction all at once. For some, it is the basis of public discourse itself, the hardware on which we run reason's software. Simultaneously everywhere and nowhere, it is political air.

Given the seeming inexhaustibility of the political demand to reclaim public space, what is stranger is that nobody admits they have no idea what it is. Most of us assume we know, but more often the assumption is a matter of piety rather than argument—and confused piety at that.[1]

Consider the text of a recent open letter to the mayor of Toronto from the Toronto Public Space Committee, an activist group concerned about surveillance cameras:

> The proposed police cameras will be surveying public spaces through-out the city. We feel that it is reasonable to assume that law-abiding cit-izens should be free to walk the streets and enjoy the public spaces without being monitored by the police. The very act of monitoring reduces the freedoms we all value within our public spaces. It puts into jeopardy our rights to privacy and anonymity, on the streets of the city.... We can choose to not frequent a private business which makes use of cameras; we cannot, however, choose to avoid traversing the streets of our city. We cannot avoid being effectively followed by these cameras in our daily lives.[2]

The concern with cameras is a real one and indeed central to the polit-ical debates about public space, especially in cities. In Britain, there is one CCTV camera for every twelve citizens, with more coming, and no clear consensus on whether these enhance safety, intrude on privacy, encourage *1984*-style snitching, or (of course) all three. But even staunch opponents of the surveillance society may think that something has gone wrong in this form of thinking. What, exactly? To find out, I want to raise here two rude, basic questions that nobody seems to ask: Is public space actually a public good? And if so, what kind?

• • •

FIRST OF ALL, LET US UNDERSTAND PUBLIC GOODS AS A SUBCATEGORY of goods in general. In classical economics, a good is public when access to it is not gated by ownership, so that its benefits—what make it a good—are available to everyone, and one person's use of the good does not diminish another's ability to use it. In the jargon, such goods are non-rival and non-excludable. Public goods come in different forms: they may concern tangible things (grazing land, fish in the sea, the air we breathe) or intangible ones (education, cultural identity, political participation). Since they are non-rival, public goods are theoretically unlimited by definition; in actuality, they often become scarce as a result of use.

How? Well, suppose the public good is a natural resource, such as potable water, whose supply is limited even as its value to everyone is obvious. Access to such goods is supposed to be of common interest.

Unfortunately, when unmanaged, even abundant public goods are frequently subject to what the economist Garrett Hardin called "the tragedy of the commons." It is rational for each one of us to take advantage of a public good, but to the extent that we all do, and to the extent that we increase our advantage as interest dictates, the ultimate effect is the destruction of the resource. Hardin's common grazing land example makes the point vivid: each one of us has an interest in feeding as many of our livestock as we can, but as more and more people do so, the common land is soon brought up to, and then as quickly past, its limit. Result: everybody loses for winning.

The typical responses to this threat are regulation or privatization. Neither is without cost. Privatization of some goods—air, for example—is economically untenable as well as offensive to the common need. (Though privately supplied water, sold in bottles for profit, is now widely accepted: a red flag.) Regulation, like all law, is difficult to enforce at the margins. It also risks what economics call the ratchet effect: the more law you have, the more you will need, and you can't go back once you've begun. (To be sure, depletion of the resource is also subject to ratchet effects: use begets more and greater use, to the point of failure.)

Other problems afflict non-material public goods. Take education, which most people like to consider—and all politicians claim to be—a public good. In theory, there is no reason why it should not be: my enjoyment of the benefits of education should not hamper yours, after all; there is more than enough to go around. But in practice education is structured in the form of institutional access, and the competition for that access generates a zero-sum game—my having the good means you cannot have it. We find education quickly sliding into the paradoxical category of a positional public good: something that in principle is universally available but which nevertheless falls prey to rivalry and exclusion.

Arguably there is also a distinct category of *public positional goods*, or those sometimes called goods of excellence. The good of youth, for example, is universally distributed at birth and declines at the same rate for everyone, yet it rapidly and inevitably establishes a positional hierarchy in terms of sexual desirability or earning power. An Olympic gold medal is a good theoretically available to everyone in that it is publicly contested, openly judged, and definitively awarded; but only one person or team can ultimately enjoy it. Neither of these goods can be purchased: one does not buy the medal except as a souvenir, nor youth

except as a surgical fiction. Absent the taint of cheating or corruption—alas, large caveats especially in professional sports—such goods retain both desirability and scarcity without ever being depleted. Social status is a public positional good, in the sense that it is universally competed for but scarce by definition, hard to get yet available to everyone. It is awarded only by the esteem of others, but because status is mutable as well as intangible, it is easily confused with, or becomes tangled up with, more obvious and calculable factors such as material wealth or parentage. As with youth, one cannot compete for the latter good—the genetic lottery is a closed gate in the system, immune from regulation—while the former good usually generates a race to the bottom.

In the classical ideal theory, positional public goods and public positional goods should be contradictions in terms: anything zero-sum is not public, and anything public is not subject to relative gain. In reality, the various hybrids of publicness and exclusive competition are unfortunately common. And such hybrids are much harder to regulate than ordinary goods. Environmental quality or beauty in a landscape are other positional public goods: in theory open to all and non-rival, in practice they are frequently gated by access and opportunity costs. The given landscape view may be obtained only from a private house, for example, just as the university place may be preferentially available to the daughter of a graduate. Theoretical general access is almost always unevenly distributed in fact. Here we have only to think of the alleged public goods known as equality before the law and the rightful pursuit of happiness. The latter in particular tends to generate the competitive equivalent of a commons tragedy, a race to the bottom. Ever struggling to establish position against their neighbours, individuals compete so hard that everyone ends up spending more than they have. Once more working in ratchet, they progressively price themselves out of their own happiness market, but on a wide social scale.

Since happiness is not itself subject to political regulation, at least in liberal states, and because the public good of status lies beyond their ambit, governments tend to manipulate the competition instead, using regulation, taxation, or reparation to express a common interest in the distribution of public goods. In an ideal world, the income produced by regulation can end up managing the first kind of public goods, such as scarce land or fresh water, so that they survive commons tragedies, or maintaining a vigorous public interest in goods that tend toward competition, such as education, to avoid unequal use or races to the bottom.

Of course, whatever economists may say, we do not live in a world of ideal theory.

• • •

IS PUBLIC SPACE ONE OF THESE GOODS EVEN SO? FRAMING AN ANSWER to that question is important if we are to assess the strong claims in favour of protecting such space. By the same token, the question is difficult to answer in part because space falls somewhere between the tangible and intangible. It can mean material facts such as right-of-way easements on private fields, or the sidewalks and parks of a city. These are there for everyone's use and enjoyment and, absent vandalism or overuse, they should remain non-rival and non-excludable.

But public space can also mean something larger and looser: the right to gather and discuss, to interact with and debate one's fellow citizens. Indeed, the first definition is too narrow for most activists because, even if material facts and built forms are crucial to public space, the merely interstitial notion of public space is too limited. This larger notion of public space brings it closer to the very idea of *the public sphere*, that place where, in the minds of philosophers at least, citizens hammer out the common interests that underlie—and maybe underwrite—their private differences and desires. Here we seek to articulate, according to an ideal theory, *the* common good, not just a bundle of specific ones. Public space enables a political conversation that favours the unforced force of the better argument, the basis of just social order.

This notion of a singular public good has both a semantic and a justificatory affinity with Rousseau's distinction between the will of all (mere aggregation of interest) and the general will (what is actually good for everyone); and with the liberal claim that what interests the public is not identical with the public interest. The trouble here is not that rational-public-sphere versions of public space are romantic fictions, though they may well be that. Ideals and romances can be powerful political levers, after all, just as reason's normative power can be effective even amid widespread irrationality. No, the real problem is that these ideals clash at base and in principle with the presumed authority of private appetite operating in economic reason, where goods are understood as things to be used, enjoyed, or consumed.

A different sort of tragedy of the commons obtains when the order of priority runs from private to public, from individual to social, indeed when the line between them is blurred so decisively by the larger reign

of capital that "public" is reduced to an empty signifier. Now instead of having a healthy threshold function which, in the ideal democratic case, insists upon public reason-giving for any decision concerning the line between public and private, there obtains a negation of the gap between public and private, between image and reality.[3] Instead of the destruction of a public resource from overuse by individuals, we observe the conceptual obliteration of publicness itself because of presuppositions of propertarian individualism. A shopping arcade or street is a public space only in the sense that there each one of us pursues his or her own version of the production of consumption.

Note two crucial ironies of this clash. First, private individuals enter into the so-called public space as floating bubbles of private space, suspicious of intrusion by strangers and jealous of their interests. This is the "right to privacy and anonymity" cited by the Toronto Public Space Committee. It has a specific urban version, often cited as a gift of cities (as opposed to small towns or rural locales), stranger-status as a pleasurable respite from being known or addressed: one thinks here of the glamour and excitement Simmel, for example, attaches to urban anonymity.[4] The right also has a more general political value: think of our cherished anonymity in the voting booth, contrasted with the demand to state one's name in a criminal court. But in this common model, "public" space is not really public at all; it is merely an open marketplace of potential transactions, monetary or otherwise, between isolated individuals. Contracts are engaged, sometimes generating negative externalities—noise, crowding, traffic—which are shouldered as opportunity costs for the general activity. Or the transaction may be a silent one of letting the other be, a positive externality of namelessness and solitude amid the hustle and bustle of other strangers' various projects and movements.

Here the ongoing concern with surveillance, which is often deployed as a concern over public space, really entails an obliteration of it. "It is fashionable to complain how, today, when one's extreme personal intimacies, including details of one's sex life, can be exposed in the media, private life is threatened, disappearing even," Slavoj Žižek notes. "True, on condition that we turn things around: what is effectively disappearing in the public display of intimate details is public life itself, the public sphere proper, in which one operates as a symbolic agent who cannot be reduced to a private individual, to a bundle of intimate properties, desires, traumas, idiosyncrasies."[5] The well-documented spectacle of

French president Nicolas Sarkozy jet-setting and canoodling with his supermodel girlfriend Carla Bruni may be taken as a case in point. In the past, this private matter, staying private, would have bolstered Sarkozy's public role as a man of both passion and discretion. "This time the media is not trying to pry into the private life of a public man," David Remnick commented in *The New Yorker* magazine; "this time, a public man is trying desperately to parade his private life in front of the media."[6]

Second, and as a direct result, any porousness of public and private, say from technological change, generates a confusion which is invariably resolved in favour of the private, as in the protest letter from the Public Space Committee which confuses public space with individual extension of private space. Social networking websites, to take another example, are sometimes praised as a form of public space, but they are invariably defended by users as, in the breach, private. Narcissistic, competitive, and isolating, these systems leach interest and energy away from the real world even as, user by user, they work social interaction free of actual spaces. Fearsome stories of coordinated harassment and suicide are avoidance rituals that keep the confusion active. The only occasion, or response, to the issue is a legal presumption of individual rights; only their violation prompts regulatory interest in the "electronic commons"— and it is doomed to failure anyway, since transnational networks supporting such websites are impossible to control with traditional mechanisms. Touted as freedom, in fact these networks are no more than unsupervised orgies of self-interest and self-surveillance, vast herds of humans indulging the evolutionary aping behaviour philosopher René Girard labels "mimetic desire"—and which some of us call lemming behaviour. Even Charles Taylor, who saw that absent any other values, individual freedom invariably gives way to vanity and relativism, could not have predicted the sad aimless antidemocratic reality of Facebook, where friendship is a commodity.

Thus the strange case of unpublic public space. Even when nobody in particular owns a given area of a city, concrete or virtual, it hardly matters. That space is, conceptually speaking, owned by the dominant rules of the game, which are hinged to the norm of private interest— notwithstanding that they may destroy privacy at the very same time. As Kristine Miller notes in her analysis of selected "public" spaces in New York, among them Federal Plaza and Times Square, "The story of each location reveals that public space is not a concrete or fixed reality,

but rather a constantly changing situation open to the forces of law, corporations, bureaucracy, and government. The qualities of public spaces we consider essential, including accessibility, public ownership, and ties to democratic life, are, at best, temporary conditions and often completely absent."[7] Of course they are! Conceiving of ourselves as individuals, the great legacy of modern political thought, reveals itself as a kind of booby prize, because the presumption of clashing private interests everywhere suffuses the spaces, all spaces, of life. Typical arguments for safeguarding public space, inevitably phrased against this background and so in its terms, are always already lost.

For illustration of this point, consider one haunting narrative of that dominance, from a century and a half ago.

• • •

HERMAN MELVILLE'S "BARTLEBY THE SCRIVENER"—SIGNIFICANTLY SUB-titled "A Story of Wall-Street"—has for generations offered readers the unsettling spectacle of a man who appears to refuse to live. Bartleby, the mysterious copyist who appears one day in the "snug" chambers of a smug, well-to-do Manhattan lawyer, at first takes hungrily to the objectively dispiriting job of hand-copying legal documents: "As if long famishing for something to copy, he seemed to gorge himself on my documents. There was not pause for digestion." Bartleby's craving is all for work, and he takes to the task of copying with an aura of perfect mechanical efficiency, a pre-facto Xerox machine in—albeit somewhat cadaverous—human form.[8] "I should have been quite delighted with his application, had he been cheerfully industrious," the lawyer admits. "But he wrote on silently, palely, mechanically."

The lawyer who narrates the tale "of that strange class of men," the copyists, writes as one recalling a surreal turn of events. He does not lack for self-knowledge, noting how he liked to follow the dictum that "the easiest way of life is the best" and repeating his association with John Jacob Astor, whose name "hath a rounded and orbicular sound to it, and rings unto bullion." The plaster bust of Cicero on his desk is an ironic tribute to eloquence from a man whose entire legal practice is without litigation or courtroom appearance. The narrator is a Master of Chancery, an office that provides him a comfortable and untroubled livelihood. Readers will not need to be reminded that chancery is the court of law concerned with wills and estates. The lawyer is a man who makes his living at the transactional margin between life and death—

especially in dispute. (Dickens's tragic and interminable *Jarndyce v. Jarndyce* in *Bleak House* is a chancery case.)

Bartleby, that paragon of biddable labour, soon reveals new depths. First he refuses to check over his work. Then to fetch a document for the lawyer. Then to join an office conference with the other copyists, Nippers and Turkey—the latter a man of uneven temperament and the former a man who "knew not what he wanted," forever adjusting his work table in search of optimum height. Then to speak, move, or eat. By the story's midpoint, Bartleby, once a fearsome and seemingly unstoppable engine of mechanical reproduction, has by stages attained a condition of near stasis. In the world of movement that mid-nineteenth-century Wall Street represents, the shifting transactions and circulating paper of the legal and financial capital, he is motionless and unresponsive. His is not the rejection of work-time imperatives enacted by the aimless wandering of the flâneur, that hero of nineteenth-century culture and twentieth-century theory, especially in Benjamin's sprawling *Arcades Project*. Bartleby does not amble or loaf, tasting experiences and indulging the stimulating, various leisure of the urban environment, walking slowly nowhere in particular as a kinetic critique of the rushing, straight-line trajectories of the working world. He does not walk at all, he does not even venture outside if he can help it. The street is not his friend or his scene. In his speeding up to a standstill, he is already a much more disturbing and baffling figure than the flâneur, whose strolling leisure can all too easily be assimilated and commodified in the form of the mall-bound shopper.[9] In his refusal of all motion, Bartleby is, instead, a new figure altogether, a singular instance of the anti-flâneur. He rejects the demands of the world of work, Wall Street's logic, but not in favour of the world of leisure; both realms are, for him, impossible.

And yet, *refuse* and *reject* are not quite right here, because Bartleby's notorious expression of non-cooperation, the phrase that irks the narrator even as his other underlings begin subconsciously to echo it, is "I would prefer not to." This is not refusal, then, in the sense of active objection, but neither is it the expression of an active desire, the way we might speak of a voting preference or preference among offered goods. Bartleby's progression is one of staged nullification, as he moves from not-working to not-answering to not-moving to, finally, not-living. He dies in prison, removed there from the lawyer's former offices when, in a panic of frustration, the lawyer has uprooted his practice rather than continue to confront immovable Bartleby and his "dead-wall reveries,"

so different from daydreaming or woolgathering. Cajoling him with promises of comfort and food even in prison, the lawyer receives the story's most affecting line: "I know where I am," Bartleby says to him, and turns his face to the final wall.

Bartleby's is a story of walls and walled streets, as well as of Wall Street, the "cistern" of the lawyer's office and the blank wall of an emergent skyscraper blotting the sky from Bartleby's window view. But it is also the story of a wall of peculiar resistance to the logic of capitalist presupposition, expressed in the norms of work and pleasure, office and home. Lest that claim sound too flat-footed, we note that it is likewise a story of a peculiar tension that is lodged in the heart of the modern liberal project, and its presumptions concerning identity, privacy, and publicity. Bartleby insists on himself as an exception (again, if "insist" is even the right word to use), with such claims of exception understood as being the prerogative of all under the conditions of individual right. And yet, his exceptionality is too extreme to be accommodated by those conditions, highlighting instead the actually exception-hostile liberal state, the state of individualist conformity. Difference is what makes us individuals; it is what we all have—but not too much![10]

Elizabeth Hardwick, in her perceptive essay on Melville's story, "Bartleby in Manhattan" (1981), notes that the existential generality of the story is in tension with the specificity of its historical setting, which is less the gloried Mannahatta of Whitman's ecstatic songs than it is the violent near-slums of Five Points, main site of *Gangs of New York*. (The story was published in 1853, ten years before the New York Draft Riots that feature in the climax of Martin Scorsese's 2002 film.) From this perspective, Bartleby's not leaving the office at the end of the workday highlights, if only negatively, that which he prefers not to do. "It is very easy to imagine from history where the clerks, Nippers and Turkey, are of an evening," Hardwick writes. "They are living in boarding houses, where half of New York's population lived as late as 1841: newlyweds, families, single persons. Whitman did a lot of 'boarding around,' as he called it, and observed, without rebuke, or mostly without rebuke, that the boarding house led the unfamilied men to rush out after dinner to the saloon or the brothel, away from the unprivate private, to the streets which are the spirit of the city, which are the lively blackmail that makes city citizens abide."[11]

Lively blackmail and the *unprivate private* are the two poles of the commercialized social order. Inside, space is private in name but subject to

crowding, density, stacking, and endless subdivision. Outside, rescue from the "third place"—not home or office—is at best double-edged. "Bartleby is not a true creature of Manhattan," Hardwick goes on, "because he shuns the streets and is unmoved by the moral, religious, acute, obsessive, beautiful ideal of Consumption. Consumption is what one leaves one's 'divided space' to honor." This phrase *divided space* is central for Hardwick. It means the way space is divided between public and private, to be sure, but also how private space itself is always divided, between apartments or houses, the thin, contested thresholds of private property and privacy. It recurs in two subsequent Hardwick essays, those on Edith Wharton and Henry James, whose New York characters typically had less first-hand experience of it.[12] (Though spare a thought for poor Lily Bart in Wharton's *The House of Mirth*, reduced to labour by conflicted nature, sitting chilled in Bryant Park and dying alone in a sad rooming-house chamber, whether from suicide or accidental overdose we will never know.) Bartleby will not play the game of capital by the rules of general economy—which rules demand, first, the production of consumption and then, as a consequence, the production of *excess*, paroxysms of luxury.[13] Bartleby's course is itself excessive, however, a luxury of not-doing. He prefers not to work. He prefers not to eat. He prefers not to leave work for the sake of either an unprivate private or an unpublic public. And though his preference ultimately means death, he lives on as a challenge to the accepted order of things—what Althusser calls "the problematic," that realm where problems and solutions alike are delineated under the rubric of the possible.[14]

This is not an overtly political act—there is no call to arms—but it is one with political significance. Just note how the otherwise comfortable lawyer cannot shake off his sense of responsibility and confusion in the encounter, which begins to resemble a capitalist reprise of Hegel's master/slave dialectic. The lawyer is beholden because Bartleby is infinitely withdrawing from care and sense, without actively resisting anything and certainly without being infinitely demanding. His is not a utopian gesture; rather it is a gesture of refusal to engage. His "resistance to amelioration," to use Hardwick's phrase, and his refusal to enter the accepted lists of consumption—in all senses—make of Bartleby the endgame example of critique. With this "gesture of subtraction at its purest" (Žižek), where "body and statement are one" (Hardwick), Bartleby challenges the very idea of making sense according to the terms of sense that are presumptively accepted. "This is how we pass," Žižek argues,

"from the politics of 'resistance' or 'protestation,' which parasitizes upon what it negates, to a politics which opens up a new space outside the hegemonic position *and* its negation." In other words, his withdrawal is not an *objection*, which might be taken over and nullified by power's dominant play. As Jean Baudrillard has crisply put it, critique is "complicit with what it denounces" because "critique always precedes what it criticizes." Bartleby's gesture is not critique; it is, rather, a refusal to play the game at all as it is currently ruled—thus creating the possibility of a new game altogether, albeit one with a grim end under present conditions.[15]

"At present I would prefer not to be a little reasonable," Bartleby tells the lawyer in response to one especially desperate charitable offer. With this, he gently rejects—note that oddly formal mitigation of *at present*—the basic tenet of all private-to-private exchange, the very foundations of a liberal public sphere and public goods: the norm of reasonableness and civility. In this rejection he articulates what the homeless denizens of our contemporary urban public spaces can only embody, a helpless exemption to the rules of the social game. Bartleby's own kind of homelessness, his peculiar lack of accommodation, differs in both tenor and location. Lying—or rather, standing—somewhere between the poor unaccommodated man of Lear wandering the heath, and the shabby tramp who has no place to sleep because a city bylaw has decreed that all public benches must be designed to roll you off them or with barriers that allow sitting but not lying, Bartleby is not only the anti-flâneur; he is also the ultimate loiterer. In this he calls attention, among other things, to the real opportunity costs associated with taking up even the bare roles of social personhood, that smooth negotiation of private and public.[16] Like both the homeless and the uncrowned Lear, Bartleby loiters because he has nowhere else to go. Once situated, he prefers not to submit to the ironies of public space structured by consumption. He prefers not to move on. He prefers not to be reasonable. His preferences, so far from being moves or claims in a larger game of justification and negotiation, stand as insults, undigested remainders. Result: confinement, starvation, death.

Bartleby is not Kafka's hunger artist, a man not quite comprehending his own refusals and withdrawals, seeking an approval and acclaim that has deserted him; Bartleby knows, to the end, where he is—and how he got there. With this knowledge, his action outlines a figure of purity, a violent gesture free of determinant content. His "perfect act of

writing" becomes a "pure act" of ever potentially not-writing. Giorgio Agamben, drawing inspiration from Walter Benjamin's critique of determinate violence, notes with approval the suspended potentiality of this preference not to. In the Arab tradition, Agamben writes, Aristotle's notion of agent intellect—thought without determination—"has the form of an angel whose name is *Qalam*, Pen, and its place is an unfathomable potentiality. Bartleby, a scribe who does not simply cease writing but 'prefers not to,' is the extreme image of this angel that writes nothing but its potentiality to not-write."[17]

But note for the record that this mystical-anarchist Bartleby is distinct from the ruthless-authoritarian Bartleby posited by Žižek, as indeed both are distinct from Hardwick's exhausted-anti-consumer Bartleby. The commonality in all three decodings of the preference gesture is, however, obvious. Bartleby's mildly expressed preference is experienced *as violence*.[18] Whatever meaning the refusal has—even if it has none at all—it remains a disruptive and dissociative fact, an indigestible ethical and political remainder marking the contested threshold between potential and act, self and other, private and public, insanity and reason.

• • •

I WILL NOT ATTEMPT TO ADJUDICATE THE MULTIPLE-BARTLEBY DISPUTE here. Regardless of the specific interpretive frame used to parse his gesture, we can say this for certain: Bartleby enacts a refusal to act, and in this manner he exceeds all standard grids of sense-making. Without bias, we may then say that the truest account of Bartleby is that he is an *epokhé*, or bracketing of meaning, such as might be found in the phenomenological tradition, the setting aside of a framing natural attitude in order to examine it as what it is. "Account" is then immediately wrong, however, since he (and his story) will not submit to the calculating narrative desire of the master of chancery, that keeper of accounts. And though his act (or non-act!) is thus outside of meaning, it is never without meaning since it queries meaning's own conditions of possibility. Exceeding the logic of contract and exchange, it is a gift—albeit a very peculiar one—whose value cannot be calculated and whose debt can never be repaid. Bartleby's condition is, finally, an ethical one insofar as it reveals at the end its epistemological basis: he knows where he is. Can we say the same?

In addition to the realm of wills and estates, chancery law was historically concerned with matters of bankruptcy and confession. Let us

confess, as Melville does in his story, the bankruptcy of our current notions of public space. We are all masters of chancery in the sense that we profit to varying degrees from the current arrangement, but in the end, like Melville's lawyer, the inequalities and contradictions of that arrangement will not be resolved by more pious gestures in the direction of revitalized or reclaimed public space. What is needed is a more radical reorientation—and inheritance. The estate we inherit is nothing less than democracy itself, for democracy is a—perhaps *the*—chancery case.[19]

In the unfortunate prevailing view, public space is a public good at worst of the positional sort, where enjoyment is a competition, and at best of the simple sort, available for everyone's selfish use. Nowhere does it manage to evade or transcend the presuppositions of the property model. In the collective unconscious, public space is leftover space, the margins that remain between private holdings and commercial premises, the laneways and parks in which we negotiate not our collective meanings but our outstanding transactional interests, the ones not covered by production and consumption. Even nominally public institutions such as the large cultural temples—museums and art galleries, artifact-holding artifacts of a democratization of aesthetic experience—do not outpace this unconscious diminution of meaning. They are beholden to private donors, their architecture decided by opaque competition, their curation a matter of esoteric intimidation.

None of which is to say that there is not much enjoyment to be had in these spaces, even as there surely was in the saloons and brothels of Melville's New York. But arguments that remain engaged with the enjoyment question leave the larger presuppositions unquestioned. The suspicion of surveillance, though similarly mired, contains a kernel of awareness. The non-private streets and parks are still under the eye of the state, which monitors the presence of individuals via its monopoly on "legitimate" use of force. Each one of us is made forcibly aware of the traces we leave whenever we traverse these spaces, the swirl of bodily fluids and DNA as well as sheer visibility that is the stock-in-trade of forensic evidence. It is not a coincidence that cultural glamour currently attaches to the details of the forensic mechanism, technologies of visual spectacle celebrating the technologies of criminal localization as in the inescapable *CSI* franchise. David Caruso snatches off his sunglasses and falls backward out of the frame, intoning, just before the repurposed Who song clangs in, "And that, my friend, is … murder." The lesson carried by this televised mythologeme is that you are always present in

the trace of potential guilt, the collar you cannot remove. In English sporting slang, a boxer or wrestler is *in chancery* when he is pummelled repeatedly while his head is locked in the opponent's crooked arm.

Such pre-controlled public spaces are precisely what Althusser predicted as the final victory of ideology under conditions of individual interest, since not even the countermove of looking back with personal recording technology—what the cyborg innovator Steve Mann has labelled *sousveillance*—changes the background order of things.[20] Both being seen and seeing oneself are forms of being called to account: the "Hey, you there!" summons of the state that Althusser labelled *interpellation*, carried within each one of us as the expectation of singularity. Insistence on individual position and individual right—individual sight, individual claim—masks the fact that, in public and private alike, we are always already in the grip of the state. Even if we try to turn cameras back to bear on the state's functionaries—no bad tactic for specific battles of charge and countercharge—it is the state which controls the exception as well as the force of executing that exception.[21]

The deeper reason for this tangling is that contemporary Western societies remain an uneasy hybrid of associational and authoritarian social forms, their citizens more socially conditioned than (as they imagine) autonomous. Democracy is a confusion of claims for individual liberty made among state-controlled structures of order and security which may, at any moment, revert to violence. Calling for sousveillance, though apparently liberating, is a move that merely returns us to the incoherent objections of the Toronto Public Space Committee.

The salvation of this state is, theoretically, that *we the people* are the sovereign power, and that its mechanisms are thus always subject to our public decision and consent. And yet, the structural irony remains. The mechanisms for exerting this mechanism control are themselves subject both to the state's regulation and the de facto trivialization and commercialization characteristic of the private-public order. Consider the vast "war chest" needed to contest an election, or the distorting feedback effects of exit polling and media saturation. The rational public sphere remains a chimera, albeit an essential one for the politico-cultural surround to gesture towards, as long as the actual public spaces of our polity are merely public goods in the use-value sense, and the public interest reducible at any instant to the sum of what interests the public.

● ● ●

THERE IS ONE FURTHER RESONANCE TO BE RECALLED ABOUT THE CHANCERY court, the unspoken centre of Bartleby's demise. In English common law, chancery courts accepted claims made in excess of the strict text of the law. That is, equity or fairness arguments could be levelled there, against black letter application of statute—a nuance that saves common law from the tyranny of bureaucratic heartlessness. Chancery recognizes that justice is not achieved simply by mechanism, however efficient.

As with the court, so with a just society. There can be no useful recourse to public space unless and until we reverse the polarity of our conception of publicness itself. It is sometimes said that the threshold between public and private must be a public decision. True, but go farther: the public is not a summing of private preferences or interests, nor even a wide non-rival availability of resources to those preferences or interests. It is, instead, their precondition: for meaning, for work, for identity itself. We imagine that we enter public space with our identities intact, jealous of interest and suspicious of challenge, looking for stimulus and response. But in fact the reverse is true. We cannot enter the public because we have never left the public; it pervades everything, and our identities are never fixed or prefigured because they are themselves achievements of the public dimension in human life.

This is unsettling, and sometimes unwelcome. The right to anonymity is a fragile negotiation, and sometimes we will be seen and recognized for who we are. Sometimes we may experience the even less welcome instability of finding ourselves the spectators, the lookers, the judgers. James Stewart's character L. B. "Jeff" Jefferies, in Alfred Hitchcock's *Rear Window* (1954), does not think he is a voyeur, only a photographer bored with his injury-forced immobility and loneliness. But his eye draws him into the various worlds of his Manhattan courtyard neighbourhood: romance, despair, salvation, ambition, success, and of course, murder. In an agony of indecision about what he is seeing and what to do about it, he wonders whether he has any right to look. His equally unnerved socialite girlfriend, Lisa Fremont (Grace Kelly), cannot engage the issue. "I'm not much on rear window ethics," she says. But it is the rear window, Hitchcock suggests, that is really the one before us, even if we pretend not to look. The point, which suffuses the film, is raised explicitly in an earlier exchange, this time semi-mocking. Stella, the massage therapist helping Jeff with his recovery, opines,

"We've become a race of Peeping Toms. What people ought to do is get outside their own house and look in for a change. Yes sir. How's that for a bit of homespun philosophy?"
Jeff: "*Reader's Digest*, April 1939."
Stella: "Well, I only quote from the best."

Which seems to dismiss the point as a matter of pop-sociology guff. And yet it is Jeff's police detective friend, Lieutenant Doyle—the state embodied in the form of a person—who makes the decisive judgment (even if he is wrong about the murder Jeff believes he's seen). "People do a lot of things in private they couldn't possibly explain in public," Doyle says. Indeed they do; and sometimes they have to try and explain even if they don't want to, and can't. Urban life is public life, the courtyard is the city, and proximity inevitably creates the complicated shared gazes of the unprivate private—which is to say, the always already public.[22]

We cannot escape these facts, and we can only control them to some small degree—a degree small enough that we ought to pause and wonder why control is even the issue, why we imagine that our selfhood is so stable or so inviolate. In fact it is neither, and the city forever reminds us of this. The city evolved even as we did, and it now pushes us relentlessly toward new self-conceptions, developing notions of personhood beyond the horizon of stability—which was never stable in any event. Reconsidered under terms such as these, public space is never interstitial, marginal, or leftover. It is contested, always and everywhere, because identity is ever a matter of finding out who we are in the crucible of perspective-reciprocity. Public space is not a public good so much as an existential one—one without which democratic politics is impossible, since without a viable res publica there is no demos, and vice versa. Upon this conceptual reversal, or what we should rather call the constantly renewed twinning of self and other, of public and private, of gift and thanks, the feared call of the state transforms into the unsettling but necessary call of the stranger, my fellow citizen, without whom I am nothing.

Hey, you there …

NOTES

1 I plead guilty: my defence of public space in *The World We Want* (Toronto: Viking, 1999) was optative and sentimental; I attempt a more rigorous examination in *Concrete Reveries: Consciousness and the City* (Toronto: Viking, 2008), especially chap. 8.

2 http://www.publicspace.ca/cameras/letter/

3 Guy Debord, perhaps typically for him, calls this negation the final triumph of capitalism. See *The Society of the Spectacle*, trans. Donald Nicholson-Smith (New York: Zone Books, 1995). For more on threshold functions and their importance for urban life, see Mark Kingwell, *Concrete Reveries: Consciousness and the City* (Toronto: Viking, 2008), especially chap. 7 and chap. 8.

4 Georg Simmel, "The Metropolis and Mental Life" (1903), reprinted in *The Sociology of Georg Simmel*, ed. Kurt Wolff (Glencoe, IL: Free Press, 1964), 409–24.

5 Slavoj Žižek, "Notes towards a Politics of Bartleby: The Ignorance of Chicken," *Comparative American Studies* 4 (2006): 381; reprinted in *The Parallax View*, Žižek (Cambridge, MA: MIT Press, 2006), chap. 6.

6 Remnick, lamenting the loss of "organized hypocrisy" in politics, chalks the issue up to Sarkozy's insecure male vanity: "what is particularly pathetic is his delusion that Bruni is a notch on his belt, when he is so obviously a notch on hers" (*The New Yorker*, January 28, 2008).

7 Kristine F, Miller, *Designs on the Public: The Private Lives of New York's Public Spaces* (Minneapolis: University of Minnesota Press, 2008).

8 Scriveners were not always mere copyists. Jonathan Rosen notes that John Milton's father was employed as a scrivener at the beginning of the seventeenth century and acted as an moneylender as well as a drafter of legal documents—an employment so regular and lucrative that the poet, born in 1608, never had to work for a living. See Rosen, "Return to Paradise," *The New Yorker*, June 2, 2008.

9 For more on this process of assimilation, see Mark Kingwell, "Idling Toward Heaven," introduction to Joshua Glenn, *The Idler's Glossary* (Emeryville, ON: Biblioasis, 2008).

10 The fact that this critique of liberalism can be lodged by both the left and right creates an interesting political tangle; see note 20, below, on Carl Schmitt's version of the position, which has lately become a familiar touchstone for leftist thinkers such as Chantal Mouffe, in, for example, *The Challenge of Carl Schmitt* (London & New York: Verso, 1999) and *The Return of the Political* (London & New York: Verso, 1993).

11 Elizabeth Hardwick, "Bartleby in Manhattan," in *American Fictions* (New York: Modern Library, 1999), 8; the essay was first published in 1981. There are of course multiple Bartlebys, even speaking only politically; Armin Beverungen and Stephen Dunne, in "'I'd Prefer Not To': Bartleby and the Excesses of Interpretation," *Culture and Organization* 13, no. 2 (June 2007): 171–83, suggest that this interpretive fecundity is itself a site of *textual* surplus or excess. The story generates an ungraspable and always unresolved remainder not exhausted by Negri, Hardt, and Žižek's "political" Bartleby, Deleuze's "originary" Bartleby, or Agamben's "whatever" Bartleby. "On the basis of

these interpretations we derive a concept of excess as the residual surplus of any categorical interpretation, the yet to be accounted for, the not yet explained, the un-interpretable, the indeterminate, the always yet to arrive, precisely that which cannot be captured, held onto or put in place" (171). The character Bartleby refuses to be assimilated within the story; the philosopheme "Bartleby" likewise refuses to submit completely to any single interpretive assignment or form of consumption!

12 Hardwick, "Mrs. Wharton in New York" (1988) and "Henry James: On Washington Square" (1990), both reprinted in *American Fictions*.

13 Georges Bataille puts it best, in *The Accursed Share*, vol. 1, trans. Robert Hurley (New York: Zone Books, 1991): from the particular perspective, the problem of economy is one of *scarcity*; from the general perspective it is one of *surplus*, ever-renewed growth and spending, leading finally to a luxury-dominated public world. Written a century after Melville's story, the following could easily be a characterization of Bartleby's challenge to that world: "A genuine luxury requires the complete contempt for riches, the somber indifference of the individual who refuses work and makes his life on the one hand an infinitely ruined splendor, and on the other, a silent insult to the laborious life of the rich" (*The Accursed Share*, 76–77).

14 Louis Althusser, "Ideology and Ideological State Apparatuses: Notes towards an Investigation," *La Pensée* (1970); reprinted in *Lenin and Philosophy and Other Essays*, Althusser (New York: Monthly Review Press, 1971 and 2001).

15 Žižek, "Notes," 393.

16 Ann Levey, discussing a proposed bylaw in the city of Calgary, noted the irony of statutes that associate the norm of civility with such routine forbearances as not urinating in public or sleeping in public. Because the homeless have no private retreat and must attempt to reside in public, their very existence is uncivil ("Privatization of Public Space: The Politics of Exclusion," symposium on urban philosophy, Canadian Philosophical Association, University of British Columbia, June 2, 2008).

17 Giorgio Agamben, *The Coming Community*, trans. Michael Hardt (Minneapolis: University of Minnesota Press, 1993; orig. *La comunità che viene*, 1990), 37.

18 It is entirely likely that these different Bartlebys—and there are still others possible—would, assuming a confrontation arranged in imagination, regard each other with suspicion and perhaps even violence. The genius of Melville's character is that the significations of Bartleby outstrip the denotations of his figure. I thank Devlin Russell for this insight.

19 Jacques Derrida dilates at length on the notion of "inheritance" while discussing his anti-realist conception of *democracy to come*; see both *Rogues: Two Essays on Reason* (Stanford, CA: Stanford University Press, 2005) and *The Politics of Friendship* (London & New York: Verso, 2005). The latter includes important critiques of Schmitt (see note 20). Democracy is a promise, or a gift, we inherit; but it also a legacy we (may) continue. Bartleby's private/public "unassimilation" is a complex property within this already complex gift economy.

20 The term is introduced and the practice defended in Steve Mann, "Oversight without Undersight Is an Oversight" (unpublished paper, 2008); it plays on

the *sur* = over / *sous* = under replacement just as his title plays on the doubleness of meaning in "oversight." Mann's idea of prophylactic self-recording as a form of freedom jibes with the recent interest in such "looking-back" events as recording police brutality or deception with cellphone cameras. The minor flurry resulting from these reversals shows how minimal their effect really is: looking back is still a form of looking, and while important in calling functionaries to account, it implicitly affirms that the main technology of "veillance" remains in the hands of the state.

21 "Sovereign is he who decides on the exception," Carl Schmitt wrote as the first, flatly declarative line of his *Political Theology: Four Chapters on the Concept of Sovereignty*, trans. George Schwab (Cambridge, MA: MIT Press, 1985 and Chicago: University of Chicago Press, 2005), 5. The original text was published in 1922, revised in 1934. Schmitt, "the Hobbes of the twentieth century," is a political arch-realist and anti-liberal who argues that all sovereign states define themselves by means of a friend/enemy distinction, the essence of the political as such. From this vantage, liberal procedural democracy—where legitimacy flows from the people to the state, via public debate and decision—is a dangerous myth. A divergent assessment of political exception, inflected by 9/11 and the Bush Administration's response, is offered by Giorgio Agamben in *State of Exception*, trans. Kevin Attell (orig. pub. 2003; Chicago: University of Chicago Press, 2005).

22 One feels the need to curb this insight, but with no clear argument for how. Except to note that the line connecting *Rear Window*'s Jefferies to sleazy porn-star voyeur Jake Scully in Brian De Palma's Hitchcock homage *Body Double* (1984), then to serial killer and voyeur Patrick Bateman in Bret Easton Ellis's 1991 novel *American Psycho* (also a 2000 film with Christian Bale)—who claims to have seen the De Palma movie thirty-seven times—is one that is, at least, unnecessary!

WE WUZ ROBBED JOE ALTERIO

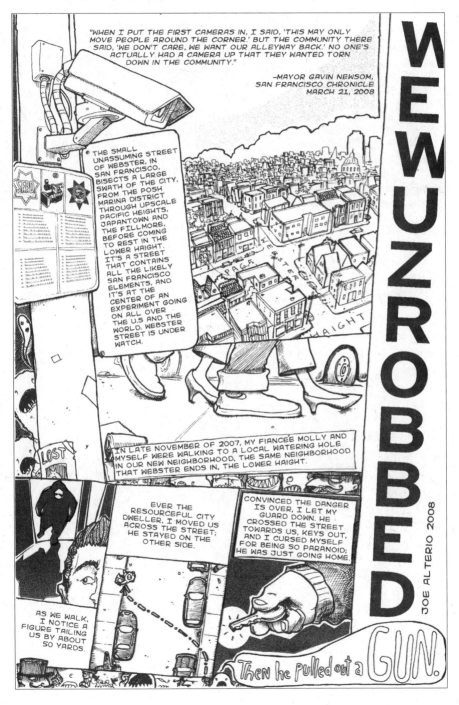

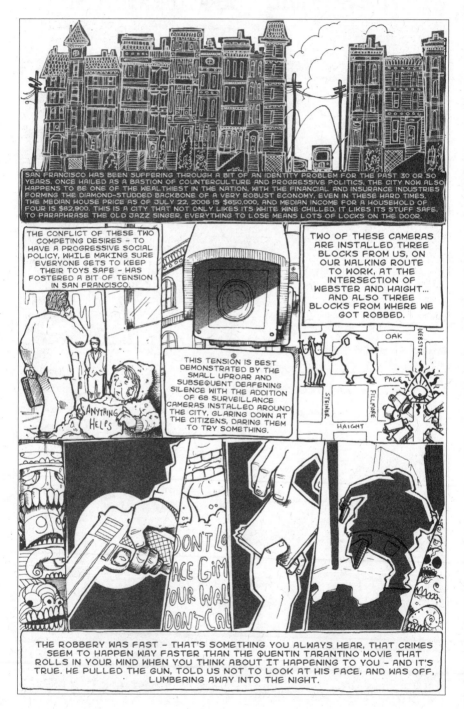

SAN FRANCISCO HAS BEEN SUFFERING THROUGH A BIT OF AN IDENTITY PROBLEM FOR THE PAST 30 OR SO YEARS. ONCE HAILED AS A BASTION OF COUNTERCULTURE AND PROGRESSIVE POLITICS, THE CITY NOW ALSO HAPPENS TO BE ONE OF THE WEALTHIEST IN THE NATION, WITH THE FINANCIAL AND INSURANCE INDUSTRIES FORMING THE DIAMOND-STUDDED BACKBONE OF A VERY ROBUST ECONOMY, EVEN IN THESE HARD TIMES. THE MEDIAN HOUSE PRICE AS OF JULY 22, 2008 IS $650,000, AND MEDIAN INCOME FOR A HOUSEHOLD OF FOUR IS $82,900. THIS IS A CITY THAT NOT ONLY LIKES ITS WHITE WINE CHILLED, IT LIKES ITS STUFF SAFE. TO PARAPHRASE THE OLD JAZZ SINGER, EVERYTHING TO LOSE MEANS LOTS OF LOCKS ON THE DOOR.

THE CONFLICT OF THESE TWO COMPETING DESIRES – TO HAVE A PROGRESSIVE SOCIAL POLICY, WHILE MAKING SURE EVERYONE GETS TO KEEP THEIR TOYS SAFE – HAS FOSTERED A BIT OF TENSION IN SAN FRANCISCO.

TWO OF THESE CAMERAS ARE INSTALLED THREE BLOCKS FROM US, ON OUR WALKING ROUTE TO WORK, AT THE INTERSECTION OF WEBSTER AND HAIGHT... AND ALSO THREE BLOCKS FROM WHERE WE GOT ROBBED.

ANYTHING HELPS

THIS TENSION IS BEST DEMONSTRATED BY THE SMALL UPROAR AND SUBSEQUENT DEAFENING SILENCE WITH THE ADDITION OF 68 SURVEILLANCE CAMERAS INSTALLED AROUND THE CITY, GLARING DOWN AT THE CITIZENS, DARING THEM TO TRY SOMETHING.

OAK
WEBSTER
PAGE
STEINER
FILLMORE
HAIGHT

DON'T LO
ACE GIM
OUR WAL
DON'T CAL

THE ROBBERY WAS FAST – THAT'S SOMETHING YOU ALWAYS HEAR, THAT CRIMES SEEM TO HAPPEN WAY FASTER THAN THE QUENTIN TARANTINO MOVIE THAT ROLLS IN YOUR MIND WHEN YOU THINK ABOUT IT HAPPENING TO YOU – AND IT'S TRUE. HE PULLED THE GUN, TOLD US NOT TO LOOK AT HIS FACE, AND WAS OFF, LUMBERING AWAY INTO THE NIGHT.

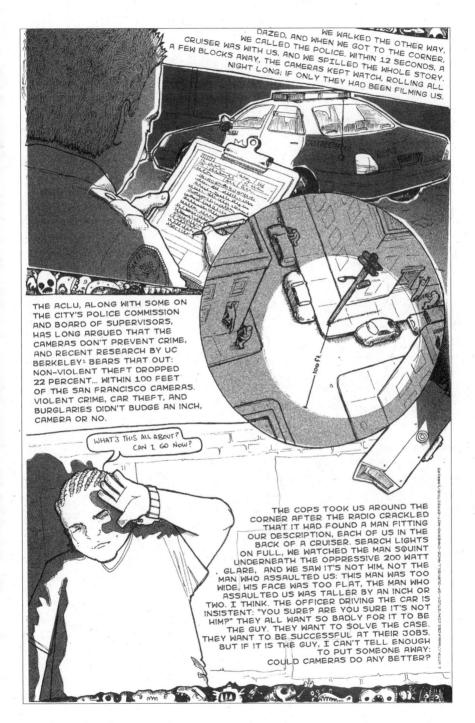

WE WALKED THE OTHER WAY, DAZED, AND WHEN WE GOT TO THE CORNER, WE CALLED THE POLICE. WITHIN 12 SECONDS, A CRUISER WAS WITH US, AND WE SPILLED THE WHOLE STORY. A FEW BLOCKS AWAY, THE CAMERAS KEPT WATCH, ROLLING ALL NIGHT LONG; IF ONLY THEY HAD BEEN FILMING US.

THE ACLU, ALONG WITH SOME ON THE CITY'S POLICE COMMISSION AND BOARD OF SUPERVISORS, HAS LONG ARGUED THAT THE CAMERAS DON'T PREVENT CRIME, AND RECENT RESEARCH BY UC BERKELEY[1] BEARS THAT OUT: NON-VIOLENT THEFT DROPPED 22 PERCENT... WITHIN 100 FEET OF THE SAN FRANCISCO CAMERAS. VIOLENT CRIME, CAR THEFT, AND BURGLARIES DIDN'T BUDGE AN INCH, CAMERA OR NO.

100 Ft.

WHAT'S THIS ALL ABOUT? CAN I GO NOW?

THE COPS TOOK US AROUND THE CORNER AFTER THE RADIO CRACKLED THAT IT HAD FOUND A MAN FITTING OUR DESCRIPTION, EACH OF US IN THE BACK OF A CRUISER. SEARCH LIGHTS ON FULL, WE WATCHED THE MAN SQUINT UNDERNEATH THE OPPRESSIVE 200 WATT GLARE, AND WE SAW IT'S NOT HIM, NOT THE MAN WHO ASSAULTED US: THIS MAN WAS TOO WIDE, HIS FACE WAS TOO FLAT, THE MAN WHO ASSAULTED US WAS TALLER BY AN INCH OR TWO. I THINK. THE OFFICER DRIVING THE CAR IS INSISTENT: "YOU SURE? ARE YOU SURE IT'S NOT HIM?" THEY ALL WANT SO BADLY FOR IT TO BE THE GUY. THEY WANT TO SOLVE THE CASE. THEY WANT TO BE SUCCESSFUL AT THEIR JOBS. BUT IF IT IS THE GUY, I CAN'T TELL ENOUGH TO PUT SOMEONE AWAY: COULD CAMERAS DO ANY BETTER?

1. HTTP://WWW.KQED.COM/STUDY-SF-SURVEILLANCE-CAMERAS-NOT-EFFECTIVE/1468195

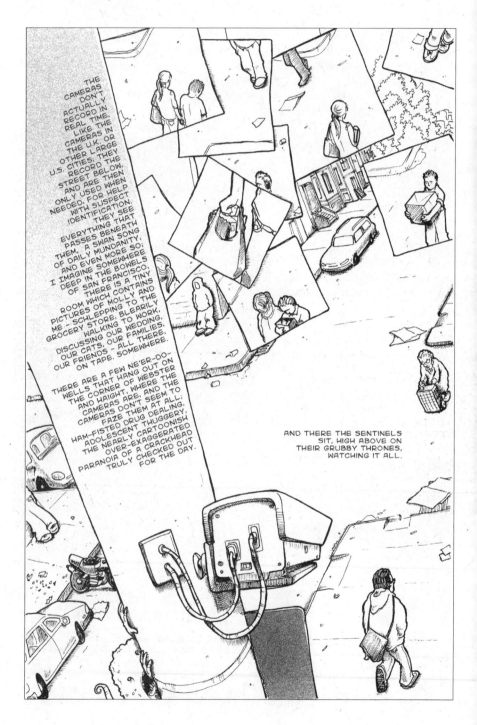

THE CAMERAS DON'T ACTUALLY RECORD IN REAL TIME LIKE THE CAMERAS IN THE U.K. OR OTHER LARGE U.S. CITIES; THEY RECORD THE STREET BELOW, AND ARE THEN ONLY USED WHEN NEEDED FOR HELP WITH SUSPECT IDENTIFICATION. THEY SEE EVERYTHING THAT PASSES BENEATH THEM, A SWAN SONG OF DAILY MUNDANITY, AND EVEN MORE SO; I IMAGINE SOMEWHERE DEEP IN THE BOWELS OF SAN FRANCISCO, THERE IS A TINY ROOM WHICH CONTAINS PICTURES OF MOLLY AND ME - SCHLEPPING TO THE GROCERY STORE, BLEARILY WALKING TO WORK, DISCUSSING OUR WEDDING, OUR CATS, OUR FAMILIES, OUR FRIENDS - ALL THERE, ON TAPE, SOMEWHERE.

THERE ARE A FEW NE'ER-DO-WELLS THAT HANG OUT ON THE CORNER OF WEBSTER AND HAIGHT, WHERE THE CAMERAS ARE, AND THE CAMERAS DON'T SEEM TO FAZE THEM AT ALL; HAM-FISTED DRUG DEALING, ADOLESCENT THUGGERY, THE NEARLY CARTOONISH OVER-EXAGGERATED PARANOIA OF A CRACKHEAD TRULY CHECKED OUT FOR THE DAY.

AND THERE THE SENTINELS SIT, HIGH ABOVE ON THEIR GRUBBY THRONES, WATCHING IT ALL.

PART II

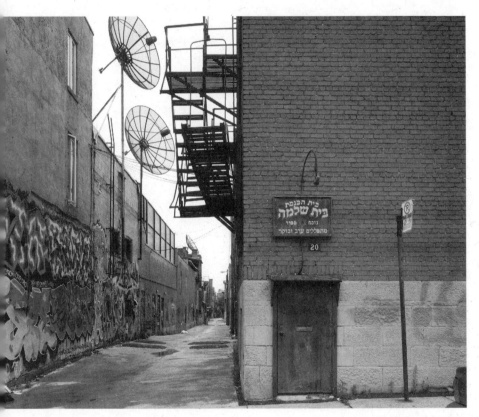

PUBLIC SPACE
Lost and Found

KEN GREENBERG

P UBLIC SPACE HAS BEEN PUT ON THE CRITICAL LIST BY SOME, but the dire prognosis may be premature. It has seemed as if TV, the mall, the car, and the Internet would kill it, and it has been tempting to see its demise as a one-way downward spiral evidenced by painfully visible signs of deterioration all around us in Canadian cities—potholed streets, cracked sidewalks, barren parks, and dying trees—but should we conclude that public space in the city is a lost cause?

The challenges have been severe: economic—it is not essential and we can't afford it; technological—it will be supplanted by a virtual cyberworld; political, social, and cultural—we don't have the time, we are too divided, it is a holdover from the welfare state, we are in retreat from life in public. In fact the fate of public space has been subject to a precarious ebb and flow—near-death and revival—but stubbornly persisting, the commons seems to be essential to our well-being as human beings and social creatures.

I would argue in fact that for a variety of reasons what we are now witnessing reflects a time lag. The desire for public space has returned; although the means to address the unfulfilled need are still lacking, this in no way diminishes that need or the underlying forces that will press for its fulfillment.

How did we get to this point of vulnerability for what seems to be a basic human need? One of the root causes was an intellectual time bomb with a very long fuse. Perhaps inevitably growing out of the Industrial

Revolution was a fascination with potential to refashion cities in the image of well-oiled, frictionless machines. The highly influential 1933 Congrès International d'Architecture Moderne (CIAM) produced a manifesto, the Athens Charter, dedicated to "The Functional City," which was to have profound impacts. Its key underlying concept was the creation of independent zones in refashioned cities for four primary "functions"—living, working, recreation, and circulation (featuring the automobile)—as a means of perfecting each function in relative isolation. In this vision, there was plenty of buffering green space surrounding individual buildings—also known as "towers in the park"—for light, air, and health. But there was little room in this mechanical conception for a complex category like public space that did not have a precise function, though we now see it as fertile breeding ground for the creative society, fostering synergies, social cohesion, and support networks. With its self-proclaimed mission of reordering urban life, CIAM called for, for example, the elimination of the complex historic "public street"—providing circulation, address, services, and a place for civic and social life— seen as an unhealthy and confusing hybrid, and advocated its replacement by more specialized roads for vehicular circulation and separate gathering spaces divorced from the complex web of overlapping activities that were the essence of city life.

This grievous mid-twentieth-century misunderstanding of the organically integrated nature of cities was to have far-reaching consequences and contributed significantly to the reductive form of much postwar reconstruction in Europe, the ravages of urban renewal in North America with urban neighbourhoods plowed under for massive housing projects, and segregated dormitory suburbs on urban fringes around the globe. The idea of the city as a complex organism was under attack and with it the concept of public space as an integral part of the urban fabric.

Even within CIAM itself, critiques emerged as the sterility of these mechanistic models became evident. In 1953, Team 10, a breakaway group of younger members formed (including noted architects Jaap Bakema, Georges Candilis, Giancarlo De Carlo, Aldo van Eyck, Alison and Peter Smithson, and Shadrach Woods), which began to criticize the Athens Charter for its lack of flexibility and inhumane outcomes.

But it was from outside the professions that the most powerful and radical critiques emerged. Jane Jacobs's *Life and Death of Great American Cities* (1961) pulled us back from the misguided hubris of modernist

theory to the pragmatic on-the-ground evidence of how cities actually work and the valuable cohesive social glue of sidewalks and neighbourhood parks lined with active uses. *The Urban Villagers* (1962) by Herbert Gans chronicled and contributed to saving Boston's fabled North End and its lively street life from the wrecking ball. William H. (Holly) Whyte, author of *The Organization Man*, produced a number of seminal works, including *The Social Life of Small Urban Spaces* (1980), which provided close observation (including revealing time-lapse photography) of the sterility of so-called urban plazas divorced from true street life, and, through the organization he founded, Project for Public Spaces, proposed antidotes to repair the damage.

Notwithstanding these powerful rebuttals and countercurrents, however, the influences of the modernist onslaught on the city were powerful and cumulative. The "reductive" concepts of CIAM and their derivatives have been widely adopted by urban planners and still have their leaden influence in prescriptive zoning, ordinances, and destructive anti-city practices compromising the ingredients and relationships necessary for a successful public realm.

In pursuit of functional purity and efficiency of circulation (one of the four functions) a generation of "unbundled" development models emerged within cities which sought to separate vehicles and pedestrians to diminish conflicts and to limit exposure to a "hostile" outdoors. The cure was far more alienating than the problems it proposed to solve. But by putting people in "Plus 15" (fifteen feet above sidewalk level) tubes or skyways above streets given over to cars—Calgary, Edmonton, Minneapolis—or conversely in basement tunnels—Toronto, Montreal—the city's ground plane became desolate. Street level was largely abandoned to vehicles, and public life at grade atrophied; active shops drawing on many clienteles became basement- or upper-level food courts whose activity was limited to business-day lunch hours. With time, these surrogates for a true public realm have gradually retreated back to street level and become more sophisticated, attempting to re-appropriate more of the look and feel of "publicness" by scenographically emulating open-air "streets" but often still situated in carefully controlled environments such as hyper-malls, gated enclaves, lifestyle centres, and so on.

Meanwhile the ongoing move to segregate land use at ever-larger scales and distances advanced rapidly in the great migration to suburbia. The resulting isolation of environments—for living, the subdivision; for working, the office park; for shopping, the big-box corridor or

power centre; for recreation, the sports and rec centre—robbed the public spaces that did exist of the essential overlaps of people and use to make them alive and vital. Propped up by occasional special events, these unbuilt voids within or between monocultures had little chance of success. The in-between times and in-between spaces which are the essence of public life were zoned out.

What made this separation and the required journeys between dispersed daily activities possible was the ascendance of the private automobile as the primary means of circulation to an extent never imagined. And in fashioning a world shaped by the car's needs we gradually "despatialized" our environment. In postwar suburbia we substituted distance measured by time spent in a capsule for space, the intuitive, perceived, and measurable, relationships between actual places. The counterintuitive movements of highway engineering with circuitous moves and "you can't get there from here" situations—the impossible walk across the arterial road from the subdivision to the mall—have eroded the shared ownership of the public realm and produced the deeply estranged and alienated sense of our surroundings so well chronicled in the film *Radiant City*.

More recently the virtual world has inserted itself into this dematerialized physical world as a new form of shared territory. E-commerce, Facebook and chat rooms have become almost universally present on the appropriately named "Web" along with home entertainment centres, texting and cell phones, increasing in volume, intensity, and demands on our time, both further isolating and connecting us.

But it has clearly not been all one way. The overlapping and in some ways complementary reaction and counter wave have also been powerful. The same past decades have also seen a robust revalidation of the city and a reversal of the postwar exodus as important demographic cohorts—immigration and in migration; young people and empty nesters (and increasingly now young families) voting with their feet—are repopulating city centres and older neighbourhoods, seeking what cities have to offer: convenience, urbanity, cultural life, sociability, and so on. There has been very significant reinvestment in cities, and a centrepiece of this investment has been the attempts to restore, improve, and expand the public realm.

But as this movement back to the cities has gained momentum it also has been threatened and undermined by serious funding challenges. In a series of draconian moves to deal with debt and deficit in the 1980s,

the federal government in Canada made drastic cutbacks in funding to the provinces. These in turn were reflected in even more drastic erosion of support to cities. Decades of budget slashing have had a devastating impact on the ability of cities to maintain their physical plants and vital services. The destructive collapse of support for urban infrastructure and public space has been one of the key areas of collateral damage.

In Ontario under the recent hard-right Conservative government this withdrawal of support proceeded in lockstep with highly partisan ideological attacks on the very role of government and public services (and by implication, public spaces), an embrace of a user pay philosophy, increased privatization, and Proposition 13–like limits on public spending. Predictably, the outcomes of this have included increasing income polarization, homelessness, and severe stresses on social services including support for parks and community centres.

This toxic combination—the deeply flawed but highly influential planning ideas about "functionality," the suburban explosion, the love affair with the car, the allure of the cyber world as a surrogate reality, and punitive budget slashing and impoverishment of cities—would suggest a fairly bleak prognosis for the survival, let alone thriving, of public space. Yet just as the prospects for public space seemed almost hopeless, an intractable yearning for some form of social life in public, a new perception of economic necessity, and an environmental imperative have appeared on the horizon as a combined array of powerful new forces to the rescue.

A pervasive desire for some form of sociability in true public space seems to meet a fundamental human need. On a personal level, many of us have a pent-up longing for the unscripted possibilities—absolutely "no surprises" is deadly—of being among our peers face to face, anonymously or not. Seeing and being seen in public says something important about our place in the universe as humans and the connectedness of things. Encountering the "other" has something fundamental to do with self-actualization, and when we don't find it close to home, we seek it elsewhere. North Americans will travel great distances to experience these qualities in exotic locales. When the mall tries to replicate the feel and atmosphere of the public street, it is inevitably an unsatisfying sanitized facsimile. Nor can virtual space entirely satisfy this need. As in many other previous examples—telephone, movies, television—new technological capabilities are absorbed and become complementary to this basic need for the face-to-face encounter.

We have also come to understand how critical this common ground of public space is for the survival of democratic societies. In increasingly diverse Canadian cities which now effectively have no majority population, it is an indispensible precondition for peace and harmony to have places and spaces where we tread the same sidewalks, see each other, and begin to know each other better as crucial cultural intertwining occurs. We see only too clearly that the failure to maintain the commons in many cities around the world, with concomitant social isolation and withdrawal, has severe consequences. Yet the presence of the commons is by no means to be taken for granted. Central Toronto lives on its historic capital of relatively dense and interconnected pre-war neighbourhoods with shared public space, but David Hulchanski, Director of the Centre for Urban and Community Studies at the University of Toronto, has painted an alarming picture of the erosion of this common ground as income polarization is reflected physically in Toronto's accelerating city-wide division into three very separate cities: a growing area of poverty (housing a large population of recent immigrants) in the post-war suburban fringe, a growing high-income enclave in the city centre, and a shrinking middle class in between.

But there is another even more basic argument for the presence and quality of public space, one where right and left, social equity and enlightened self-interest, all come together. It is the economic counter to the ultimately self-defeating neo-conservative legacy of neglect and withdrawal which leads to private wealth inside gated communities and public squalor without. There is now a broadly shared understanding among many economists that cities are the principal generators of wealth subject to their ability to attract investment in a diverse creative economy. This new paradigm for economic development emphasizes quality of life and *place* as values equally as much or more than the traditional focus on factor costs (i.e., land, labour, and capital). Cities and regions which compete with each other primarily on cost are engaged in a losing game. "Beggar thy neighbour" policies inevitably lead to a race to the bottom and impoverishment of the public realm and public services.

This new paradigm is also driven by the increasing globalization of economic activity. All locations within the developed world can be seen as expensive when compared with the low wage rates available in Asian and Third World countries, along with material cost factors and tax policies that provide incentives for taking production offshore. Site location decisions, especially for the knowledge-based industries that

are increasingly driving the North American economy, are to a significant degree based on the value that a particular location offers, and businesses can now choose from among local, regional, or international cities. This in turn relates directly to the concept of place and most importantly the quality of the public realm.

As Alan Broadbent has argued persuasively in his recently published book, *Urban Nation*, this new economic reality of diverse cities as economic drivers and the dramatically altered demographics of Canada (an immigrant society which now has eighty percent of its citizens and the vast majority of recent arrivals living in a few major urban regions) poses major challenges to the traditional conception of the country as one whose economy is based on resource extraction and traditional manufacturing. At issue is the legacy of policies, political agendas, and distribution of representation in federal and provincial parliaments which reflect another era. Recognition of this profound demographic and economic shift is the key demand of the so-called cities agenda. Why should Canada's big cities as major generators of wealth and prosperity be so severely and inequitably hobbled in their ability to invest in the future and the lives of their citizens? Adequate support for the creation and maintenance of urban infrastructure and the public realm as a strategic investment in quality of life, but also competitiveness on the world stage, is at the heart of this debate.

These reaffirmations of the indispensable contribution of cities and, by implication, the public life and space that is fundamental to their success and well-being has run in parallel with the astonishing shocks to the competing vision—the seemingly unchallengeable suburban paradigm. The meteoric and probably irreversible increase in the cost of fossil fuels for cars, trucks, heating, cooling, and air travel and its reverberations are having dramatic and rapid consequences. The fact that SUVs and minivans and oversized houses inaccessible by transit are drastically decreasing in value is not just an isolated aberration but the harbinger of a profound shift as people scramble to make adjustments in their lifestyles. *The Atlantic* has predicted that many isolated suburbs will be the new slums, unfortunately to be inherited by the most vulnerable.

While economic incentive is always the most persuasive changer of behaviour, increasing consciousness of environmental stress and degradation, sheer commuter fatigue, inconvenience, and social isolation have also been major contributing factors to the fairly dramatic repopulating of major city centres. As the imperative to modify self-destructive practices

begins to suggest forms of development inherently more environmentally sustainable, cities are the crucibles where solutions are found to otherwise intractable problems. The environmental thrust is gaining traction and broad popular appeal as a common ground that cuts across class, cultural, and political lines and is rapidly pushing into new areas of investigation. In ways both superficial and profound, this desire for greener solutions is giving birth to lower-impact lifestyles and new design approaches for city districts as well as individual buildings and landscapes. It augurs, among other things, a greater mix and proximity of daily life activities—living, working, shopping, culture, recreation, and leisure; increased walkability, cycling, and transit, and less car dependency—all key ingredients in fostering successful public spaces—along with lower energy consumption and alternative energy sources; improved waste management and treatment; and new approaches to stormwater management.

In the face of this array of new forces—a personal and social need for shared life in public spaces serving complex heterogeneous populations, the need for competitiveness in a knowledge-based or creative economy based on quality of place, and an environmental imperative and the need to find alternatives to deal with the dramatic increase in the costs of unsustainable lifestyles—what we are seeing is the reversal of many of the major tendencies and projects of mid-twentieth-century urban-suburban planning. The remarkable thing is that these hard-wired prescriptions which altered so much of the urbanized face of the planet in a little over two generations are now being vigorously challenged and in some cases overturned. This change in consciousness and entrenched practices will be a complicated and in many ways painful shift—geographically uneven and inconsistent, with many pockets of resistance—but the underlying pressures are undeniable.

In virtually all planning agencies, public and private, efforts to specialize and separate uses are giving way to new formulations for mix, overlap, shared space, and flexibility. More dynamic models are emerging that seek to emulate the organic processes of continual change identified by Jane Jacobs, and others are informing the need for integrating "concepts" at the intersection of economy, community, and environment. This more "ecological" understanding of connectedness favouring solutions that integrate a broad range of issues is bringing together many kinds of skills and knowledge and challenging disciplinary silos and past practices and tools.

As the core of this far ranging reconsideration of priorities and practices, public space—the streets, parks, squares, and trails that make up approximately half of the land area of the city—are being rethought. A renewed appreciation of the city's "physicality," moving from the abstractions of statistics and arcane definitions to the qualities of space and place, and a new public confidence and interest in design are very much in evidence. Pedestrians and cyclists are vigorously staking their claims for a greater place in the public right-of-way. "Roads," previously the exclusive province of traffic engineering with the avowed purpose of maximizing vehicular traffic flows and minimizing impediments, are again being re-conceived as "streets" serving a variety of complex needs. New, more sustainable circulation networks are being advocated that look, feel, and work differently and that give first priority to people on foot.

City parks and squares have emerged as a potent new focus for community allegiance, civic pride, and neighbourhood identification. Even where government is severely challenged in providing and maintaining such spaces, civil society in the form of communities, individuals, the private sector, and institutions is stepping up in a kind of groundswell with support for the "commons," from high-profile efforts like New York's Central Park Conservancy to hundreds of more modest "Friends of" organizations. Partnerships have become the way to accomplish what government could no longer manage alone.

The interesting thing about this comeback and revival of public space in the city is that for the most part it is not the picturesque replication of New Urbanism with its literal return to real or imagined earlier periods and models. It is about reinventing and reinvigorating older prototypes yet at the same time introducing something new. The new sensibilities in play for the public realm, like the city itself, tend to be more multivalent and overlapping, linear and kinetic, weaving through the city and intertwined with natural systems. In fact, perhaps more rapidly than we realize, we are witnessing a major dissolution of the false professional and conceptual dichotomy that divided the city from the natural world. Like many powerful and timely impulses, this reconciliation has had many sources, scientific, cultural, and aesthetic. It is a striking example of simultaneous discovery motivated by a sense of crisis, as the scientific community calls attention to appalling degradation, dangerous consequences, and the undeniable fragility of human life on the planet.

This change in consciousness vis-à-vis nature in the city was antici-
pated and fostered by inspired practitioners and writers including Ian
McHarg in *Design with Nature* (1971), Anne Whiston Spirn in *The Gran-
ite Garden* (1984), and Michael Hough in *City Form and Natural Process*
(1984). Their ideas opened possibilities for a new way of thinking beyond
conventional mitigation of impacts on nature to one based on new pos-
sibilities for creative synthesis working *with* natural process, in the
acknowledgement that humans are part of nature and that, to some
extent, nature everywhere on the planet has become a built environ-
ment deeply altered by human interaction with it. The seismic shift in
goals and priorities is also producing a cultural predisposition to a new
form of coexistence, the intertwining of city and nature in a new sense
of place. Renewed places reflecting these approaches will be more rooted
and specific, with the underlying layers of natural setting revealed and
better appreciated. In the words of Betsy Barlow Rogers, former exec-
utive director of the Central Park Conservancy, "As the city becomes
more park-like, the park becomes more city-like."

Coinciding with these new perceptions has been the opening up of
remarkable opportunities to forge new relationships with natural fea-
tures in cities. Waterfronts on oceans, lakes, and rivers have become a new
frontier for many cities, with the potential for reuse of vast tracts of obso-
lescent port, industrial, railway, and warehousing lands. In the mid
1990s, I first used the phrase "retreat of the industrial glacier" as a
metaphor for this process. As the industrial glacier recedes, it reveals an
extraordinary terrain of availability and a host of new possibilities. In
terms of expanded public terrain there is an almost universal psycholog-
ical desire to be near water. The powerful allure of these great natural
features draws people to them. They offer respite from the pressures of
city life and a boundless or expanded horizon. Because of the central-
ity of these places, relating to the reasons the cities were founded there
in the first place, they have an inherent capacity to produce more "sus-
tainable" development, putting housing closer to workplaces and reduc-
ing travel times. For many city dwellers, the public realm of the new
waterfronts becomes the "resort" in situ for leisure in close proximity, a
high priority as place becomes the key to value.

Every retreat or recycling of obsolescent features in cities creates new
possibilities. One new kind of increasingly popular public space is the
linear and kinetic path or urban trail wending through the urban fabric
or along the edge of a canal, river, creek, valley, or ravine. Availability and

access open up previously forbidden territories. New conduits to these edges and thresholds emerge, tracing rediscovered links along rail lines, canals, and abandoned rights-of-way. Industrial harbours re-emerge as new "harbour rooms," blue and green spaces with public edges and recreational water sheets. A related systemic opportunity arises as aging mid-twentieth-century highway infrastructure nears the end of its useful life and demands repair and renewal, resulting in reconfiguration or, in some cases, removal.

The new green sinews—links as opposed to nodes, in planning jargon—are penetrating and opening up the city in areas that were formerly terra incognita. Unlike the grand and formal front-of-the-house spaces, they provide a unique vantage point and back-of-house experience which is in tune with the complex, overlapping, flash back and forward, multi-layered sensibilities of twenty-first-century life. The desire to meander through the city in public space is ancient—witness the promenade, the passeggiata, the paseo. And Frederick Law Olmsted's green ribbons through cities (Boston's Emerald Necklace, for example) and other similar nineteenth-century visions such as Horace Cleveland's Grand Rounds and Chain of Lakes in Minneapolis/Saint Paul are antecedents to be sure. But there is also something new here in the immense popularity of walking, jogging, cycling, in-line skating (often with kids in tow), or otherwise exercising while exploring new territories.

Every city worth its salt now already has multiple examples of these new urban trails reconnecting isolated fragments of the urban fabric on vacated lines and water's edges, with new ones in the works. The Manhattan Waterfront Greenway now extends around the island of Manhattan, the Canal Saint-Martin pathways traverse the east end of Paris, and the car-free greenways of Bogotá are ubiquitous.

The creation and design of these links has occupied an ever greater place in my work over the past years, including in Toronto the Martin Goodman Trail across the central waterfront, the Beltline on a former rail line, and the Lower Don Lands traversing the new estuary at the mouth of the Don River; in Boston and Cambridge linking to and along the Charles River and Boston Harbor at NorthPoint, Kendall Square, and Boston University and the Crossroads Initiative criss-crossing the Rose Kennedy Greenway on the footprint of the Central Artery vacated by the Big Dig; in Lower Manhattan along the East River and on the Brooklyn side through the Brooklyn Bridge Park; in Calgary the Riverwalk at the confluence of the Bow and Elbow Rivers; in Detroit along the Detroit

River; and in Saint Paul along the banks of the Mississippi. These new trails also provide a "greening" opportunity—reintroducing natural systems, tree canopy, naturalized areas, and habitat corridors following the same trajectories. With time, the individual trails are extended and linked and begin to form vast networks.

The phenomenon which has come to the city may in some ways have been inspired by the popularity of the great hiking and trekking trails in the countryside, such as the Appalachian Trail in the U.S. or the Bruce Trail in Ontario, which follows the Niagara escarpment to Tobermory, passing through wilderness and farmland. More recent "hybrid" urban/countryside trails through the Niagara Peninsula follow the Niagara River and the Welland Canal but also go cross-country to traverse countryside, vineyards, villages, and towns; these are matched by similar trails in the nearby Finger Lakes District in New York State that also link viniculture, history, culture, and recreation in new ways.

Like ski trails, these crosscutting urban trails can be experienced at any desired level of challenge, from novice to expert, alone or in the company of others, on foot or on wheels. They are often unfinished and episodic, skipping back and forth in time like contemporary novels, layers revealed and peeled back.

In some ways this is the twenty-first-century version of the kinetic mind-and-body sensorial experience of the nineteenth-century boulevard flâneur, with the open-ended allure of the "road" but in another form. Venturing into uncharted territory can be deeply satisfying psychologically, a quest combining discovery and self-discovery. Encountering others en route, people-watching on the fly with occasional acknowledgement, greeting, and communication of the shared experience and the possibility of gregarious encounters—all of this reinforces a sense that "I am not alone." For me, especially from the raised vantage point of a bicycle seat, the feeling is reminiscent of snorkelling; like an exotic seascape, the city reveals itself in new ways.

For many the ostensible reason or pretext for getting out is that we also stretch our bodies and enjoy the health benefits of exercise, increased cardiovascular stimulation, and movement of our limbs outside the gym or fitness centre. But it is much more than exercise. Moving self-propelled at relatively low speeds restores the intuitive geographic understanding of spatial relationships that the car weakened—a feel for the real distances between things, a sense that it's all connected. The ability to move around relatively freely and discover the world close at hand breaks

through perceived barriers between neighbourhoods and city districts. Discrete experiences are joined; relationships and flows become more continuous.

Increasingly the virtual world helps to guide us into the real. Traditional low-tech maps are supplemented by GPS technology and sophisticated websites providing detailed GIS-based information and online assistance for this new form of exploration. Originating in Toronto, the [murmur] project, for example, is a documentary oral history project that records stories and memories told about specific geographic locations. In each of these locations, a [murmur] sign is installed with a telephone number on it that anyone with a mobile phone can call to listen to that story while standing in that exact spot, engaging in the physical experience of being right where the story takes place.

Honouring Jane Jacobs, Toronto-based Jane's Walk is a coordinated series of free neighbourhood walking tours organized via the Internet and given by locals who care passionately about where they live, work, and play, offering a pedestrian-focused event that combines insights into urban history, planning, design, and civic engagement with the simple act of walking and observing. In May 2009 over 10,000 people took part in 250 walks in 40 North American cities with one walk in Mumbai, India. There were 103 walks in Toronto alone. One of the greatest "design" challenges in creating and opening up these trails is overcoming jurisdictional, bureaucratic inertia and risk aversion so as to allow the public into formerly off-limits territories. But breaking through these administrative and legal barriers has been driven by an increasing sense of the public's perceived need and right to overcome barriers and get to and along the water's edge, or down the ravine, or from neighbourhood to neighbourhood in other than motorized vehicles. In some jurisdictions this right has been enshrined in legislation and practice. This phenomenon is still in the early stages, and it will be fascinating to see where it goes. It is not too difficult to imagine cities traversed by extensive green and sociable networks as the legacy of a post-automobile age. This increased physical and psychological access to the city may portend a new form of democratic public space and a powerful reversal of the postwar retreat from life in public spaces.

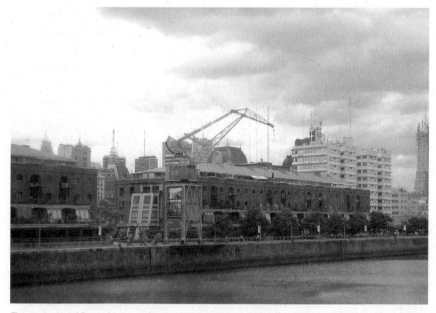

The conversion of Puerto Madero, a former industrial harbour in the heart of Buenos Aires, has created a new, intensively used network of public space which incorporates artifacts of the industrial past and connects them to an adjacent Reserva Ecológica on the Rio de la Plata.

The remarkably far-sighted 1909 *Plan of Chicago*, by Daniel Burnham and Edward H. Bennett, proposed among other things reclaiming a vast connected park network along the Lake Michigan lakefront for public use. This plan has served the city well and continues to guide the creation of parks, trails, and natural areas.

Crissy Field, a former airfield on San Francisco Bay that has been converted into a magnificent linear park, added a critical missing link around the bay for public access to the water.

This pedestrian-and-cycle bridge crosses over the Humber River where it enters Lake Ontario in Toronto. It is a popular gathering place at a point where several expanding regional networks converge, including the Martin Goodman Trail along the lakefront and the Humber River Trail.

A nineteenth-century commuter rail loop linked to downtown Toronto was converted into an intimate, green, somewhat magical pedestrian corridor known as the Beltline, which follows the traces of the abandoned tracks through much of the built-up city.

The plan for the Lower Don Lands in Toronto involves the relocation of the river mouth from an industrial channel to a generous naturalized estuary entering the harbour at the culmination of the Don River Trail network. (Prepared by a team led by Michael Van Valkenburgh Landscape Architects, of which I am a member. Illustration by MVVA.)

Building on the legacy of Frederick Law Olmsted's Emerald Necklace, Boston and Cambridge have continued to open up new additions to the public realm along the Charles River Basin and Boston Harbor.

My initial sketch for the Crossroads Initiative in Boston, which builds on the historic investment of creating the Rose Kennedy Greenway on the footprint of the demolished Central Artery, shows the creation of new public space that links neighbourhoods to the Greenway, the water, and each other.

ARCHITECTURE AND PUBLIC SPACE

ALBERTO PÉREZ-GÓMEZ

THE ARCHITECTURAL PROFESSION HAS STRUGGLED FOR OVER two centuries with the definition of its proper place, both within modern culture and, more concretely, in relation to the city. The problem seems to have become even more difficult since cities have increasingly proliferated and become hostile, unmanageable entities, conceptualized as efficient systems of circulation and consumption. While the definition of architecture has shifted historically, I would argue that its main interests have always related to the configuration of public space.

Indeed, the central, traditional concern of architecture has been the disclosure of a social and political order from the "chaosmos" of experience, starting from the perceptions of meaning that our cultures have shared, embodied in historical traces, while projecting imaginative alternatives that go beyond stifling and repressive inherited institutions. Thus, in the best cases, architecture has provided spaces of encounter and participation where the Other is recognized and respected, spaces that enable human freedom. Despite the well-argued skepticism about the possibilities of a public realm that we find in the writings of celebrated architects like Rem Koolhaas, often vindicated by the interests of modern consumer societies, I still believe that the proper vocation of architecture is the configuration of public space, meaning specifically a poetic proposition disclosing collective order. This is not merely analogous to design as defined by Bruce Mau, understood as clever or aesthetically pleasing planning, an activity which it

has become fashionable to associate with all human endeavours. While it could be argued that the privatizing tendencies of most modern societies remain on the rise, and that individuals in the industrialized and developing world are not interested in "symbolic space," usually associated with repressive political or economic forces, it is also true that our sense of radical homelessness encourages dangerous pathologies. We interact more with machines than with other human beings, and this results in narcissism, alienation, and the incapacity to grasp a sense of purpose for our actions, which sometimes translates, in our epoch of incomplete nihilism, into violent expressions of nationalism and fanaticism. In other words, using an analysis of Vilém Flusser,[1] we may no longer need home in the sense of *Heimat* (rooted nationalism), but we always need "a home" in the sense of *Wohnung*, and this cannot be reduced exclusively to our private residence.

The functioning power of public spaces as a site for intersubjective meaning started to deteriorate after the closure of what Michel Foucault called the age of representation, at the end of the European eighteenth century. Understanding the problem in a longer historical perspective is important to help us contemplate possible alternatives in the age of cyberspace. While we cannot conceive of public space as simply a "designated area" in the city, no matter how formally appealing, I believe our cultural heritage still offers alternatives, distinct from the telematic space of our computer screens which has become so popular recently as a forum for supposedly "public" interaction.

Using the Greek polis as a point of departure, public space was famously defined by Hannah Arendt as "the space of appearance." It is the site where I find myself and recognize my place *through* the eyes of the Other. Public space is a space of full embodiment, a space of dialogue, gesture, and erotic exchange. It is ultimately irreducible to geometric space, regardless of its form of representation, whether on paper or on a computer screen. The communion it enables is also irreducible to other forms of communication, regardless of the technology we may invoke, from printing to hypertext. Like orality with respect to written language, it is always antecedent.[2] In the Western tradition, public space—urban space— is also political space. As opposed to cyberspace, it is a space with boundaries; in fact, it is the space where the horizon may (and must) become visible: our inescapable mortality. Its reality depends on the inner workings of a culture and its rituals.

In the case of our late-modern societies, justifiably suspicious of traditional rituals and political values, the architect (like the poet) may try to implement alternative programmatic strategies: visions of life intended to reveal that which we forget, through a poetic image, at a particular moment in time, even if it is only ephemeral.[3] Ever since the late eighteenth century, cities stopped being articulations of ritual places and became mere circulation. The master metaphor of planning for 200 years has been circulatory: efficiency in this regard seems to be all that truly matters. And yet, we remain fundamentally embodied consciousness. This is our true nature: our mindfulness is not computer memory, and we are not Cartesian points in the ether of telecommunications. Is it simply naive to ask that we consider ways of subverting the city as a circulatory system? Is it simplistic to demand that cities must start by being places where one can walk and experience reality synesthetically—that is, by allowing that our first encounter with the given is not reducible to sensations given to specific senses, as if these were isolated functions connecting to a computing mind?

Montreal, the city I call home, is a large island, yet its connection to the surrounding water is invisible, forgotten. It possesses a large network of subterranean tunnels and shopping malls, yet the meaning of being underground is rarely acknowledged. These simple, forgotten conditions raise questions that may be addressed, thus creating potential spaces of participation. Montreal also possesses, like many other North American cities, liminal, obsolete areas left over by development, areas that contain a mortally wounded or dead technology, places which, when properly recognized, seem particularly poignant. Regardless of our skepticism, these questions and observations, among many others, start to reveal fertile grounds for a potential public space. Given the scientistic inclinations of architects and planners, the poignancy of such potential spaces is often made clearer in other art forms, such as literature, painting, in-site installation works, multimedia, and film.

Examining the history of public urban space in Western architecture, we may identify, for the sake of our argument, two traditions. Resonant with a metaphysics of presence, one of these traditions endeavoured to name things clearly. The agora was the unambiguous space for public speech and the debate of political issues by citizens. Vitruvius insisted that the semantics of signifier and signified were at work in architecture, implying that the building signified the order of the universe, an assumption accepted by all his successors at least until the late seventeenth cen-

tury.[4] Even during the following century, Enlightenment theorists employed linguistic analogies to account for the problem of meaning originating no longer in nature, but in culture and history itself.

Our Greek cultural ancestors, however, also initiated a tradition of "alternative" public space that may perhaps be more useful in our predicament. They associated this alternative public space with the theatre and our encounter with the arts, a mediated public realm for αλλοσ αγορια, for "other speech" or allegory. Interestingly, Vitruvius also recognized that the theatre was perhaps the most important of all urban institutions, as in it a catharsis took place, a purification that allowed each citizen to discover a sense of purpose and belonging.[5] He describes the manner in which the theatre conveys this sense to the spectators as they participate in the event of the dramatic representation. The circular plan of the building is mimetic of the cosmos, its twelve divisions that generate the parts of the building emulate the order of the zodiac, and proportional harmony is crucial. Yet the meaning of the building is not given as an aesthetic experience in the sense of disinterested contemplation: it is not in the details, the materials, or our experience as voyeurs. Rather it is only conveyed "when the spectators sit, with their pores open" at a performance, and the whole event becomes cathartic, a purification that allows for the spectators to understand, through their participation in the space and plot of drama—which is also the space of architecture—their place in the universe and in the civic world.

Let me now go back to the initial question. Is it possible, despite our obvious distance from Classical drama, to imagine this model of "architecture as event" as a framework to configure potential urban space in our cities? Despite our radical skepticism and our lack of shared beliefs and rituals, is it possible to imagine that architectural works may indeed bring us back to introspection, allow us to ask important human questions, and change our life? Perhaps we recognize in them that which, although we have never seen it before, is yet familiar; that which, although we must receive it in silence, demands to be articulated in words: namely, the coincidence of life and death in a moment of poetic incandescence? As we walk through the prosaic and relatively inhuman spaces of our cities, there are sites that have a greater potential to escape the hegemony of panoptic domination and technological control. These are found by framing the city through appropriate questions, by means of alternative mappings that have nothing to do with geometric precision. Sites that appear to have been torn from the seeming continuum of progress

and that reveal chasms and wounds may be particularly propitious. The surrealist writers of the early twentieth century taught us very well how to navigate through our seemingly prosaic cities and appreciate their capacity to reveal the vectors of desire,[6] proposing, if not a new "mythology," at least the openness of our world to mystery, our capacity to reveal the "weakness" of the truths we associate with technology and science and to accelerate their demythification.

This mode of working is obviously very different to an architect finding a site and merely using it as a neutral canvas, as geometric space. "Places," potentially participatory and pregnant with qualities, are not merely "found." It is not enough to find or preserve a site, as merely naming it would mean its demise. It is naive, as Ivan Illich has argued, to believe that merely creating an artificial lake in the middle of Dallas would bring to the citizens the experience of water:[7] a much more radical operation is needed to "destructure" H_2O and bring back the experience of water as a life-giving liquid, analogous to blood and semen, necessary for remembering and forgetting. First we must understand and acknowledge the importance of history, while recognizing its affinity with fiction, as Jorge Luis Borges has taught us. This is of particular concern for the development of appropriate urban programs. It is paramount to avoid aestheticism, reductive functionalism, and either conventional or experimental formalism, to consider seriously the potential of narrative as the structure of human life, a poetic vision realized in space-time. The architect, given such a task, must also write the "script" for his drama, regardless of whether this becomes an explicit or implicit transformation of the "official" urban program. This is, indeed, a crucial part of the urban design activity, as well as the vehicle for an ethical intention to inform the work. We should always keep in mind that for modernity, whenever buildings become "idols" (or signposts—like the logo of a corporation or a national government) they lose their capacity for edification. They should rather allow us to see through meaning precisely by not restricting it, in themselves meaning no single thing. Only under these conditions may urban interventions become spaces for collective participation, where individuals may exercise, with their freedom, a reciprocal responsibility to "participate" in the recreation of a communal project that is no longer dependant on a shared cosmic order.

Such places, moreover, cannot be merely the result of the egocentric imagination of an architect, nor mere novelty, the product of deranged

computer virtuosity: they must refer to the natural and cultural horizons embodied in their sites. Potentially effective urban space is therefore articulated as a narrative, "metaphoric" projection grounded on recollection. On one hand it should resist easy consumption and celebrate traces of cultural continuity. On the other, it should invite the inhabitant's intimate participation in recreating the work through language for it to yield its "sense," gathering a potential recovery of communal purpose and human solidarity.

Richard Sennett has pointed out that spaces come to life when they are used for purposes other than those for which they were conceived.[8] While this is often true, it is important not to misconstrue this statement as a plea for the architect to abdicate responsibility for the program, as is often the case today. Openness is key, but this is precisely the character of works of imagination: open enough to invite participation, but engaging a critical view. In our predicament, this critical view must be addressed to the hegemony of technology and its systems of domination, in the hope of weakening its hold on our way of life and revealing its ultimately mysterious origins. There are alternatives to the voyeuristic conceptions of experience present throughout our consumer society, caricatured in extreme forms as theme parks and fenced-in housing communities. To propose alternative urban spaces it is first crucial that we realize our capacity to perceive purpose in human works, to see not deception but real values in our cultural and artistic heritage, and to heal ourselves from the cynicism and despair brought about by subjectivism and the homogenization of difference often reflected by post-structuralist criticism.

Potential urban space is neither a dematerialized, infinitely malleable cyberspace nor a reticent, inanimate extension of material objects; rather, it is the place where technology may be cracked open by the imagination, where humanity may become aware of its capacity for true understanding in the dark and silent space of metaphor, yet also includes spaces *within* technology, revealing the *actual presence* of mortality, the imminence of being. For as Friedrich Nietzsche asked rhetorically, while modern humanity may pursue its quest for scientific understanding and control, "Is not seeing itself—seeing abysses?"

NOTES

1 Vilém Flusser, "Taking up Residence in Homelessness," in *Writings*, ed. Andreas Ströhl (Minneapolis: University of Minnesota Press, 2002), 91–103.

2 This is a complex issue admirably argued by Walter Ong, *Orality and Literacy* (New York: Methuen, 1982).

3 I use the concept of poetic image as defined by Octavio Paz. See Alberto Pérez-Gómez, *Built upon Love: Architectural Longing after Ethics and Aesthetics* (Cambridge, MA: MIT Press, 2007), 81–107.

4 The notion that architecture functioned as a cosmological image was questioned for the first time by Claude Perrault in his *Ordonnance des cinq espèces de colonnes* (Paris, 1683).

5 See Vitruvius, *The Ten Books of Architecture*, ed. Ingrid Rowland and Thomas Howe (Cambridge: Cambridge University Press, 1999), Book 5, 65–70.

6 See for example Louis Aragon, *Paris Peasant* (London: Picador, 1987), and Andre Breton, *Mad Love* (Lincoln: University of Nebraska Press, 1987).

7 See Ivan Illich, *H_2O and the Waters of Forgetfulness* (Berkeley, CA: Heyday Books, 1985).

8 Richard Sennett, *The Fall of Public Man* (Cambridge: Cambridge University Press, 1977).

THE ENDURING PRESENCE OF THE PHENOMENON OF "THE PUBLIC"
Thoughts from the Arena of Architecture and Urban Design

GEORGE BAIRD

VIDENTLY, MARK KINGWELL HAS GROWN WARY OF THE IDEA OF "public space"—or at least of a considerable number of current discourses put forward in its name.[1]

He is far from alone in his skepticism. In my own field of architecture and urban design, such skepticism has grown significantly—especially among those one might label the "intelligentsia" of our field. Some years back, for example, the young scholar who became for a time the head of the graduate program at a leading California design school published an interview with the famous Marxist scholar Fredric Jameson, in which the two agreed that the "end of civil society" was imminent.[2] A few years after that, the head of the urban design program at New York City's CCNY published an anthology of essays subtitled "The New American City and the End of Public Space."[3] Subsequent to that, these commentators have been joined by an ambitious curator of architecture (he has most recently served as the director of the 2008 Venice Biennale of Architecture)—albeit one of a rather different political persuasion from the first two—who has contributed to the ongoing discussion a telling essay entitled "Nothing But Flowers: Against Public Space."[4]

Sharing some of Kingwell's specific concerns, members of this group have noted the growing tendency towards the privatization of public space, most particularly within American cities, but also in many other parts of the world: shopping malls with their own police forces, gated communities of all sorts, proliferating video surveillance systems—all

these point to a degradation of a once robust urban public realm. Others in the group lament what they see as pathetic efforts to "beautify" our urban centres and to hold on to urban forms—the public square is an obvious example—that they think have become historically or socio-politically obsolete. So there is no doubt that the idea of "public space" has come into radical question in the fields of architecture and urban design.

For myself, I don't deny the consequence of the tendencies that have been identified by observers such as I have cited above. Indeed, I also have found the phenomena they have described troubling. Nonetheless, unlike them, I have not given up on the phenomenon of "the public." All one has to do, according to my argument, is to spend time in the vibrant streets of a summer evening in Toronto or Mexico City or Shanghai (here I concede I am thinking of Nanjing Road, and not of Pudong) to experience the robust energy of large numbers of citizens "out in public" together. Indeed, despite the more severe erosions of public space that one finds in American cities, it is not impossible to find such vibrancy even in some parts of cities such as Houston or Miami.

In reframing this old observation of mine about street life in cities around the world, I am reminded of the dramatic personal and political experience of the intellectual mentor who has so powerfully shaped the idea of "the public" in my own mind. This is Hannah Arendt, the twentieth-century German American political philosopher whose intellectual arguments in *The Human Condition* and in the collections of essays that followed it have deeply influenced my thinking.[5] Arendt, of course, first became renowned as the author of *The Origins of Totalitarianism*, the book that made the unprecedented claim that Hitler's Germany and Stalin's Soviet Union were, conceptually speaking, more politically similar to one another than they were different from one another. In part a creature of Frankfurt School revisionist Marxism and in part one of the phenomenological philosophy she had learned as a student from Martin Heidegger and Karl Jaspers, Arendt portrayed in her book on totalitarianism a bleak political future for the world.[6]

Despite this, while she was in the process of writing her next major work, *The Human Condition*, she found herself watching with fascinated attention as, first in East Berlin in 1953 and then in Budapest in 1956, citizens—especially young people—rose up against their Soviet oppressors. After all, according to the arguments she herself had made in respect to totalitarianism, Stalinist procedures of political control were

supposed to be so implacable as to preclude any such possibility of polit-ical resistance. The epic historical episodes in East Berlin and Budapest influenced Arendt deeply and moderated her political pessimism. Mov-ing further from the dark outlook of Frankfurt School Marxism, she developed a remarkable argument characterizing what she had come to see as the enduring human capacity for "action" in the world. Indeed, in her mature political thought, the argument ran that it was by means of "acting" in the world that men came to grasp their own being-in-the-world. As a well-known quotation from her states,

> Action and speech create a space between the participants which can find its proper location almost anytime and anywhere. It is the space of appearance in the widest sense of the word, namely, the space where I appear to others as others appear to me, where men exist not merely like other living or inanimate things, but make their appearance explicitly.[7]

Hence her enduring admiration for the concept of "voluntary associa-tion"—so important to the framers of the Constitution of the United States; for such potent historical structures as the "workers' councils" that were created in the very early Soviet Union, and in many other parts of Europe, before they were crushed by such centralized political structures as those developed by Lenin; and for the various modalities of "participatory democracy" that emerged in the United States and Europe in the wake of the May 1968 events. For Arendt, the beginning of politics lies in such grassroots praxes as these.

Now you might ask, what is the link between vibrant street life in Toronto, Mexico City, and Shanghai and "voluntary association"? But in my view, the link is actually a rather close one. We need only turn to the seminal work of the other of the twentieth century's two pre-eminent philosophers of "the public" to see it. In his groundbreaking *The Struc-tural Transformation of the Public Sphere* of 1962, Jürgen Habermas argued that it was precisely in such venues as the clubs and coffee houses of eighteenth-century London that the bourgeois version of a "public sphere" gradually came into being.[8] That is to say, in Habermas's view, shared, informal discourse on the events of the day, such as sustained con-versation among social peers in such venues, formed a basis of the polit-ical structures that came to typify bourgeois European society.

Indeed, these insights of Habermas lead me even to attempt a qual-ified defence of the relative degree of "publicness" of a shopping mall. To be sure, a mall is privately owned space, and restrictions are routinely

imposed by its owners on public behaviour within it. But this does not prevent the mall from being a preferred venue for informal gatherings among suburban teenagers (who admittedly do not have many other nearby non-institutional venues within which to gather). But the eighteenth-century clubs cited by Habermas were privately owned as well, and this did not prevent them from participating in the formation of the bourgeois public sphere. As Arendt noted, the space that action and speech create "can find its proper location almost anytime and anywhere."

So perhaps I can hope to cause my colleague Kingwell to moderate his pessimism in regard to "the public" a little, just as the events in Berlin and Budapest caused Arendt to moderate hers. Indeed, I have to say that I am skeptical that the intellectual construct of "the public good" that Kingwell employs for an early part of the argument of his text, is, in the end, all that helpful. For it leads quite directly to the invidious zero-sum game that he goes on to characterize in some detail. And it seems to me that once "the public good" is posited as the frame of reference for the discussion, this will almost inevitably happen. Arendt's "space of appearance" on the other hand, emerges out of nothing that is material, requiring only the action and speech of its participants to come into being. For this reason, it is not subject to the constraints of zero-sum. Indeed, I can go further still and make the case that even the "consumption" that is the ultimate raison d'être of the shopping mall does not preclude the emergence of the space of appearance even there, so long as that consumption is not its only defining social or political characteristic. And we know quite well that those teenagers "hanging out" in the mall are doing so because of interests which undoubtedly encompass consumption but are obviously not limited solely to it.

It is on this account that I see the phenomenon of "the public" as having such an enduring robustness. It seems to be able to withstand a surprising number of the efforts of prejudicial social and political forces to undermine it. Indeed, given that the arguments I have made thus far have characterized "the public" as "situated," both phenomenologically (Arendt) and historically (Habermas), let me go further and make a speculation about the contemporary controversy surrounding the electronic surveillance of public space. For in pondering this question, I have found myself going back to recollect Jane Jacobs's famous phrase regarding the safety of neighbourhoods. "Eyes on the street" was the condition that Jacobs called for, and she argued that neighbourhoods with

the kinds of close social bonds that perpetuated the presence of such "eyes" were safer than those that did not. Does this not suggest the possibility that even so controversial a topic as electronic surveillance in the public realm might productively be discussed in terms of the operative mechanisms of social and political control that govern that surveillance, rather than the basic condition of surveillance itself? Certainly, the proliferation of recent episodes involving the making public of cellphone images of controversial incidents in public (the October 2007 tasering of Polish immigrant Robert Dziekanski at Vancouver International Airport, or the July 2008 attack on a cyclist by a police officer at a cyclists' demonstration in Manhattan) would suggest that surveillance may perhaps be a more complex socio-political phenomenon that it has seemed to date—particularly so in circumstances in which its control is not centralized but widely dispersed.[9]

I offer one further short commentary growing out of my observation of the "situatedness" of the phenomenon of "the public" as we know it: as I write, there is on display in the gallery of my faculty at the University of Toronto a fine photographic exhibition from France entitled *The street belongs to all of us!*[10] Surely it does, and the exhibition eloquently demonstrates the power of this claim. Yet the question that I want to pose in regard to the "situatedness" of the contemporary phenomenon of the public is this: Is there any justifiable cause for the imposition of any limits on personal conduct in public? This, it is coming to seem to me, is an equally complex question as that having to do with surveillance. On the one hand, we are presented with the obvious need for marginalized groups to challenge the norms of behaviour in public. Think of the famous and defiant slogan called out in protest marches by members of the early gay activist group Queer Nation: "We're here; we're queer; you better get used to it."[11] On the other hand, it is also clear that there exist forms of behaviour in public that are so clearly intimidating to others as to prompt them to leave it. The public behaviour of soccer hooligans would seem to be an obvious case in point.

We understand from Habermas's examples—not to mention the exemplary conditions of public life in multicultural Toronto—that a public space that can embrace multiple different kinds of individuals and groups is a more vibrant one than a space that can only accommodate a small number of them. And the title of the French exhibition I have just referred to seeks to make this inclusiveness universal. I cannot take this argument further here, but suggest simply that in due

course, "surveillance" can perhaps be joined by "public decorum" as a topic of further study by scholars and researchers in this area. Perhaps they might use as a starting point the wry observation of Jean Cocteau: "Tact in audacity consists in knowing how far too far one can go."

All these assorted theoretical speculations of mine make me, I think, somewhat more hopeful than my colleague Kingwell of the contemporary possibilities of "the public."

But this having been said, let me conclude by observing that I could not agree more with his concluding—and to my evidently highly attuned ear—quite Arendtian statement:

> Public space is not interstitial, marginal or left over. It is contested, always and everywhere, because identity is ever a matter of finding out who we are. Not a public good so much as an existential one, one without which a democratic politics is impossible.[12]

NOTES

1 Mark Kingwell, "The Prison of Public Space," *Literary Review of Canada* 16, no. 3 (April 2008): 18–21.
2 Fredric Jameson and Michael Speaks, "Envelopes and Enclaves: The Space of Post-Civil Society; An Architectural Conversation," in *Assemblage*, no. 17 (Cambridge, MA: MIT Press, 1992), 30–37.
3 Michael Sorkin, *Variations on a Theme Park* (New York: Hill and Wang, 1992).
4 Aaron Betsky, "Nothing But Flowers: Against Public Space," in *Slow Space*, Michael Bell and Sze Tsung Leong, eds. (New York: Monacelli Press, 1998), 456–78.
5 Hannah Arendt, *The Human Condition* (University of Chicago, 1958). As for the essays, I am thinking in particular of her *Crises of the Republic* (New York: Harcourt Brace Jovanovich, 1972).
6 Hannah Arendt, *The Origins of Totalitarianism* (New York: Harcourt Brace Jovanovich, 1966).
7 Arendt, *Human Condition*, 198.
8 Jürgen Habermas, *The Structural Transformation of the Public Sphere* (Cambridge, MA: MIT Press, 1991).
9 This observation reminds me of the importance of videocassettes when the Soviet state was unravelling in the 1980s. While the regime could readily control television broadcasting because of its centralized control, it discovered that it could not control video on cassette, since the cassettes could so easily be passed from individual to individual, bypassing the central mechanisms of control altogether.

10 City on the Move Institute, *La rue est a nous … tous! The street belongs to all of us!* (Paris: Au Diable Vauvert, 2007).

11 I am given to understand from friends associated with gay activism that the activist stance represented by this brazen slogan itself owes a debt to Hannah Arendt. Young gay students of hers in the '60s were deeply impressed by her insistent claim that "if one is attacked for being a Jew, then one must fight back as a Jew, not simply as a believer in human rights." It is said that they coined the famous slogan as a gay analogue of Arendt's observation.

12 Kingwell, "Prison of Public Space," 7.

PRIVATE JOKES, PUBLIC PLACES: AN EXCERPT

OREN SAFDIE

COLIN Tell us about the sequence.

MARGARET Sequence?

COLIN Run us through the project. How one enters, where one goes, how one gets to the pool.

MARGARET I was getting to that.

COLIN Fine, proceed, please.

Margaret lets out a deep breath of tension.

WILLIAM It's okay, Margaret…. Take your time.

MARGARET *(defensive; aside to William)* I know! *(back to jury)* What I di— what I was trying to do here is to have the building announce itself to the pedestrian and create a feeling of procession…. So, here you can see how when the person enters—

COLIN Who?

MARGARET Excuse me?

COLIN Who do you envision entering this space, using this place?

MARGARET I'm not quite sure what you—

ERHARDT Is it anybody off the street…? A poet … a homeless person … us … Someone specific?

MARGARET It's for people who swim.

COLIN *(with a condescending chuckle)* Erhardt knows it's a swimming pool … That's not his point. If you want this space to be open to everybody, just state so.

MARGARET Ah, yes…. This is a public place so it's open to everyone.

COLIN You're sure?

MARGARET Ah ...

COLIN Have you ever spent much time at a public swimming pool in this city? Or for that matter, any public indoor space, especially in the winter.

MARGARET Well, maybe there could be some sort of security guard standing by the entrance ...

COLIN *(taking note in his book)* Uh huh.

ERHARDT Please, continue.

Margaret wipes away sweat from her brow.

MARGARET It's kind of warm in here ... *(no sympathy)* Umm ... okay.... The main access to the pool is from this point here, and you descend the ramp down to the locker rooms. Here are the changing rooms and they are divided for maximum privacy. When undressing, the person has a choice to be in this room by herself, or in an open area.... But still the space can be further divided, with a special area for the hand-icapped.... The pool itself allows the swimmer to get into the water in his or her respective locker room and swim into the main pool area without having to walk along the perimeter—

COLIN Why is that?

MARGARET Just in case someone feels intimidated at exposing their body in a bathing suit ... in public. Again, it emphasizes the privacy within a public space ...

COLIN And these large openings along the street, overlooking the pool ...

MARGARET Yes—I mean.... Those are large glass windows. Visually, it's as if there's no barrier between the street and the water.

COLIN So where's the privacy? Any person walking along the street can look down from above and stare at the swimmers.

WILLIAM Much in the way people watch figure skaters at Rockefeller Center.

COLIN Not when they're dressed in bikinis.

ERHARDT Personally, I have nothing against the naked body. *(making a joke)* Maybe it's because I'm from Europe. But one thing I'm certain of is that this country has a real inability to construct a healthy relationship with their own bodies. There exists a puritanical sensibility to sex, and in a way the dichotomy that you present here highlights the dilemma rather paradoxically. On the one hand, perhaps ideas like this can help de-mystify such pornographic obsession, on the other, this could exacerbate the problem, attracting some pretty disingenuous characters.

COLIN If you're a mother, do you really want your little girl exposed to the entire city?

WILLIAM But the swimmers will be in the water, isn't that right, Margaret?

MARGARET Yes.

COLIN Well sure, she addresses the issue of getting back and forth from the locker rooms, but what happens when a swimmer wants to get out and rest, catch his breath, perhaps engage in discussion with friends.

WILLIAM Oh, well you see, Margaret's widened the cavity wall usually used for insulation purposes, so that it actually becomes a three foot space, forming an arcade around two sides of the pool, similar to those that encompassed the old Turkish baths.

MARGARET Visibility from the street is limited from the knees to the feet.

COLIN And what happens when the swimmer wants to use the diving board?

WILLIAM This is really exciting. *(referencing the model)* The diver can get out of the water here, actually walk up the stairs, climbing through the walls—*(catching himself he looks to Margaret to continue; subdued)* Go ahead, Margaret.

MARGARET The diver can climb up through the walls, remaining "invisible" to the swimmers below, as well as the pedestrians along the street, only to be momentarily revealed at the last second before hitting the water.

COLIN But still, from the moment the person leaves the diving board until the moment the person impacts the water, the diver is public domain.

MARGARET Yes, but the act of diving is, inherently, a public performance. Anyone who's ever climbed up on a diving board knows that.

COLIN But then why go through all the trouble of concealing the diver's journey from the pool to the diving board?

MARGARET To increase the sense of drama.

WILLIAM Like the anticipation a theatre audience has before the curtain goes up.

COLIN But then what happens to the swimmer's privacy?

MARGARET It's still there, but now you have the public—the diver, within the private—the water; within the public—the building …

WILLIAM & MARGARET Within the private—the block.

MARGARET Within the public—the city!

Colin looks at Erhardt, confused.

COLIN I feel a bit like my head's going through a washing machine.

ERHARDT It's the dryers that go round and round, no?

MARGARET *(frustrated that her message is not getting across)* It's really quite simple—

COLIN Is it.

MARGARET I have a diagram if you'd like to—

COLIN That's all right.... If I don't get it the first time, chances are I won't get it at all.

MARGARET Perhaps I can shed some light on—

ERHARDT Let's not get bogged down in technicalities ... *(delivered with sexual undertones)* Rather than focus on a vocabulary of pliant and reconfigurable forms and gestures, I think it's important that you research a procedural agenda, or practice, that is pliant and reconfigurable. You see, I believe that constructs of architecture respond, by degrees, to the influence of forces present in their environment. Research on the generation of space and form has led to the development of systems that can be configured to address and respond to variable influences of context—private, public and henceforth. Therefore, new definition of context must be used: the confluence of financial, physical, social, temporal, and legislative influences that prepare a thickened membrane within which an architectural intrusion can be inserted. Each project should attempt to develop a methodology of insertion and create a conceptual engine supple enough to respond and react to external forces while maintaining the project's integrity, spatiality, and coherence. These provisional typologies do not represent or reflect a formal condition that can be equated with a single origin or physical contextual source, but rather are understood to be stimulated by multiple actions or disturbances emitted from the surrounding fields. The deployment of a design intent into a field of play allows the responsive typological system to search for the dissolution of boundaries and generate a network of ambient unities that are both singular and continuous. The results should not be viewed as the implementation of smoothed difference, but rather as a comprehensive blending of events and context into implied multivalent arrays, protean trajectories, and labile forms. *(turning to Margaret)* Do you see what I'm getting at?

MARGARET ... Yes.

ERHARDT *(sensing uncertainty)* What?

Margaret freezes, not knowing what to say.

MARGARET Well ... that ... you think that.... Could you just repeat the
last part.

ERHARDT What part?

MARGARET About the ... dissolution of boundaries ...

ERHARDT You don't understand a thing I just said, do you?

MARGARET *(dispirited)* Not really.

PART III

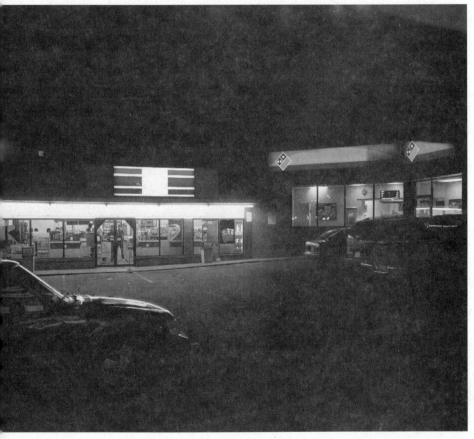

HOLISTIC DEMOCRACY AND PHYSICAL PUBLIC SPACE

JOHN PARKINSON

HERE IS A COMMON VIEW ABOUT PUBLIC SPACE: THAT ITS extensions into virtual realms of media, the Internet, and discourse more generally matter more to political action than the old "bricks and mortar" accounts. Thus, "public space" is increasingly used as a metaphor that refers to the myriad ways in which citizens separated in time and space can participate in collective deliberation, decision making, and action such that "the literal meaning has almost been wiped out."[1]

But while the pursuit of metaphorical conceptions of public space is doing much to broaden conceptions of democracy, I think it would be a pity to wipe out the literal meaning. I argue instead that physical public space matters to democracy, but that it matters in a variety of ways that are underappreciated by many urban theorists. Those oversights have the potential to undermine democratic public space, quite the opposite of what some of its defenders intend.

My starting point for this discussion is a holistic, deliberative view of democratic societies and the various actions and roles that are expected of democratic citizens. It recognizes the importance of creative spaces for action in the "informal" public sphere and in the "formal" public sphere of representative institutions, with a range of mediating institutions in between.[2] It is an action-oriented account to the extent that it asks what citizens should be expected to *do* in a democratic society. At the formal end of the public sphere, the majority of citizens have the task

of electing representatives who are then expected to deliberate on policy, represent the views of their constituents, and come to decisions which have binding effect on the rest of us. The rest of us are expected to be attentive to those deliberations so that we can, at the very least, make informed choices of representatives. Citizens are also expected to engage with each other in the informal public sphere and to communicate with their representatives, to press public claims on them. Some will become activists who discuss and champion the claims of others, either through interest groups or political parties, as public servants, journalists, and so on, feeding public conversations that develop and evolve across time and space. Sometimes, however, large numbers of people need to be mobilized to protest against the action or inaction of the powerful.

The question What are citizens expected to do? leads to the question Where are they expected to do it? The answer, broadly, is "in public space," here considered in its physical aspects. In this chapter I unpack that concept a little more. I offer a novel conceptualization of public space based on the principles of accessibility, common concern, and public role performance. I dismiss definitions based on ownership and unscripted encounters with strangers. I then explore the different kinds of space needed for a variety of democratic actions, from the formal public sphere of parliaments to the informal public spheres of civil society, fleshing out the answer to why physical public space matters. The chapter concludes by considering some of the policy implications, arguing that a narrow conception of public space can lead to spatial redesign that may undermine the very freedoms sought.

The Concept of Public Space

When discussing public space it is common to start by trying to get some clarity on the more general distinction between "public" and "private." It might be a common strategy, but it is also a fundamentally mistaken one, because the labels hide bundles of often conflicting qualities. We can discern four broad categories of things that are appealed to under the public/private labels:[3]

1. Freely accessible places, where everyone has free right of entry or free right of informational access, as opposed to places that are not freely accessible, that have controllers who limit access to or use of that space

2. The things that concern, affect, or are for the benefit of every-one—collective goods or collective resources—as opposed to things that primarily concern individuals

3. The people or groups that have responsibility for things covered in (2)—"the public" as a noun, rather than an adjective

4. Things that are owned by the state or the people in (3) and paid for out of collective resources, like government buildings, military bases and equipment, and so on, as opposed to things that are individually owned, including things that are cognitively "our own," like our thoughts, goals, emotions, spirituality, preferences, and so on

How do physical settings express these meanings of "public"? The first kind of public is itself spatial: freely accessible space, often defined in terms of encounters with strangers, contrasted with the world of the home, family, friends, and those one chooses to invite and interact with. However, the "conflicting qualities" point made above is perfectly illustrated by this strangers-and-unscripted-encounters emblem. For one, it is a well-worn truism that one can choose one's friends but not one's family, so *choice* cannot be the defining element of private things, nor its lack definitive of public ones. For another, there is, in Western societies at least, what Erving Goffman calls "the principle of civil inattention," which is the norm that, in publicly accessible places, people should behave in unobtrusive ways.[4] One could present this principle in more general terms as a requirement that people act in public within locally accepted limits, because following the rules, whatever they are, signals to others that one can be trusted, can be communicated with, can be treated as a fellow-member of the relevant "public" rather than an outsider, an "other." This need not imply a bland uniformity: we might expect some categories of people—youngsters, even academics—to behave in challenging ways. Furthermore, there are many kinds of public events in public space that are even more scripted and impose quite rigid standards of behaviour, well beyond everyday norms and boundaries. Think of major ceremonial events in which the rituals of membership of a given polity are acted out, rituals such as the installation of presidents, fireworks displays in central parks on national holidays, parades given for sports people or military personnel, and so on. Therefore, precisely how we should react to the features of a particular space when it comes to unscripted encounters with strangers depends very much on the capacities, uses, and purposes of the space in question.

The second meaning of "public" is those things that concern, affect, or are for the benefit of everyone, and the sorts of space that fit into this category include public facilities like parks, baths, promenades, skating rinks, concert halls; other public facilities like libraries, schools, assembly rooms, public toilets, some places of worship, even cemeteries; infrastructure, including power, water, and transport systems allowing people to access all the other public facilities, including not just buses and trains but, in a few cities, public bicycle schemes; or, at the very least, public roads and parking systems.

Thinking about the public in senses three and four allows us to add a few more items: spaces for the performance of democratic roles, such as legislatures, town squares, speakers' corners, and broad avenues; monuments and streetscapes where the demos represents itself, anchoring identities and memories; spaces owned by "the public" for other collective purposes, such as security (police, military, and intelligence facilities) and the housing of other public servants (government office buildings).

The ownership criterion (number four) may, at first glance, not appear to be separate at all. For some, the right to limit entry flows from ownership of a particular space, so that ownership *defines* whether something is open or not. This is not obviously so. In Britain, for example, national parks are on privately owned land, but people have the right to wander across that land uninvited and with relatively few restrictions. Equally, there are buildings and spaces that we call "publicly owned" in the sense that they are owned by the state but to which there are more limited rights of entry: national parks in most countries, military bases, the offices of government departments, even Parliament itself.

The ownership dimension can also be misleading because it divides space into separate packages that can be assigned to some particular individual.[5] This causes two problems. First, some kinds of public space are not separable. Like other common goods, they cannot be subdivided without destroying them, and they involve and affect many people without distinction. For example, a building might be a separate entity, and thus be owned either privately or by the state, but a collection of buildings makes up what is called "the built environment" which creates and delimits common, public space. Second, a given territory can have multiple geographies, multiple boundaries, and interesting examples arise in conflicts over land access and use between indigenous people and colonists in Africa, Australasia, and the Americas. The first observation

means that some kinds of public space cannot just be treated analytically as a special class of property, one that happens to be owned by the state or some other collective body. Rather, they need to be treated more like other public goods. Therefore, relevant to any discussion of public space will be the usual issues that arise with other public goods, namely, ensuring their continuing existence given the free-rider problem and the "tragedy of the commons." Nonetheless, we might still want to include in the idea of public space those spaces that are owned by the collective: the central state, local government, publicly-funded agencies, and so on. This is less because of their ownership per se (sense four) than their relationship to collective resources (sense two): one of the fundamental things that the public in a democracy decides is how to allocate collective resources (maximally) or to hold accountable those who make allocation decisions (more minimally). That means that we can include in the idea of public space those things to which the public does not normally have access and so are not public in sense one, such as military bases and the private offices of senior officials, but which are nonetheless public in sense two because they consume common resources and have purposes related to collective goals. Likewise, we can include some things that are individually owned but have collective impacts, such as the built environment or "public" facilities that are controlled by private companies (bus systems, leisure facilities, and so on).

Thus we are left with three major ways in which physical space can be "public": openly accessible space; space of common concern (by using common resources or having common effects); and space used for the performance of public roles.

Space can be public in all three senses, like the large central plazas of the Zócalo in Mexico City or Red Square in Moscow. It can be public in just some of the senses: for example, recreational and other "public" facilities (senses one and two) or legislatures (senses two and three, but with only limited access). Or it can be public in just one of the senses, including privately owned and tenanted skyscrapers that dominate the built environment, affecting access to air and light (sense two). Examples of space that is public only in sense three might include privately owned locations that are used for public purposes, such as the conversations about collective matters that go on every day around the kitchen table, whether among family and friends or among dissidents gathered away from the watchful eye of the state, the activity determining the publicness of the space more than any intrinsic features of the space itself.

The Use of Public Space in Democracy

We are now in a position to give much more detailed answers to the questions of what people are expected to do in democratic societies and where they are expected to do those things. In this section, I survey the physical spaces needed for democratic action in the informal public sphere of civil society and the formal institutions of representative assemblies, as well as public space which is not overtly political at all.

Informal Public Space

Democratic life gains its energy and vitality from millions of small-scale participatory moments in many different locations at many different times, all contributing to a diffuse public conversation. In this view, it is important to the health of democracy that many different locations for public debate are available and that they be ones not overwhelmed by the power of the state. For a contrast, consider societies such as those behind the Iron Curtain before the 1990s, in which this freedom to gather in small groups to discuss political topics simply did not exist.

Democrats working in this mode have been most responsible for the shift in political theory away from the physical and into the virtual worlds of public space. They speak in metaphorical terms about the "space" available in the media and the informal public sphere, considering the subtle ways in which power acts to open and close access, either through direct pressure or the more subtle processes by which ideology and discourse construct the parameters of what is discussable and the spaces in which that discussion is allowed to happen. What is missing from this kind of work is a recognition that, nonetheless, physical space still matters to discursive democratic engagement. Consider the pressure tactics employed by otherwise decentred, discursive networks. They do not merely act in cyberspace. For one thing, they organize mass protests and occupations of physical space: that is, they work hard to demonstrate the sheer physical presence and scale of popular displeasure. For another, the media is reliant on pictures, which in turn require physical subjects and physical confrontation. This is why interest groups, lobbyists, and politicians themselves work so hard to create "photo opportunities": the unfurling of a banner on a smokestack by environmentalists, disability activists chaining themselves to inaccessible buses, the pictures of thousands of people in the streets.

Traditionally, the site of this performance has tended to be the squares, parks, avenues, and plazas where protesters gather to impress their displeasure on their representatives. Capital cities have been particularly important in this regard, being as they are the seats of political power. Protesters want to get close to where their representatives sit, and most of the world's major cities have at least one locality that is almost always the centre of such activity. In Washington, D.C., it is the Mall; in Kiev, the Orange Revolution was conducted in Independence Square; for those brave enough in China, the centre is Tiananmen Square. London is an oddity in this regard, having two traditional sites for protest, Parliament Square and Trafalgar Square. This is partly due to the small size of the former and the accessibility and visibility of the latter, but choosing the latter does tend to place protest a little more comfortably—for representatives—at arm's length. Still, from my normative standpoint, it is essential that such common space exists for the expression of protest and the challenge of elites, and important that efforts to restrict public access to and use of such space be resisted.

So, thinking about the informal public sphere directs us to consider whether or not a given society has space available for the use of its citizens. This should include privately owned space free from state surveillance—the living rooms and private clubs in which groups in civil society meet—but there are questions about how inclusive and democratic a purely private style of civil society can be. In addition, there should be publicly owned space available, including not just town halls but also village halls and public assembly rooms, or meeting rooms in public libraries, rooms that do not charge convention-centre rates for the privilege, and which are easily accessible by a variety of people. There should also be town squares and plazas which can be used by people to press public demands. The accessibility requirement in turn implies not just things like disabled access, but reasonably extensive public transport networks and other infrastructure that enable all kinds of people to participate in collective life, as well as strict limits on the degree to which security services, both public and private, can interfere with the pressing of those claims.

Formal Public Space

If the informal public sphere is the energy source of a democratic society, the formal public sphere is required to bring the disparate results of public conversations together in order to debate their differing conclusions and come to binding collective agreements. Because there is no

obvious way of getting everyone in a large-scale, complex society into one room at one time—the demos just will not fit into the agora any more—we require the role separation that comes with representative institutions. Given that fact, having single deliberative arenas helps the rest of us scrutinize our representatives: we want our leaders to be in the spotlight and stay there, not to sneak off into the wings and make deals without our seeing.

Historically, the increase in size of democracies has led to a shift away from open, outdoor forums to enclosed assemblies, and one can see this transformation happening in relatively recent times. In Iceland, the Althingi assembly moved indoors from its open field in the nineteenth century, after a few decades of interruption thanks to a Norwegian invasion. Six of the eight Swiss cantons with outdoor *Landsgemeinden* abolished them between 1848 and 1997, and while the Isle of Man's Tynwald still meets on Tynwald Hill every 5th of July, it is more a ritual, symbolic expression of participatory ideals than one that involves actual deliberation or decision making. Most of the substantive work of Manx democracy is done indoors.

This shift indoors has been associated with a double transformation of democratic public space. For one, marketplaces stopped being the primary locality for public reason and became either the sole preserve of the economic sphere or flagged or paved parks stripped of their formal democratic role. At the same time, the architecture of the forum shifted from common spaces made up of lots of individual creations, with the whole owned by none and accessible to all, to individual buildings owned by the state, designed by a few individuals with singular visions, and with only a few areas openly accessible.

The architecture of parliaments is itself an interesting sub-topic, and one that has received far too little attention. Again, those political scientists who use the language of architecture tend to do so metaphorically, applying it to the design of democratic institutions and procedures rather than the bricks and mortar. Even those who do comparative studies of legislatures spend very little time on the physical settings themselves. The notable exception is Charles Goodsell, who argues that the exterior and interior design of debating chambers, parliaments, and government offices has important "cueing" effects on the behaviour of representatives and the public alike.[6] Goodsell concentrates on the varying effects on deliberative style of oppositional chambers like Britain's versus the semi-circular, radially divided chambers like Germany's, although his

observations are cautious and hedged with caveats. A few others con- · sider the messages conveyed by the exteriors of political buildings, from the alleged hierarchical messages of neoclassical parliamentary buildings to the more egalitarian messages that are said to be conveyed by build- ings such as the German Bundestag and the Australian federal parlia- ment, in which the public are able to express symbolic dominance by walking over the heads of their representatives.

However, it is far from clear how to read those messages. Parliamen- tary buildings can serve not so much to intimidate but to set apart polit- ical deliberation from the rest of life—that is, not only to impress on people the importance and power of collective decision making, but also to encourage them to take those deliberations seriously. Likewise, media images of parliamentarians involved in all-out brawls in suppos- edly consensual assembly chambers should at least make us think twice before making general claims about the democratic effects of different chamber seating arrangements. A building's meaning is established in a context and built up through use and association, and thus it is cultural factors that have more to do with explaining political culture and how we come to symbolize it than any direct effect of bricks and mortar on our behaviour.[7]

Market Democracy and Public Space

One final idea I want to consider briefly is the relationship between pub- lic space and what might be called market democracy. By this I mean the libertarian idea that democratic values are best realized not by govern- ments but by empowering people in markets.

This might seem, on the surface, to be a kind of democracy that does not need the kind of *political* public space I have been talking about at all. In the libertarian model, the public space that exists is one that results from innumerable, individual decisions made in private. Mar- kets still require physical public space to function, however. This is obvi- ously so on the traditional understanding of a market as a town square: sellers need somewhere to lay out their goods for inspection. It is also the case in markets of services and ideas: sellers need physical spaces in which to proclaim their brands, whether it is through the rush to acquire naming rights to a prestigious new development or the more prosaic methods of billboards, footpath signs, and neon lights.

However, the market democratic vision of public space is also one that alerts us to the importance of public space that is *not* overtly political.

There are two aspects to consider here. One is the idea that, for many, quality public space in the "built environment" sense noted earlier arises from millions of uncoordinated individual actions rather than from the desks of central planners. Those who have visited Australia's federal capital, Canberra, will appreciate the force of this. It is a city planned on the garden city model, for grand vistas with big monuments, wide avenues, and widely separated suburbs, and while this creates a marvellous parklike atmosphere in places, its low density means that the centre can be a little like a ghost town, especially on winter weekends. It is a city of 325,000 people that can feel like there is nobody there. Now, for some that may sound like paradise, but many others seem to prefer the vibrancy that comes from higher population density and uncoordinated, market-driven development—in other words, those who prefer the chaos of Hong Kong to the orderliness of Singapore.

One response to this kind of observation is to point out that those who praise creative chaos tend not to have to live in its worst areas. This was the response of the Singapore government when foreign visitors lamented the bulldozing of parts of old Chinatown and the infamous Bugis Street, places that were all very photogenic for the rich foreigners who could go back to their fancy hotels, but not so good for the residents who had to live in the relatively poor conditions. But then, the disasters of housing renewal policies in many countries in the 1960s should remind us that the quality of one's community matters too, and that may be quite unrelated to the health and national pride issues that concern central planners.

The other aspect to consider is the fact that some public space just needs to be fun, with no political uses or overtones at all. People need space in which to walk, run, or cycle—alone or with the family—to play games, have picnics, sit and read, people-watch, or daydream. However, and contra libertarian injunctions, some of those facilities may need to be publicly provided and state protected if they are not to be sold off and developed for private gain. One of the great things about many Australian cities is the dozens of publicly maintained gas barbecues dotted through city parks. Anyone can wander down of an evening with friends or family, "crank up the barbie," and enjoy the sizzle as the sun goes down. By contrast, it is one of the tragedies of Britain in the last two decades that many schools and councils sold off playing fields and other recreational space when their budgets came under pressure from the centre. Public space does not bring in much, or any, revenue when it is

held by schools and local authorities, but sold to property developers, it can be worth significant amounts of money, especially in city centres. The result can be an important diminution in quality of life for residents. This highlights the point that public space is not all about protest marches and getting hot under the collar; it is also about relaxing, having fun, and doing the things that make life worth living. However, while market democracy alerts us to the importance of such space, the property market is not the mechanism for protecting them. That requires a more active kind of collective decision making.

Implications and Conclusions

In those branches of the academic literature that have not gone all "virtual," most definitions of public space focus on the accessibility criterion and tend to celebrate accessible space where people meet all kinds of others in unscripted, uncontrolled encounters. This, it must be pointed out, is not the same as "space where no one can control whom I encounter." On the contrary, many defenders of public space argue that the space itself needs to be of quite a particular type if "unscripted encounters" are to occur. The reason many writers want to encourage such encounters is that they worry about the breakdown of a sense of "we," a loss of opportunity to meet others with different looks, tastes, needs, and experiences, and that such a "we" is itself necessary for the healthy functioning of democracy. Thus, rather than applaud open plazas that people rush across, they applaud "programmed" space where people are encouraged to stop, sit, and strike up casual conversations.

There are three issues here. The first is that the "encounters with strangers" claim is separate from the "openly accessible" claim, and cannot on its own define public space, as I argued above. The second is whether encountering diversity *is* necessary for a healthy democracy: I do not have space to go into that here, but let's assume that it is true. The third issue is the one that this chapter has focused on: that there is more to public space than open accessibility. That is just one of three major ways we might define public space, the others being space of common interest and space for the performance of public roles.

Crucially, I have also argued that some space can be public in all three ways, but often just in two, sometimes even in one. This helps us make sense of the fact that we commonly label some spaces "public" that "the public" does not, and should not, have access to, or has only

conditional access. These restrictions do not make these spaces any less public, because "public" does not mean just one thing: it means three things in a spatial sense, four in a more abstract sense. "Public" refers to a bundle of often incompatible ideas, ideas that only show their natures when we come to make actual decisions in real political contexts.

Given all that, I am perfectly happy to believe that it is a good idea to have city parks with lots of furniture and "breaks" that encourage people to stop and smell the roses. However, it is also important that we have *some* blank, large, open plazas for demonstrating public anger and making public claims. Unfortunately, spaces that perform the first function well are terrible at the second. My favourite example comes from Hong Kong, where the only available public spaces in Central District— Chater Garden and Statue Square—have had any democratic usefulness squeezed out of them by excessive programming: benches, tables, fountains, plantings, and so on. All the furniture makes it impossible for more than about five thousand people to gather there, and those can only congregate in small groups, meaning that while large marches have an obvious starting point in Victoria Park they have no obvious terminus. These spaces thus privilege casual, accidental publics over organized, purposive ones.

Democracy demands other kinds of space too, because it demands various roles of us, not just that of encountering strangers. Looking at the formal end of democratic societies leads us to consider the importance of assemblies, not just as decision-making forums but as settings which impress on people the importance and value of collective decision making and allow us to put the powerful under the spotlight of collective scrutiny. Looking at the informal public sphere directs us to think about the availability and accessibility of public squares in which large numbers of people can gather to express their pleasure or displeasure with decision makers. When assessing the quality of such space, it would be important to consider how it is policed: whether legitimate protest is too tightly controlled to have any impact, for example. One might also consider, as has been observed in the United States, whether politicians come to avoid confrontational space and instead do their handshaking and smiling in controlled spaces like shopping malls, where private security can whisk away inconvenient protesters. The rules of behaviour in different spaces may have to change, depending on how the powerful try to avoid or shut down confrontation in the name of behavioural norms and public order. Thinking more broadly still, participatory norms

lead us to consider the availability of space in libraries, assembly rooms, village halls, and so on, in which small groups can gather to discuss issues without having to pay corporate rates. We also need to consider issues of accessibility, most obviously through public transport links.

Another implication concerns the equation of "public" with freedom and "private" with restriction, and in that vein many writers celebrate activity which disrupts attempts to privatize, and thus limit access to, public space. One of the fashionable examples is to celebrate downtown skateboarding as reclaiming public space from private corporations. I share the concern with uncontrolled privatization, but it is a mistake to assume that public space requires no negotiation about the use of that space by different sectors of democratic societies. Public space is, much more than private space, somewhere in which individuals need to negotiate access to a limited resource, and thus respect others' freedom to enjoy that space to the fullest possible extent. So, I find myself thinking that space colonized by skateboarders is no longer "public" for the frail and elderly: a collision between a boarder and an eighty-year-old might bruise the former but kill the latter. That need not imply banning skateboards; it could mean providing public skate parks. The point is that the public, in sense two, involves negotiating conflicting needs, not "anything goes" anarchy.

These points are obscured by taking a single view of the public/private distinction and a single definition of public space. People act democratically in multiple ways; "public" means different things in spatial terms; but not all spaces can perform all the functions at once. We therefore need a variety of public space, from the blank to the programmed, from the formal to the informal. Anything less gives us an attenuated democracy.

Acknowledgements

This paper is part of the Democracy and Public Space project, supported by The British Academy's Small Grants scheme, SG-44244. Earlier versions were given at the British Journal of Political Science conference on political theory at The British Academy, June 2006; at the conference of the Australasian Political Studies Association at the University of Otago, August 2005; and in the Social and Political Theory program, Research School of Social Sciences, Australian National University, also in August 2005. Many thanks to all participants for their generous comments and criticism.

NOTES

1 Marcel Hénaff and Tracy Strong, eds., *Public Space and Democracy* (Minneapolis: University of Minnesota Press, 2001), 35.

2 Jane Mansbridge, "Everyday Talk in the Deliberative System," in *Deliberative Politics: Essays on 'Democracy and Disagreement,'* ed. S. Macedo (New York: Oxford University Press, 1999); and John Parkinson, *Deliberating in the Real World: Problems of Legitimacy in Deliberative Democracy* (Oxford: Oxford University Press, 2006).

3 This discussion owes much to Raymond Geuss, *Public Goods, Private Goods* (Princeton, NJ: Princeton University Press, 2001). Compare Hannah Arendt, *The Human Condition* (Chicago: University of Chicago Press, 1958).

4 Erving Goffman, *Behavior in Public Places: Notes on the Social Organization of Gatherings* (New York: Free Press, 1963).

5 Jeremy Waldron, *The Right to Private Property* (Oxford: Clarendon Press, 1988).

6 Charles T. Goodsell, "The Architecture of Parliaments: Legislative Houses and Political Culture," *British Journal of Political Science* 18, no. 3 (1988): 287–302; Goodsell, *The Social Meaning of Civic Space: Studying Political Authority through Architecture* (Lawrence, KA: University Press of Kansas, 1988). See also Dvora Yanow, "Built Space as Story: The Policy Stories That Buildings Tell," *Policy Studies Journal* 23, no. 3 (1995): 407–22.

7 Wolfgang Sonne, *Representing the State: Capital City Planning in the Early Twentieth Century* (Munich: Prestel, 2003).

PUBLIC SPACES AND SUBVERSION

FRANK CUNNINGHAM

THE LARGE FOYER OF THE CENTRAL ARTS BUILDING AT MY UNI-
versity is full of all manner of public activity: students talk-
ing, reading, dozing, playing cards; tables representing a wide
variety of ethnic communities and clubs advertising their func-
tions, soliciting membership, and serving as gathering places;
and—most directly related to the topic of this essay—students advocat-
ing mainly radical political causes, passing out material exposing and
denouncing putative (and more often than not correctly imputed) wrong-
doings by authorities ranging from the university administration to the
federal government and beyond. It is true that both university officials
and students making use of this space count on its campus setting to
informally discourage use of it by other than students, but the space
admits of an indefinite variety of uses, and at least no members of the
university community are excluded.

Encroachment on the foyer's public activities has, however, begun
creeping in from another source. A commercial coffee counter takes
up some of it, and periodically the entire space is rented out for the sale
of posters. While normally it is almost unthinkable that city police or
even campus police would evict people or for that matter enter the
foyer, at least in uniform, it is not at all unthinkable that they would inter-
vene, and do so without sparking campuswide protest, should the stu-
dent activities disrupt the sale of coffee or marketing of posters. The
foyer could thus serve as a model for a number of critics of contempo-
rary cities who see conservative political consequences in the erosion of

public spaces such as public parks and plazas that find activities within them constrained in the interests of surrounding commerce and private dwelling. Further, they deteriorate due to city neglect and shrink or disappear altogether as public land is sold off, thus leaving fewer public spaces or replacing them with private forums such as the shopping mall.

Many critics of this erosion decry it not just on an abstract principle in favour of there being places where people can do as they wish, but on the political grounds that a vibrant and oppression-free democracy demands the ability of people effectively to challenge or, indeed, to subvert the status quo. Different ways that public spaces facilitate such subversion are articulated, of which three are prominent. Most obviously, direct publicity within public places of failings within a society and exposure of those who profit from and sustain the failings is rendered difficult: soapbox oratory or its analogues is simply *verboten* in a shopping mall.[1] Less directly, public places are required for robust democratic debate and deliberation, which activities are in turn required as alternatives to a status quo-supporting form of democracy where citizen activity is limited just to voting.[2] Finally, in public places people encounter those of their fellow citizens who are less fortunate, thus calling their attention to poverty and other social problems in need of solution.[3]

In this contribution I shall support the opinion that public spaces are potentially subversive of objectionable features of society (at least of our current one) and that accordingly their erosion is to be resisted. However, the subversive potentials I see are different from the three just alluded to.

Urban Public Spaces

An urban "public space" as the term is used here refers to a physical place. While recognizing that such things as the Internet, letters to editors, and call-in radio or television shows sometimes function as spaces for the public exchange of ideas, I do not think they can substitute for physical places in a city any more than virtual classrooms can substitute for real classrooms in a school or university. Thus specified, a public space is taken as one that, in the first instance, is accessible, where this means that it is non-exclusive and demographically open. It is often noted that public spaces differ from private ones in that there is no "owner" of such spaces who can exclude people from their use. This idea does, I think, capture an important feature of public spaces, though

it needs to be qualified to note that parks, sidewalks, community centres, and similar such places are not without their own informal means of exclusion.

The most obvious limitation is that they can be too full (as those who worry about the tragedy of the commons are fond of noting), but there are other forces of exclusion, such as the conventions that limit the foyer described above to members of the university community. Meanwhile, informal conventions can also lead to relative non-exclusiveness in privately owned places, as in the case of a shopping mall in downtown Toronto which has become a gathering place each morning for senior citizens from a nearby Chinese community. A conclusion later to be drawn from these observations is that the subversive functions of an urban public space do not depend upon and may even be constrained by full non-exclusion or public ownership.

To say that public spaces are demographically open is to note that they are made use of by people from a variety of backgrounds—differentiated by age, class, occupation, ethnicity—and by people embracing a variety of values and world views. It also means that many occupants of public spaces are anonymous to one another. As in the case of exclusion, this dimension of accessibility is also not absolute. The regular occupants of a public park typically demographically reflect those in neighbourhoods around it, who, moreover, come to recognize one another in ways that mute complete anonymity. Again, I hope to show that public-space subversion requires only a measure of openness and anonymity.

To accessibility in these senses must be added two more characteristics of an urban space to make it a public space. One of these is that it is multi-functional and among its functions are some that are valued for their own sakes. A sidewalk is obviously an instrument for a pedestrian to get from one point to another. This is one of its functions. However, it can also be a destination sought for itself, as in a place for taking a stroll or indulging in the pleasures of the flâneur. The final characteristic is that public spaces possess their own identities given to them by the intersection of their physical characteristics and the predominant uses and perspectives of those who avail themselves of them. A long sidewalk may traverse many parts of a city—residential, commercial, faced by small homes or shops or large ones, well treed or not, accessing a variety of amenities, and so on, each segment with characteristics unique to it.

Sometimes public spaces with these broad features promote one or more of the subversive functions often claimed for them as earlier described: radical organization and protest, democratic deliberation and debate, opening the eyes of the affluent to unjust disparities in their cities. For those who aspire to subvert a conservative status quo, there are these good reasons to protect public spaces. While sharing this aspiration and therefore favouring the preservation and expansion of public spaces in the hopes they will sometimes perform the aforementioned functions, I nonetheless doubt that there is an essential connection between the functions and public spaces *as such*.

Some public spaces clearly sometimes figure in radical protest—streets and sidewalks for marches, parks for rallies—but they do not participate in any intimate way in engendering them. The times must be ripe, and the impetuses for radical activity come from different sources. What is objected to is that denial of these sorts of spaces impedes radical activity, as when demonstrations are banned in front of consulates or government buildings, but this is different than that the spaces, qua public spaces, are essential to acquiring radical sentiments.

Christie Pits, a park in Toronto, was a site in 1933 of a violent race riot when a baseball team largely composed of Jewish locals was attacked by members of the Swastika Club. For several decades thereafter annual demonstrations against racism were held in the Pits, and marches for this and similar causes originated there. During these years the park's identity was tied up with anti-racism. But while some historical memory of the riot remains (as in a 1999 album by the rock band The Tragically Hip),[4] Christie Pits itself is not a wellspring of anti-racist sentiment, as is evidenced by the fact that public consciousness of its identity as a place for protesting racism waxes and wanes with the rise and fall of anti-racist movement activity in the city as a whole, and other functions that originate in it (for example, an annual Santa Claus parade) displace its radical associations.

A similar point can be made about democratic debate and deliberation. Sometimes—though rarely—events designed to facilitate these things are organized in appropriate public spaces, as with the teach-ins held during the Vietnam War years on the grounds of public universities or in city squares. But, again, this is no more than making use of the spaces, for which alternatives such as a church or union hall are available, and the spaces themselves do not prompt the deliberation and debate. On the contrary, places like sidewalks, parks, plazas, boardwalks,

and squares are not especially conducive to these activities by virtue of the multiplicity of their uses, the diversity of their occupants, and their anonymity. Champions of deliberative democracy see it as taking place among people with diverse views and life experiences, while insisting that all participants must be motivated to engage in the deliberation. But those who are in a place for a purpose other than deliberation can only view attempts to engage them in such as annoyances at best and assaults by cranks (not, let us face it, utterly foreign to public spaces) at worst.

The thesis about public spaces educating people to injustices comes the closest to establishing an intimate connection between the spaces and subversive attitudes, and, sadly, taking strong stands against economic injustice today is subversive of the status quo. However, there is no guarantee or even probability regarding this result. Also, the experience can backfire. Ironically, the more widespread the poverty experienced in public places, the less likely it is to have the radicalizing effect. When, in my city, homeless people began to appear begging on the streets, there was indeed outrage that the city could have come to this, and people would often stop to talk to the homeless, give them food or coins, and discuss their plight and what to do about it with others. However, as the numbers of the homeless and the begging escalated, there were too many to help personally, the problem as a social one began to appear insurmountable, and people learned how to ignore and literally step over the homeless. Similarly, where the numbers of homeless people expanded to the point that some downtown parks were becoming unusable by ordinary citizens, the parks were either absented by the citizens or measures were taken to exclude the homeless by such means as removing or redesigning benches.

Homo Ludens

In the rest of this essay, I shall suggest two ways that public spaces are more intimately subversive, at least potentially. The first connection was highlighted by Constant Nieuwenhuys and other members of the International Situationists, the avant-garde urban design and architectural movement of the 1960s and early 1970s. Drawing on a celebrated work by anthropologist Johan Huizinga,[5] they lamented the way that cities were functionally organized to promote work, informed by an image of a human as a producer—*Homo faber*—rather than as a seeker of creativity, pleasure, fun, and play—*Homo ludens*. Constant proposed a model

Homo ludens, pencil on paper by Constant, 1965–1966, 52 3/8 x 52 3/8 in. (133 x 133 cm).
Gemeentemuseum, The Hague.

for a city, "New Babylon," designed to facilitate the latter activities.[6]
Whether it is realistic for an entire city to be built on this model (and Constant did think this realistic), there are obviously places within all cities reserved for fun and play, some publicly owned and administered (exhibitions, fairs, public sports facilities), some private (theme parks, stadiums, bars, and the like).

A city devoid of any such places would be a dreary place in which to live or work, and their ubiquity attests to a human need for them. But public spaces as described in this essay have characteristics not shared by these other venues. Public-space fun is often, perhaps typically, spontaneous and opportunistic. One budgets time and usually money to go to a theme park, museum, or sporting event with specific recreational activities in mind. In a public place people find themselves stopping at a bench to rest and watch the passing parade, window

shopping, engaging in unchallenging *bavardage* with strangers, perhaps joining into shared sporting activities, exercising. In the organized sites for recreation, everyone is recreating with reference to the same thing, like watching the game, taking the same rides, or drinking beer.[7] In a public space a variety of activities are taking place: passing through, caring for children, sitting about, playing chess or cards, walking dogs, eating a snack, sketching, playing musical instruments, and so on.

A champion of Constant's New Babylon vision might note that organized and planned fun, unlike that of the public spaces, is not fun for its own sake but something that functions to enable people to continue work in the future and reward them for past work. This brings us to what it is about public-space fun that is potentially subversive of a status quo. The Situationists retrieved some revolutionary themes of Paul Lafargue, who (in distinction from the view of his father-in-law, Karl Marx, that in communism work would be "life's prime want") regarded all human woes as "due to man's passion for work" and urged the proletariat to "proclaim its right to idleness.... refuse to work more than three hours a day, and spend the rest of the twenty-four hours in repose and revelry."[8]

The point of Constant and the others, like that of Lafargue, was not just or primarily to endorse one sort of life style; it was political. A culture of work was seen as growing from and sustaining an oppressive society, namely that described by another of the Situationists, Raoul Vaneigem:

> What spark of humanity ... can remain alive in a being dragged out of sleep at six every morning, jolted about in suburban trains, deafened by the racket of machinery, bleached and steamed by meaningless sounds and gestures, spun dry by statistical controls, and tossed out at the end of the day into the entrance halls of railway stations, those cathedrals of departure for the hell of weekdays and the nugatory paradise of weekends, where the crowd communes in weariness and boredom?... From the butchering of youth's energy to the gaping wounds of old age, life cracks in every direction under the blows of forced labour. Never before has a civilization reached such a degree of contempt for life.[9]

The political dimension of the Situationist critique fits nicely with the orientation of their contemporary, Henri Lefebvre, for whom people's "right to a city" centrally includes the right to live in a city the urban design, architectures, politics, infrastructures, and landscapes of which are not subordinated to capitalist economic needs.[10] Many things impede

the realization of this right, but among them is a culture of *Homo faber* harboured by the very people—that is, nearly everyone—whose lives are regimented by exigencies of a mass-market, industrialized economy.

Not all public spaces prompt or sustain the fun-for-its-own-sake activities that run counter to this culture, and how powerful tendencies in this direction are is no doubt a matter of degree. An important quality of public spaces that helps is their multi-functionality. That the very same park or sidewalk that one walks through or on to go to work (school, shopping) is also the place in which one can stop and enjoy oneself inhibits ghettoization of playful places and a concomitant schizophrenia.[11] The cultural revolution sought by the Situationists is not one where people are workaholics during weekdays and celebrants of life in the evenings and on weekends; it is a transformation of one's view of life priorities as a whole, as well as support for appropriate social, economic, and built-environment transformations.

It should be emphasized that the Situationists were not arguing in Luddite fashion for dismantling the instruments of modern industry. Indeed, the buildings and city plans Constant projected for New Babylon are as far from garden city bungalows or deindustrialized rural communities as can be imagined. He was concerned, rather, with priorities. Nor is it suggested that a proliferation of public spaces will of itself engender a social revolution dedicated to repose and revelry. Instead the claim made here is that in offering invitations, so to speak, to spontaneous, free, and rewarding enjoyment not implicated in the mandates of work and of a society geared toward work, public spaces, if there are enough of them and if they genuinely exhibit the characteristics ascribed to a public space earlier, have the potential to help erode a culture of work in favour of a culture of fun. This, in turn, is a precondition for concerted and in the end political action to challenge and transform a society the overriding aim of which is to reproduce industrial and market-driven cycles of work.

Trusteeship

For Lafargue's father-in-law, work as it would exist in a future communist society was something that would not need to be coerced; rather, it would be done in a spirit of co-operation. While from a Situationist perspective this does not justify promotion of *Homo faber*, and may even perniciously sugar-coat it, in contemporary, capitalist society a culture

of work is conjoined with another component of popular culture, also supportive of an oppressive status quo, namely that of "possessive individualism." This term was coined by the Canadian political theorist C. B. Macpherson. The key components of a possessive-individualist culture are self-centredness, fixation on private ownership, consumerism, and greed. These attitudes, when they are dominant, describe the world view, or what Macpherson called the ontology, of a "market society."

The term *consumerism* is used by Macpherson in the ordinary sense (i.e., people putting an excessively high priority on acquiring consumer goods), but it takes on the further meaning for him of a thirst for indefinite, indeed infinite, consumption, thus shading into greed. Being self-centred carries the usual meaning of pursuing one's own interests without voluntarily accommodating the interests of others. Macpherson adds that in a market society people place a very high value on possessing and respecting private property, and they particularly value the idea that people have a right to dispose of their property as they please. This value becomes a fixation when the market value of a good is regarded as its most important characteristic and when virtually everything is thought of as a commodity or a potential commodity. This includes people themselves where one's sense of self-worth is tied up with how much he or she privately owns and where among the things that people regard as their property are themselves.[12]

Coexisting with this ontology, though overwhelmed by possessive individualism in a market society, is a view foreshadowed by Aristotle in his conception of a fulfilling life and in modern times found in some liberal-democratic thinkers, notably John Stuart Mill and John Dewey, where humans aim to develop their "truly human potentials" to the fullest and a robust democracy is achieved to the extent that all are able to do so. Macpherson's aim was to undermine the culture of possessive individualism and to retrieve the idea of what he called "developmental democracy," where people co-operate to achieve a society where everyone has the opportunity to develop his or her proper potentials.[13]

Of the several things that must be accomplished to make progress toward developmental democracy, the key cultural component is to subvert fixation on property. In particular, the notion that people have at least a presumptive right to dispose of their possessions and of their own talents as they please needs to be supplanted by a stance toward these things where one is seen as their trustees. It is very rarely, if ever, that a person's possession of something results entirely from his or her

personal efforts. Luck plays a big role, and in any case things possessed are usually the product of long and complex histories of social labour. The same thing can be said of talents. Some are inherited, and the ability to develop and take advantage of them, again, depends upon a lot of social factors, beginning with how a person is raised and educated.

Still, the notion that possessions and talents are the private property of individuals who accordingly can dispose of them with or without consideration of the consequences for others or for the future just as they please is deeply engrained in a market society. Some now all-too-obvious results are environmental crises that might, arguably, have been averted if in the past people had seen themselves as trustees of the earth for future generations rather than having viewed it as a source for individual appropriation and exploitation. Similar observations can be made about urban decay and sprawl.

Retrieving a culture of trusteeship is no small feat, but public spaces offer one potential venue for nurturing such a culture. To the extent that people who make use of a public space take some responsibility for it—for instance, by helping to keep it clean and defending it from encroachment as for private development—they may begin to learn and inculcate a habit of trusteeship generally. Of course, there are other venues where people act collectively to preserve and protect something, most notably the homes or institutions, such as a church or club, of which they are members. But these cases often still have a possessive dimension to them: the home, church, or club is regarded as the property of specified groups of people. By contrast, the collections of people who make use of a public space are largely anonymous to one another, and most realize that in protecting the space they are doing so for an indefinite number of also anonymous present and future fellow occupiers of the space. Hence, taking responsibility for a public space involves a measure of trusteeship, where this has the potential of generalization to other venues, such as the city as a whole, regarded as itself a public space writ large.

Not everyone who makes use of a public space adopts a stance of trusteeship toward it, but certain features of a public space encourage some to do so. One of these is that public spaces can be places of *Homo ludens*, that is, places of fun for its own sake. Threatened loss or degradation of such a place is more likely to call forth determination to protect it than threats to places that are nothing more than instruments for achieving some goal outside of them (a sidewalk as nothing but a means

of getting to some destination). The option of finding alternative means is always a possibility in these cases. It might be thought that the same is true of public spaces as ones of enjoyment, but here I think a feature these spaces share with homes, churches, or clubs, namely, that they have identities of their own, comes into play. Insofar as the unique character of a public space contributes to its enjoyment, something is irreplaceably lost if the space degenerates or disappears.

Openness and Publicness

Just as not all public spaces realize a potential to engender a culture of *Homo ludens*, so not all nurture trusteeship. Conditions conducive to these results must be right. One condition has to do with the way that the non-exclusivity of a public space is a matter of degree. In order for public spaces to have the desired consequences they must retain an element of anonymity and openness. The swimming pools of gated communities or the back lawns of condominiums do not foster a general ethic of trusteeship, and whatever joyful activity is engaged in them is similarly ghettoized. At the same time, a public space whose population is so open that there are no "regulars" to form the nucleus for collective care of the space will fail to offer opportunities for trustee activity. People cannot enjoy a space if it is populated not just by a variety of different people but by some whom they find threatening or frightening. Required is a certain and likely delicate balance.

Another condition pertains to the nature and degree of the "publicness" of the spaces in question. Earlier it was noted that privately owned spaces can function as public ones. Sometimes this is possible because the spaces have been, as it were, seized by a public. This is the case with the Toronto mall, referred to earlier, that is largely taken over in the mornings by the Chinese seniors. At first owners and managers of this mall worried that the large number of mainly non-customer occupants of tables and benches would cut into business, but against this they had to take into account the bad public relations that would certainly follow forced eviction. Later, they saw advantages as the presence of this community lent an aura to the mall (indeed, an identity) that many others found attractive thus, in fact, increasing business. Also, in a kind of symbiosis, the seniors, not wanting to jeopardize the availability of this space, are careful to confine their use to the pre-lunchtime mornings. Analogues can be found in other malls and in other privately owned places,

such as some bars or cafés, but, again, requisite conditions cannot always be counted on.

Fostering trusteeship in spaces that are publicly owned requires different, but also unique, conditions. Such a place is already held in trust by the public body that administers it, for instance, a municipal agency. If that body completely abdicates its responsibilities, this might prompt citizen action to maintain the venue, but it can also discourage such action, in part by making the task too daunting, in part by deflecting enthusiasm for public trusteeship to anger ("Why should we do the job of a derelict government for it?"). At another extreme, a city agency that insists on complete control over a public place does not leave tasks for ordinary citizens to perform and may even actively discourage involvement. (This scenario is not imagined: a committee in my neighbourhood that wanted to clean up a local park was initially denied permission by the city to do so, claiming fear of liability for possible injuries and reactions of the union representing park workers.) Again, only situations falling between these extremes will be conducive to trusteeship-favouring activities.

Urban Challenges

These considerations about openness and publicness throw into relief some problems. If one of the requirements of a public space fostering a culture of *Homo ludens* is that people not feel threatened by others using the space, and if they find the presence of homeless people or those they fear out of racial or other prejudice threatening, they will be tempted either to abandon the space or try to exile the threatening others from it, as, for instance, in the forced removal of homeless people from New York's Times Square. In addition to the morally objectionable aspect of such attitudes, an effect is to make places to play into places to hide, thus perpetuating closed-minded attitudes and exacerbating them with a fortress mentality. Repose and revelry are still, of course, possible, but they are diminished and hard to sustain when conjoined with paranoia.

A problem regarding trusteeship and government action or inaction is that whether governments are prepared to take responsibility for a public space while at the same time facilitating citizen involvement in its care is usually a matter of serendipity. Proactive measures are impeded by the weak form of democracy current in most cities where, as at other levels government, citizens are for the most part no more than passive

voters, and city government officials and civil servants have, at best, paternalistic attitudes toward citizens.

For reasons given earlier in the essay, I do not think that protecting and multiplying public spaces is in any central or direct way effective for addressing these sorts of problems. Rather, successfully combating racism, dealing justly with homelessness, and achieving integration of government and citizen action are themselves preconditions for public spaces to realize their subversive potentials. Concerted and society-wide campaigns around these issues are in order. Political campaigns to deepen and extend citizen input to the governing of their city (as in community councils), economic and public health campaigns to address the sources of homelessness, educational campaigns against racism and prejudice— these efforts are clearly important to pursue in their own right. If success contributes to public-space subversion, so much the better.

NOTES

1 One illustration of this complaint is in a paper by John Paul Jones III, "The Street Politics of Jackie Smith," in *Companion to the City*, ed. Gary Bridge and Sophie Watson (London: Blackwell, 2003), 448–59; another is in Don Mitchell, "The End of Public Space? People's Park, Definitions of the Public and Democracy," *Annals of the Association of American Geographers* 85, no. 1 (March 1995): 108–33.

2 This is a central theme in Robert Beauregard and Anna Bounds's paper, "Urban Citizenship," in *Democracy, Citizenship and the Global City*, ed. Engin Isin (London: Routledge, 2000), 248 and passim. Another example is John R. Parkinson, "Does Democracy Require Physical Public Space?" in *Does Truth Matter? Politics and Public Sphere in Democracy*, ed. Raf Geenens and Ronald Tinnevelt (Dordrecht, Netherlands: Springer, 2008).

3 Margaret Kohn describes this concern (along with several others) in *Brave New Neighborhoods: The Privatization of Public Space* (New York: Routledge, 2004), 7–9.

4 *Phantom Power*; the song is "Bobcaygeon."

5 Johan Huizinga, *Homo Ludens: A Study of the Play-Element in Culture* (Boston: Beacon Press, 1970).

6 Constant's essay "New Babylon" is published along with other Situationist documents in Libero Andreotti and Xavier Costa, eds., *Theory of Dérive* (Barcelona: MACRA & ACTA, 1996), 154–69. In a similar spirit, Iris Young, referring to Roland Barthes, identifies eroticism ("the pleasure and excitement of … encountering the novel, strange and surprising"), as essential to urban life, in *Justice and the Politics of Difference* (Princeton, NJ: Princeton University Press, 1990), 239–40.

7 Citing perhaps the best-known Situationist, Guy Debord, for support, Margaret Kohn notes that movie theatres, sports stadiums, and such like position individuals "as spectators rather than participants," thus, in her view, missing the interactive dimension of public spaces (Kohn, *Brave New Neighborhoods*, 14).

8 Paul Lafargue, *The Right to Be Lazy* (Chicago: Charles Kerr, 1907), 29. The passage as quoted is taken from the superior translation used in Leszek Kolakowski's *Main Current of Marxism*, vol. 2 (Oxford: Oxford University Press, 1981), 147, in a chapter on Lafargue. Marx's comment about work being life's prime want is in his *Critique of the Gotha Programme* (1875) in *Karl Marx & Frederick Engels: Selected Works in One Volume* (New York: International Publishers, 1968), 324.

9 Raoul Vaneigem, *The Revolution of Everyday Life*, published in 1968 as *Traité de savoir-vivre à l'usage des jeunes générations* (Paris: Gallimard, 1992) and translated by John Fullerton and Paul Sieveking in 1972.Vaneigem continues, alas optimistically but not uncommonly in 1968, by extolling the artistic, political-activist, and sexual revolutions of that epoch as a front "against forced labour" and as "molding the consciousness of the future."

10 Henri Lefebvre, *The Right to a City* (1968), published in English translation in Eleonore Kofman and Elizabeth Lebas, eds., *Henri Lefebvre: Writings on Cities* (London: Blackwell, 1996). Lefebvre himself interacted with the Situationists, and similarities bearing on the thesis of this paper are noted by Rosalyn Deutsche, "Breaking and Entering: Drawing, Situationism, Activism," in *The Activist Drawing: Retracing Situationist Architectures from Constant's New Babylon to Beyond*, ed. Catherine de Zegher and Mark Wigley (Cambridge, MA: MIT Press, 2001), 75–81.

11 Though not identical, the point is akin to one made by Barbara Rahder and Patricia Wood, who contrast the experience-limiting confines of the car to the variegated experiences on a city sidewalk: "From the sidewalk, we see [all one can in a car] plus the headlines of newspapers in their boxes, the fruit that's in season at the grocers, local workers waiting for the bus, seniors enjoying the garden in front of their retirement villa, parents pushing strollers, young nannies with toddlers, dogs lapping at bowls of water while their owners chat over coffee—and we can smell the freshly baked bagels, hear the conversation about changing school districts. As we stroll, hundreds of threads of city life spin around us." In "A Funny Thing Happened on the Way to the Future," in *Utopia: Towards a New Toronto*, ed. Jason McBride and Alana Wilcox (Toronto: Coach House Books, 2005), 238–39.

12 The essential theory is developed by Macpherson by tracing the early political-philosophical expressions of this culture in thinkers from Thomas Hobbes to John Locke in *The Political Theory of Possessive Individualism* (Oxford: Clarendon Press, 1962).

13 This view is most fully developed by Macpherson in *Democratic Theory: Essays in Retrieval* (Oxford: Clarendon Press, 1973). Examples Macpherson gives

of truly human potentials include the potential "for rational understanding, for moral judgment and action, for aesthetic creation or contemplation, for the emotional activities of friendship and love, and, sometimes, for religious experience" (ibid., 4). The potentials have in common that their achievement by some people does not mean they cannot be achieved by other people. Indeed, most potentials require co-operation, on which, moreover, they typically thrive as people enter into valued projects with others.

TAKE TO THE STREETS!
Why We Need Street Festivals to Know Our Civic Selves

SHAWN MICALLEF

WHAT ARE CITIES FOR? FOR SOME, THEY ARE CENTRES of production and little else: machines made for doing business. Big cities are often referred to as the "engines of the economy," a sentiment put forward to bolster the importance of urban areas during various national debates on where tax dollars should flow. Much of the infrastructure in cities facilitates business and the movement of people and goods for this purpose. In North America, the social aspect of cities tends to be a secondary function, judging by how much limited civic infrastructure is given over to spaces intended purely for social interaction. Compared to that of many European cities which have traditions of providing public commons and squares, the North American approach to the social city has been, at best, an afterthought.

In Toronto, the rules and codes of public conduct are famously officious and uptight, so it's a good choice for examining what happens when the streets are given over to people. While there are many anecdotal examples of Toronto's civic life that prove this "boring" reputation false, it is a commonly held self-perception and does dictate how people behave. Torontonians are routinely and perpetually down on their own city, even if they lead lovely and full lives in it. This is the great unexamined elephant in Toronto, and it has been a plague on the civic zeitgeist for decades. It's also why it is so important for Toronto to have the ability to close down city streets for various festivals and spontaneous events.

With Toronto's reserved reputation, the effect of these street closures can be profound, and the liminal space they open up in the city can be quite remarkable. Liminal is one of those great words that haven't yet made their way into most computer spell-check programs, but it accurately captures the evasive spirit created during street festivals. It refers to an in-between state on the threshold of another place, not as completely dreamlike as it sounds, as the feeling is firmly rooted in the physical present. In her book *Wanderlust: A History of Walking*—a bible for any walking enthusiast—Rebecca Solnit writes, "On ordinary days we each walk alone or with a companion or two on the sidewalks, and the streets are used for transit and for commerce. On extraordinary days— on the holidays that are anniversaries of historic and religious events and on the days we make history ourselves—we walk together, and the whole street is for stamping out the meaning of the day." Street festivals have the power to change the basic function of a city, temporarily, and open space for new interactions and understanding of our place in the city. In Toronto, it takes a street festival for us reach that liminal state, and when we do come up to that threshold, we notice.

• • •

TWO MONTHS AFTER I MOVED TO TORONTO IN 2000, THE PRIDE FESTIVAL took over Toronto's Church-Wellesley neighbourhood as it does every year at the end of June. This event marks the beginning of summer, for those who have it on their mental calendars, the way Canada Day does for everybody else a few days later. Moving from the mid-sized provincial city of Windsor, Ontario, to Toronto was not without its dazzling moments of big-city awe—the crowds, the subway and streetcar network, and the jumbo size of everything—but there was nothing to prepare me for the radical and sometimes shocking breakdown of the usual rules that govern public life the way Pride does. The Toronto I thought I knew became something else.

The extent to which Toronto bends during Pride, in the face of that perceived uptight civic nature, is dramatic. Equally remarkable is the way the festival's presence builds almost imperceptibly during "Pride Week." First there are the street closings that escalate as the festival days go by until the entire neighbourhood—or "gaybourhood" as it is often called—is closed to traffic all day Sunday, making it the site of one of the largest pedestrian-only events in the city. As any group or organization that has tried to get a street closure in Toronto will lament, it is no small

feat to negotiate the bureaucratic maze at City Hall standing between normalcy and the desired liminal state. With so many detailed rules to follow involving security, safety, and the logistics of where stages, booths, and tents will be set up, the fact that it happens so smoothly is quite something. One Pride manager recently mentioned to me that during the frantic weeks before the festival, her way of dealing with details that might remain undone is to remind herself that "there are a million people coming to this party, and it is going to happen if we're ready or not."

A million people is an unstoppable force, and when they start to arrive at Pride the party comes alive slowly and builds its own momentum, not unlike the way a cocktail party operates on a smaller scale. Early in the week there are subtle signs of the coming storm: balloons outside of stores that are usually bare, heavier pedestrian traffic, and extra cash registers in bars signalling the deluge ahead. On the Friday night of the big weekend, Church Street is closed for about half a kilometre, followed by expanded closures on Saturday and Sunday. From a spectator's—or "participant's"—perspective, all of this happens effortlessly and it simply seems natural. More people arrive, more streets are blocked off, and more parts of the neighbourhood start to change.

On Friday night, when the first big street closure happens, the rules really start to bend. With all street closures, not just Pride, people continue to stick to the sidewalks for a while—it's what we've been trained to do (and for good reason). There is inevitably a moment when one realizes, "Hey, I can walk in the middle of the street." And then we do, and it feels liberating, like we're free of some kind of shackle we didn't know we had clamped to our leg. As people dip their toes into the sea of pavement, the first steps are self-conscious. *I'm not supposed to be doing this.* Then we swim out into the middle of the road and suddenly we're in a new civic living room.

From the sidewalk or a moving car, lane markers and turning arrows appear to be very small. But when standing on them, they seem oversized and unreal. This may seem like a minor detail, but we usually see our cities from the sidewalk, and when we're out in the middle of the street, the scale of the city—as well as our perception of it—changes. In this sense, a street closure is actually a simple psychogeographic technique; slightly altering the way we pass through familiar space can change the way we think of that place as well as the way it makes us feel.

At Pride, these initial breaks in the everyday rules are just the start. At times the crowd crushes together as if it's the inside of a packed nightclub—

but this is not a "controlled" space like that, it's public, *anybody* could be out here—and yet it feels alright, and there is no panic. With the exception of public transit or perhaps sporting events, there are few places people will allow their bodies so much physical contact with those of strangers. The great joy of events like Pride is playing the flâneur, wandering back and forth through and into the crowd. It's an amplified version of the usual sidewalk experience. While it's always nice to have a friend along, negotiating the crowd can be cumbersome and the ability of the agile solo flâneur to zip through even the tightest crowd can provide endless fun.

In *The Practice of Everyday Life*, Michel de Certeau examines the act of walking in the city and discusses the "nowhere" that exists during the process of going from one place to another. "To walk is to lack a place," he writes, and in a sense, to walk in a street festival is also to lack a place because the street is temporarily and radically different than what is normally there. For de Certeau's pedestrian, "there is only a pullulation of passer-by, a network of residences temporarily appropriated by pedestrian traffic, a shuffling among pretenses of the proper, a universe of rented spaces haunted by a nowhere or by dreamed-of places." During a street festival like Pride, stores look different, the usual landmarks seem a bit off and might not even be noticeable and, overwhelmingly, it is the crowd that we notice most. Is this even our city anymore? Has the change been so radical as to turn our city into something else? De Certeau sums up the "new" or "dream" city created when walking by quoting Kandinsky's description of this new place as "a great city built according to all the rules of architecture and then suddenly shaken by a force that defies all calculation." During a street festival Toronto is still there, as are its famous rules (some of which make the event possible), but somehow, inexplicably and intangibly, the city is so different it is almost unrecognizable.

The most noticeable bend in rules and conventions at Pride are sartorial in nature. Some of it is subtle and may be expressed simply: clothing that is a little tighter than normal, buttons undone a little farther down or colours and patterns louder than people usually wear. However, for a large number of people, it's the only time of the year they can express a part of themselves that they usually keep behind closed doors, and this makes Pride the best people-watching event of the year. The streets are full of goth fetish princesses, first-time transvestites, buttoned-down office workers opting for a leather day, people in dog collars, and

couples playing out fantasy rolls—it is as if secrets of the nation's bed-room have moved out onto the street for all to see. Pride in Toronto has evolved so far (and so quickly) from its initial function as a critical event establishing homosexual agency and rights to what it controversially is today: an extremely wide and accommodating queer event.

There are two moments that stand out in my mind as demonstrat-ing the true extent and depth of Pride's liminality. The first took place on Church Street on a Saturday afternoon in 2001. I had been working in a large office for a little over a year, and while it was a pleasant non-profit organization, it was a fairly conservative work environment. This was my first "real" job after graduate school, so office culture and the good people who inhabited it were not what I was used to and I was experiencing some culture shock. It was subversively refreshing, then, to run into the quiet British man who worked across the hall. Here he was, in the middle of Church Street, naked, holding a tin can collecting money for the festival (Pride does a fundraising push each year). I quickly realized my boring office had stories and secrets that ran deep, and I started to feel this about the city at large. If it hadn't been for the rule-changing atmosphere at Pride, I'd not have known this, and while I'm very happy keeping my own clothes on, knowing there was some-body nearby who was itching to get out of theirs made the long days at the office more tolerable. From that moment onward, my office work environment was a lot more interesting, even if that moment on the street was never spoken of (though it likely had much more impact on me than on my co-worker).

The other event happened late on a Sunday evening when Pride was winding down and we were heading back home on the Bloor sub-way line from Yonge station, located just outside of the Pride zone. As we got on the subway car, so did a fellow wearing a Speedo-style bathing suit and nothing more. He had obviously been wearing it throughout the day and felt no reason to put pants on for the ride home. Heads turned, of course, but the atmosphere in the car remained at a polite level of simply taking notice of the situation—with perhaps a quiet snicker or two—a testament to how far Toronto has come in terms of quiet tolerance. Still, for this fellow to walk out of the Church-Welles-ley neighbourhood, down the station stairs, through the turnstiles and onto the train—all of which amounts to a sort of social airlock, lead-ing from the "Pride world" to the "regular Toronto"—points to how powerful a transformation Pride has on the city. It becomes the "new

normal"; when walking out of the neighbourhood, the whole city seems queer, as if the rules have changed everywhere.

Pride is one of the largest street festivals in Toronto. There are dozens, possibly hundreds, of smaller neighbourhood and block-scaled festivals that dot the city, even during the winter. The degree of their liminality tends to relate to their size, though watching neighbourhood kids run around in the streets while their parents eat a communal dinner during a block party suggests that the freedom even the smallest street closure affords is substantial.

Caribana, held in mid-summer, is similar in scale to Pride and is also capped by a giant celebratory parade. Though a city-sanctioned event, one Caribana tradition happens organically and without any official call or support: the Saturday night Yonge Street Cruise. Caribana's city-changing influence extends well beyond the official festival zone—most of the activity takes place on Toronto Island or along Lake Shore Boulevard—to an unsanctioned location in the city. During "The Cruise" (my own term for this event)—Yonge Street becomes a slow crawl of vehicles in either direction with even more pedestrians wandering on the sidewalk and weaving through traffic. It is like an *American Grafitti*–style 1950s or 1960s downtown car cruise, but updated with gargantuan Cadillac and Lincoln SUVs, and with dance hall and hip hop music booming out of each vehicle (instead of Buddy Holly or that *Rock Around the Clock* song). Unlike Pride, where you don't know where anybody is from, this Caribana parade has an abundance of licence plates that are from Michigan and New York State, evidence of the wide draw festivals like these have. Officials do know about the event, and police foot patrols are quite heavy during the weekend, but there is no "leader" and events like these could be considered the natural precursor to contemporary flash mobs, where mobile technology is used to organize masses of people in one geographic location for some kind of event or "happening."

Yonge Street's ability to accommodate unsanctioned events like the Caribana Cruise is put to the test when a hometown or national team wins a sporting event. Almost as soon as the final whistle blows, the street is flooded with fans. Within minutes, hapless drivers have escaped onto side streets as they make way for hundreds or even thousands of people who appear instantly from the wings as if extras in an epic film. Nearby, mounted police officers wait just out of sight in case things go bad, but they usually don't. These *impromptu* sports celebrations are often the moments people remember even more than the actual game that was

played. Torontonians still talk about running up and down Yonge Street in 1992 and 1993 after the Blue Jays won the World Series (a scene repeated in many other Canadian cities on those respective nights).

The magic at these events is that everybody is suddenly your best friend. People high-five in streets and hug and smile at strangers—all highly peculiar activities at any other time. Even if you don't care about sports, the contagious euphoria of these celebrations simply feels good and is like a magnet. Where else could a communal event like this happen but in a public shared space? Most celebrations of this nature in Toronto are due to hockey games, and generally a win by one of the iterations of "Team Canada." Torontonians famously have little luck with their Maple Leafs but have been known to shamelessly take to the streets after a win in the first round of the playoffs, likely because fans know this will be their only chance to experience some joy in Mudville. After watching and wandering around numerous of these celebratory spectacles, I expect Toronto to fully burn to the ground should the Leafs actually win the cup. There is so much pent-up energy waiting for that moment that it will hit the streets with an intensity we have not yet seen. Still, though the Leafs never win, these celebrations are one of the few times Torontonians let go of their inherent civic cynicism and experience collective pride. You can feel this somewhat watching at home, but out in the streets you not only share that sentiment with others, you can hear it, feel it, and high-five it.

The other sport that routinely gets Torontonians out in the streets is soccer, but instead of Yonge Street being the focus, these celebrations take place in the ethnic neighbourhood that is associated with the victorious nation. It is a sort of benign balkanization of the usual sports celebration, and Toronto's urban lore is rife with stories of celebrations that brought streetcars to a halt and changed that part of the city. An oft-repeated fact that Torontonians share is that of the 1982 World Cup celebrations on St. Clair Avenue after Italy won: it was reportedly the largest gathering of Italians in one place outside of Italy, with an estimated crowd size of 300,000 people. During the 2006 World Cup, websites and newspapers published lists of neighbourhoods to go to when a certain team won—sort of tourists' guides to spectacle. There were the obvious and long-established ethnic enclaves like St. Clair or College Street for Italian wins, Dundas for Portugal or Brazil, and The Danforth for Greece (though they did not qualify that year). Supporters of countries that saw the bulk of their immigrants flow to Canada in more recent

years—meaning their neighbourhoods are not downtown—were directed farther away from the city centre. Iranian fans were sent to Yonge and Steeles, and those behind Trinidad and Tobago made their way to Eglinton West. However, what these more suburban locations lack is the dense urban landscape and large population that lends itself to massive pedestrian takeover, so many of these celebrations happen in private spaces and in cars or bars, never attaining the transformative power of the more urban celebrations. There is safety in numbers, and perhaps liminality resides there as well.

As with Pride, these soccer celebrations can mean a great deal personally to participants but also to a whole community. During the 2002 World Cup tournament held in South Korea, that country's team ultimately placed fourth. While it was quite a feat for a country without a long tradition of winning at the World Cup, for Toronto's Korean community it was their first step onto Toronto's civic stage. Throughout the tournament, "Little Korea" along Bloor Street was a hub of activity. Cafés and bars turned their TVs to the street, creating miniature piazzas on what had been nondescript stretches of sidewalk, and during key games, hundreds of people were huddled inside and out along five or six blocks of the Bloor strip. Due to the time difference, the final victory for the Korean Republic team occurred just as dawn was about to break here. Little Korea was my neighbourhood at the time, and I found myself shuffling up from Queen West at about four in the morning, just as the game was nearing completion. While still a few blocks south of Bloor I could hear the occasional roar of a crowd, and, having forgot about the game, I was unsure of what was going on. Once on Bloor, though, it was obvious, as all the cafés and bars were open and packed. I wedged myself into the back of one of those jammed taverns with a big-screen TV and watched Korea's victory with everybody else. Just as dawn broke and the light rain was clearing, Bloor flooded with a few thousand people, celebrating just like at any other sports victory. Cars disappeared, and unlike those early days of Pride week, there was no hesitation in taking over the streets.

Then, without any organization or leadership, the crowd started moving east along Bloor. It wound past Bathurst, through the Annex, crossing Spadina, gliding by sleepy University of Toronto and the Royal Ontario Museum and then along Toronto's Mink Mile shopping district. At the Yonge Street intersection, those at the front of the crowd turned around and headed back, folding back and weaving through the

rest of the crowd that had yet to make this instant destination. There were no police or people in orange vests directing the crowd; participants just went up to Yonge and turned around, as if there was some collective but unspoken knowledge that Yonge Street was the place this celebration had to go to be validated. It was fully daylight by the time we got back to Little Korea and I hung around the crowd a little more and though I was exhausted, the euphoria of such a spontaneous act was compelling enough that I decided to stay awhile. Eventually I made my way home and slept in. Later that afternoon on my way out to another part of the city, I passed through Little Korea again, and there were still at least seventy people along the street, cheering as cars went by—and they were there for the next three days, a gauntlet of people waving Korean flags as cars slowed down and passed between them. It became much more than simply a sports celebration; it was the coming-out party for Toronto's Korean community. They were now an established part of Toronto's civic stage, like the Chinatowns, Greektowns, and Little Italys that came before them. They belonged in Toronto, and this was asserted by their taking over the streets in such a fantastic way.

• • •

SOMEWHERE IN BETWEEN THE ORGANIZED LIMINALITY OF FESTIVALS LIKE Pride and the spontaneous street-taking celebrations after sporting events are the religious "festas"—or "feasts"—that take place on the Mediterranean island of Malta. It's useful to compare events in Toronto with those of a place like Malta because there is often the feeling that when the city closes down its streets for a festival, it is somehow more "European," but in Europe the street festival can blend both the official and unsanctioned together effortlessly. Like many southern European countries, Malta has a robust Catholic festa culture and every parish—usually one per town or village, but some larger municipalities have two or even three—has a week-long celebration for its patron saint. Though ostensibly religious festivals, they function largely as secular events with religious moments. The organized part of the festas comes together in the week or two prior, when the streets are decorated with elaborate banners, tapestries are slung from poles placed in holes in the sidewalks, and strings of bare light bulbs are hung over the roads. When approaching a town from the hinterland, you know it's festa time as flags fly over the houses and at night soft blue lights attached to antennas and rooftop water tanks cast an eerie glow over the entire area.

The centrepiece of each festa is the church, which is lit up much like a North American home during the Christmas holidays. The lighting can be so elaborate that every architectural detail on the structure is colourfully outlined. Each parish is also associated with a "band club," usually located adjacent to the church and similarly lit up. As the name implies, it is the home of a marching band, and the building functions as a clubhouse and bar. Depending on the town, the band may march each day or just on the weekend part of the festival. Each of these marches signals the big day is coming, and, similar to the way Pride activities build throughout the week, so does anticipation for the festa.

While these celebrations are all sanctioned by local councils and police often take measures to close the streets to traffic, there is a certain amount of looseness of regulations that a visitor from an officious society like North America instantly notices. Drinking in the streets is permitted as kiosks sell beer the way soft drinks are sold in North America. There are also no designated—or "licensed"—drinking zones, as it is allowed anywhere. Most sanctioned outdoor festivals in North America can have an over-regulated atmosphere where we see beer drinkers sequestered behind steel riot fencing, as if they are exotic animals in a zoo. In Malta, cafés spill into the streets, tables are sometimes set up around gas pumps, and there don't appear to be any regulations on how far they can go.

Fireworks are a mainstay in all festas, and towns are quite competitive with each other. Size and quantity matter here. During the weekend days, from morning until night, flash bombs go off at regular intervals. More than anything else, the fireworks can change a sleepy town into a place on the edge. In Malta all buildings are made of limestone. The flash bombs—sometimes called "petards"—have a particularly sharp and warlike explosive sound that in turn reflects off of all the hard built surfaces. There is nothing to suck up and dampen the sound, so it resonates differently than fireworks do in North America. All day long these explode and, because Malta is so small, they can be heard all over the island. They seem too loud—*Don't people complain?*—adding to the sense that something is different. As a dramatic device, it certainly builds tension. At night a spectacular air fireworks show is followed by ground fireworks: a collection of pinwheels set up on poles in either the town square or along the main street. All the fireworks in Malta are homemade, usually assembled in a farmhouse in the countryside, and every few years there is a tragic explosion that kills and injures the workers. This fact gives everything an air of danger. People are able to crowd around the fireworks

before they are lit and, when they do go off, there are no police to clear people out of the way—they simply make a circle around the pole about to go off. Sparks fly into the crowd, we breathe in the sulphur smoke, and errant firecrackers fly off the pinwheels and sometimes hit bystanders and it is exhilarating.

On the Sunday the large statue of the patron saint is brought out of the church to yet more fireworks and carried around on the shoulders of various men (and the occasional woman) until it returns to the church. In between is everything you would want from a street festival: crowds, food, music, arguments, laughter. Though Pride's sartorial excesses may be verboten in this very Catholic country, there are certainly some skimpy and tight outfits that suggest that at festa time, the sacred and the profane exist side by side. As a second-generation (half-breed) Maltese who grew up hearing about the pious homeland and these religious festas, it is sometimes difficult for me to reconcile that picture with what is actually happening: a really fun and sometimes wild street party. Yet it's the ease with which it all happens that suggests Maltese—and European—culture can move up to that liminal threshold quicker than North American culture can, and that it is the model that every festival on this side of the Atlantic tries to emulate, as if it is yet another (cultural) colonial vestige we're trying to get right.

In Malta the festa is old hat and only a new experience for visitors, but it's repeated every year—the same fireworks, the same parades, the same food stalls—and every year the crowds come back. Though Maltese street life on a "regular day" is much closer to the chaotic festa atmosphere than Toronto's daily life is to its festivals, the full takeover of the streets is a necessary event, a sort of charging of the emotional batteries that floating in liminal space for some time affords. Street festival culture is embedded in the European imagination, and they will always feel as if the streets belong to them. We don't have that sense here, and we can't shake another feeling—guilt—that suggests maybe we shouldn't be doing this. Yet we desperately, even urgently, need street festivals, and the desire for them builds up over time to the point that we'll take over the streets whenever an excuse arises. Some minor team won a championship? Take to the streets! Perhaps this desire is why the 2003 blackout is such a powerful and fond memory for many Torontonians. When the lights went out that hot August night people didn't stay at home, they flooded the streets and turned the city into one giant, albeit dimly lit, communal living room.

As Solnit wrote, on such days "the whole street is for stamping out the meaning of the day." In Malta it's local pride with perhaps some religious obligation, and it manifests as both an organized and disorganized street party. In Toronto, people can stamp out meaning in both the official parties and the spontaneous ones, as they both create liminal space where this can take place. As lone flâneurs, we all stamp out meaning whenever we walk through the city, but on those special days when we stamp out meaning together, as a chorus, that meaning is shared and it multiplies. We learn more about ourselves and our surroundings then than we do on all the other days when the city is simply going about its orderly business governed by those rules that keep us productive and that try, as much as they can, to keep the liminal state at bay until the next festival.

HOW INSENSITIVE: AN EXCERPT

RUSSELL SMITH

TED GOT OFF THE SUBWAY AT EGLINTON. JOHN HAD TOLD HIM to just walk north until he saw the cars. He had never been to this part of town before; it was where John had grown up. John never talked about it. Go-Go had sneeringly said it was white, just white and nothing else. In the dark, Yonge Street seemed deserted and sterile. There seemed to be a disproportionate number of specialty food shops with baguettes and jam jars and italic lettering in the windows, all closed. In between them were dry cleaners, a dark Second Cup, an imitation British pub at the base of a mirrored office building. A cold wind blew directly at him; he could see the streetlights extending in a perfectly straight line for miles, disappearing over the horizon.

He walked aggressively in John's suit and shiny shoes, craning his head sideways to see his reflection in dark windows. He carried his own worn trenchcoat; he wished he hadn't brought it. Some voice from his childhood had told him he might be cold. The trenchcoat was absolutely inappropriate for the suit. He had hesitated between the single-breasted and the double; the double seemed so much more Toronto, and this one was perfect, the dark charcoal. And his new tie. Go-Go had helped him slick his hair back with gel. He felt positively Italian.

He looked at his watch and realized that he had left it in Go-Go's room. Immediately he began to look about him, squinting, at the tops of buildings, for a pixelboard time display. There was none, and he cursed the inadequacy of the street. In a *real* city, one would always be in sight of a pixelboard.

Ahead of him was a group of tired schoolgirls in uniform at a bus-stop. They carried gym bags; perhaps they had been at a game since school ended. His unfocused gaze was drawn to their unfashionable tartan ties and skirts, their textbook whiteness. Then their bare legs in the cold wind—the kilts seemed ridiculously short for girls their age—and their long hair. They watched him boldly; as he passed he saw they all wore makeup. One smiled to another and crossed her long, goose-bumped legs; she was a woman, definitely, not a school-girl; Ted became aware of the ugly trenchcoat he carried. He looked straight ahead. It was uncharted territory up there.

Boss was immediately recognizable. A blank, two-storey façade like a factory wall, with a frosted glass door and a stream of stretch limousines and convertibles outside. Young men in windbreakers jumped into the cars as patrons abandoned them with the engines running. Ted hesitated, then remembered the suit he wore. He puffed his chest out and walked through the door.

A circus tent was his first thought. A vast, bright room, a ceiling at least two storeys overhead, bright geometric shapes like huge building blocks in gaudy colours—salmon-orange, purple, brown—a sea of tables and heads, dark-jawed Italianate waiters gliding around, frowning. Facing him, behind a sort of podium, was a tall blond woman in a purple silk dress. She seemed to be in a kind of spotlight, smiling at him brassily. "Yes?"

He approached her, murmuring Miranda's name. Frowning, she scanned the papers on her podium. Her purple dress was cut very low. Ted tried not to look. "One moment please," she said, and gestured to one of the dark-jawed men. His face and suit looked sculpted. Ted remembered a poster in a history book, praising Mussolini's army. The two hosts murmured together for a moment, studying the list of reservations with great seriousness. She looked up, smiling. "Would you care to check your coat?" She gestured to the counter to their right; behind it was an almost identical woman with even more cleavage.

The middle-aged man before Ted dropped a five-dollar bill into the coat-check woman's glass bowl. Ted sheepishly handed over the trench-coat, avoiding her eyes. He only had twenties from John and he wasn't going to ask her for change. He followed the sculpted man through the tables; every face looked up at him expectantly as he passed. The men were all in suits, the women were tight-jawed and high-heeled; they laughed histrionically and kissed one another. Men sauntered between

tables, red-faced, shaking hands. He saw with relief that most of the suits were double-breasted. The biggest bottles of champagne he had ever seen lined the walls; everything seemed exaggeratedly large. Very quickly he felt proud, as if he were growing in size himself. He wanted to talk, to be witty and acerbic.

The host led him to a crammed corner table where he recognized Arthur, Roger and Julia; Miranda wasn't there. They greeted him laconically; Arthur seated him next to a striking woman with a mass of black hair, introducing her as Lisa, and the mousy one in the corner seat with a name Ted instantly forgot. She looked like a physiotherapist. He turned to Lisa. "Teddy," he said, squeezing her hand. "Rather like a circus in here, isn't it? I was handled by four people before I got sat down. Kind of like spa attendants. Actually I've never been to a spa in my life."

"You haven't been here before?" She leaned forward in a cloud of perfume.

"No, I haven't been in Toronto long actually. Seems kind of American, this place." Someone poured him a glass of wine. He felt extraordinarily confident. "I don't trust this wealth at all, actually," he said confidingly to Lisa. "I get the feeling these people have made their money very quickly and could lose it just as quickly. Don't you agree? I mean, I can see this guy over here, don't look now, the guy with the gold bracelet—see it? I can see him losing his temper and bludgeoning his partner to death in the stairwell. With a baseball bat."

"You think these people are gangsters?" asked Lisa.

"No. Not necessarily. Quite possibly. It's rather how I imagine an expensive prohibition speakeasy night-club to look. And they were always bludgeoning each other …"

"I guess you'd rather some dark wood panelling waspy place, with hunting prints on the walls?" Ted noticed the physiotherapist staring at him. He looked at Lisa's dark eyebrows, her olive skin, and decided not to come on too strong with waspy. "Well—"

"Don't know how to treat champagne, that's for sure," interrupted Arthur, slightly drunk. "You can't keep jeroboams standing up in a hot room like this."

"It's all for show," said Ted, nodding. Arthur seemed very judicious.

"It's a terrible waste," said a voice from behind him. It was Andreas the filmmaker, dragging a chair and looking rather rumpled and tired. His ponytail was loose. Still he wore his silver-toed cowboy boots. "Sorry I'm late," he said, wedging the chair among them. "Been shooting all

day. Keep losing my fucking PA's. And I lost my fucking watch." He sat heavily.

"Do you know," said Ted, "so did I. And on my way here I was looking for a pixelboard display, you know the ones on the tops of buildings and in the subway, to check the time, and when I couldn't see one I was actually irritated? I mean we've come to expect that every street has one somewhere."

"Fully," said Andreas, pouring wine inaccurately.

"And I realized that a mere two years ago I would never have expected them on *any* street, much less desired them, and even less been embarrassed by their absence. I mean it felt strangely provincial. I've come to feel that in a *real* city you'd always be in sight of a pixelboard time display." .

Andreas laughed. "And the temperature."

"Exactly. And preferably with a constant stock ticker running, so one can keep track of New York prices. And when the New York exchange shuts down, at night, it would switch over to Tokyo prices. At least that way we'd all have some sense of being *connected*, I mean you wouldn't feel this awful dislocation that you feel up in deserted suburban areas like this. I feel so inhuman up here."

"Fully," said Andreas, taking out a pen and notepad from his jacket pocket. "That's good. I like it. Rich. Fully." He scribbled in his pad, smiling.

"If it *is* Champagne," said Roger laboriously. "It's a terrible waste."

"Judicious, Roger. You're very judicious," said Ted.

"I am, Teddy. I am. Teddy boy, you judicious man, you been doing any writing?"

"Too funny," said Ted, "I have. I was just doing an outrageously *weemo* piece on—"

"You're a writer?" asked the mousy one softly. Ted nodded. "Derek asked me to do this *weemo* piece on restaurant architecture, so I'm going to turn it into a piece on social spaces generally, you know, commercial social spaces, what is constant, what different values are reflected ..." He paused, thinking rapidly; he hadn't thought about it, really. He would have to improvise. Giddily, he began.

An hour later Miranda still hadn't arrived and Ted was eating the oysters he had had the good sense to order for the table, with disparaging remarks about Arthur's salad; someone kept ordering wine; and he had almost perfected the social spaces idea. The mousy one, who couldn't

have been a physiotherapist after all, kept asking him very pointed questions, and murmuring to Andreas the filmmaker. Andreas was complaining about how he kept losing PA's, and this and the mousy one's questions—Karen? Janet? Couldn't be Janet—disturbed him, as it interrupted his flow of thought. "Now take your Maritime tavern or cabaret, for instance," he said over Andreas. "Designed to be menacing. As few windows as possible. Decks stripped for action, so to speak. The facility for drinking as much beer as possible in the shortest amount of time, and physically," he held up one finger, "*physically* intimidating."

"Feel my hands!" said Lisa. "Icicles? *Icicles!*"

"Can't get enough of this hydroponic lettuce," said Arthur.

"Teddy," Andreas said, "Could you use some money?"

"Not at the moment. I'm on to something. Have you ever *seen* one of these places? I mean *imagine*, a sort of barracks with—"

"Because I could use a PA tomorrow. Just running around, gofer work, you know. It won't pay much, just a hundred bucks, for the day, and if we use you for more than that it could go up."

Ted stopped his wine glass before his mouth. "Andreas," he said. "You are a very judicious man. You are judicious." They drank his health. Ted agreed to be on the set at ten the next morning.

Helium seemed darker and louder than most clubs; Ted couldn't remember exactly why they had ended up there. He sat on a worn Victorian sofa in the throbbing beat with his tie loosened and a drink in his hand which he couldn't finish; green smoke swirled around him. He didn't much care where Andreas and the others had got to; he knew there was another floor somewhere on which he had watched, for a few moments, a huge whirling gyroscope machine one could get strapped into, but it had frightened him and made him slightly bilious. And then there had been a live sex show, or something close, a sexual performance dance, with two women in bodypaint and a gay man on a dais, but without his glasses he had found it frustratingly blurry. He had wandered away and hadn't been able to find it again.

He had tried dancing for a moment but had found himself sweating and coughing in the smoke. Now he was remembering Boss. Miranda hadn't shown up at all, and they had never got around to ordering main courses, since they were all waiting for her anyway, and at midnight they had all left and he had still been parted with his hundred dollars. They'd had a lot of oysters, he supposed. Someone must have paid his entrance to the night club. He looked around. The woman in the garter belt and

shaved head sauntered past him again, disappearing into the smoke and nagging him with a sense of sexual obligation—he should try to talk to her, at least. He stood up and danced for a moment, on the spot. He supposed he could be a good dancer if he tried. He wondered where he'd left the suit jacket.

"Teddy!" someone screamed in his ear, and her arms were all over him, on his neck, around his waist, inside his waist-band. He felt Miranda's breasts against his back and almost toppled over. "Teddy!" she said, pulling him back to the sofa and sitting him down, "You are the *sweatiest* guy!"

"I am," he said. "Hello. You missed your party."

"No I didn't," she said, running her hands through his hair. "I'm here now. This is my party."

"Oh." He waved to Julia and Caroline, who swirled around him, dancing in the smoke. Miranda kissed his neck. "Hell," he said.

"Come on upstairs," she said. "Let's talk." She led him by the hand through bodies and smoke, up some stairs into a sprawling, low-ceilinged room full of old sofas at odd angles, with low coffee tables between them.

The pounding was just as loud upstairs, but waitresses in stilettoes circulated with trays. Miranda and Ted sank deep into a sofa. "Now," she said, putting one hand on his neck and the other on his knee. "Tell me how you are."

Ted was looking around. "Lot of sofas," he said. "Kind of like the furniture section in Eaton's."

Miranda laughed, swaying into him. He told her of all his new projects: the play, the articles, especially the new one on social spaces, which he was sure would be published before Christmas.

"What a success," she said. "And what about John? How's he?"

"Oh, John's fine, he's—"

"What's this I hear about him having a girlfriend? What do you know about that?"

"A girlfriend? John?" Ted shrugged. "I wouldn't know." He looked around. Dark forms were embracing on sofas close to them. Two tall men were watching them, motionless, from a shadow a few yards away, holding drinks. Miranda was rubbing his neck.

"John could be *such* a success, you know," she was saying. "He's such a *brilliant* man. I admire you guys. You have such—"

"Hey," said Ted, sitting up. "Who's—it's Arthur and Roger." Their faces were indistinct, but it was definitely them; they had been there for

some time. He smiled and waved; Arthur lifted his hand, but his face was tense. Roger scowled.

"I know," said Miranda without looking at them. She played with Ted's hair, then sighed. "My man. The two men in my life."

Ted shifted slightly, trying to pull away without being rude. "I didn't know they were so close." He smiled at the two men, who weren't speaking to each other, just watching intently him and Miranda. "Miranda," he said, "how long have you and Arthur—"

"Oh, Ted*dy*. Let's talk about something that isn't *tiresome*." He looked ostentatiously at his wrist, but there was no watch. 'I'd better be going."

"Oh. Teddy, why don't we meet sometime, where we can talk? Let's meet for breakfast tomorrow."

"Breakfast. Tomorrow." He stood up, looking for the suit jacket.

"At Moue? The French place we went before?"

"Rosedale. Sure. Ten? No, I'm working for Andreas. Nine?"

"Nine. Perfect." She blew him a kiss, then stood, smiling at Arthur and Roger. Slowly, she swayed towards them.

The wind was stronger and colder on Bathurst Street. Ted hobbled into it; John's shoes were hurting him. He felt as if he had walked from a distant suburb. He wished he had remembered to retrieve his trench-coat from the Boss coat-check; it might have had a subway ticket in the pocket. At least he had found the suit jacket, under two embracing men at Helium. It smelled of oysters. He had no idea how much it cost to dry-clean a suit.

He was walking past warehouses, empty gas stations. Every outline was blurred. He tried not to think of Miranda and Roger together. Or of Georgina. Perhaps Georgina hadn't left town at all. It didn't seem to make sense to fly in from Japan—the tiny, coiffed waitresses on JAL, the sushi snacks in styrofoam—to this wind over the streetcar tracks, Toronto, for two days. Of course she had been in London with her mother for a while first. It was encouraging, really, how upset she had been by the Go-Go episode. Perhaps she had reconsidered a sudden departure and had left a note for him at home. The wind cut his eyes and Ted cursed; he lifted his arm to wipe his nose on the suit's sleeve. Over the oysters, perfume: Miranda's hair.

Two lovers passed him, Italian teenagers, wrapped together and gig-gling. With envy, he watched the girl's shiny legs in black tights pass.

By the time he reached the house his head was filled with black tights, perfume and stilettoes; the spot where Miranda had been rubbing his

thigh still seemed to tingle. He dropped his key on the front porch and had to fumble on his knees. In the dark entrance hall, the banister swayed to meet him; he bruised his shin. Lurching into the kitchen, he looked for a note on the table and for orange juice in the fridge, but found neither.

PART IV

BEAUTY GOES PUBLIC

NICK MOUNT

You find one on Madison Street, near Pike, beyond the shadow of the Manhattan Bridge. It hovers on the wall of a makeshift parking lot, over exhaust, rust, old tags. It shouldn't be here, but there it is—a hummingbird. Life-sized and lifelike, put in flight by the old painter's tricks of shadow and light. You could have thought it real but for its colours, which come from art, not nature—from the graffiti behind it, its backdrop and its ancestor. Its creator says he wants the bird to give pause,[1] and that's just what it does. Give pause. Because here, in an ugly corner of an ugly city, within choking distance of the wreckage of an ugly act, you have found the opposite of ugly. Here, beauty is back.

N 1917, MARCEL DUCHAMP BOUGHT A URINAL FROM A NEW YORK ironworks, signed it "R. Mutt," and entered it in the exhibition of New York's Society of Independent Artists. And so, the story goes, a toilet conquered the world. In 2004, a poll of 500 artists, curators, critics, and art dealers named Duchamp's *Fountain* the most influential art object of the twentieth century.[2]

Avant-garde artists like Duchamp refused to produce art for the pleasure of a society they held responsible for, among other things, World War I. They walked away from a definition of art that had ruled the West for over 2,000 years: no more beautiful imitations. Art should be a concept, not a copy. It should disturb, not please. Most important,

it should not be beautiful. The American painter Barnett Newman said it clearest: "The impulse of modern art was this desire to destroy beauty."[3]

That's why Duchamp's urinal was the right choice for the most influential art object of our time. There are exceptions, but all it should take is a walk through any major art gallery to convince you that for twentieth-century art, beauty really isn't the point. That's not to say that it's not art, or that it's not good art. In fact, according to the philosopher Arthur C. Danto, author of the best of several recent versions of this story, that was the main insight of modern art: art does not have to be beautiful to be art.[4]

If a trip to the gallery doesn't convince you—if you still say Duchamp's urinal is beautiful, or Picasso's women, or Pollock's splatters, or Hirst's rotting animals—blame your obviously expensive education. In its attempt to explain the value of avant-garde art, art criticism fell back on art's traditional value. Again and again, curators and critics said this new art *was* beautiful, if we could only open our eyes. Even when their own eyes told them otherwise. Clement Greenberg, America's most influential modernist art critic, said it more baldly than most: "Pollock's bad taste is in reality simply his willingness to be ugly in terms of contemporary taste. In the course of time this ugliness will become a new standard of beauty."[5]

Greenberg was right—more right than he would have liked, especially as a New Yorker. After September 11th, the French philosopher Jean Baudrillard wrote that "By the grace of terrorism, the World Trade Center has become the world's most beautiful building—the eighth wonder of the world!"[6] The *New York Times* called Baudrillard cold-blooded,[7] but Baudrillard wasn't especially cold-blooded, just especially educated. He could call the wreckage beautiful because he had ingested, more thoroughly than most, the modernist lesson that the ugly is beautiful, in its own way.

Beauty had other enemies in the last century besides the avant-garde and Ray Stevens. Feminism attacked the "beauty myth," the reduction of female appearance to a single, male ideal.[8] Post-structuralism and multiculturalism chipped away at universals in general, European universals in particular. Art elevated concepts over aesthetics to its logical end: the explicit exclusion of apolitical art from the international exhibition documenta X in 1997.[9] In the galleries, ugly was the new beauty. In the classrooms, everyone was beautiful. For good and noble reasons, both. But in becoming anything, beauty

became nothing, a word that could describe anything and that, consequently, no one could describe.

Beauty never left, of course. Exiled from high culture, it found a home throughout the century in mass culture, in its movies, magazines, music, advertising. On one side, cubist prostitutes; on the other, Barbies and Britneys. Advertising especially welcomed beauty: its seduction, its youth, its promise of better sex and a better life. Today, Plato's *Symposium* is a marketing manual.

While high art and high theory have never been so skeptical of beauty, daily experience has never been so certain. Countless psychological studies show us agreeing on the most attractive human face, agreement that cuts across gender, class, age, even race.[10] The jury is still out on whether this consensus comes from nature or nurture, survival of the prettiest or *America's Next Top Model*. But at the very least, global mass culture has refined our everyday taste while high culture has failed utterly to change it. With the best of intentions, the twentieth century surrendered beauty to commerce. For beautiful art, we got beautiful shoes. For beautiful cities, beautiful billboards.

In 1993, the maverick American art critic Dave Hickey surprised the art world and himself by declaring at a conference that "The issue of the nineties will be *beauty*."[11] The following year, *The New Yorker*'s future head art critic, Peter Schjeldahl, wrote a defence of beauty for *Art Issues* that the *New York Times Magazine* later reprinted as a cover story. "There is something crazy," Schjeldahl wrote, "about a culture in which the value of beauty becomes controversial."[12]

So began, or so we noticed, what looks like beauty's return to its old haunts. In the universities, the last decade has seen an outburst of conferences, graduate seminars, articles, and books on beauty. Because of the academy's confusion of its responsibility with page counts, it's dangerous to take quantity as a real measure of its interest in anything. But the best of the new work on beauty—like Hickey's *The Invisible Dragon* (1993), Elaine Scarry's *On Beauty* (1999), and Alexander Nehamas's *Only a Promise of Happiness* (2007)—seems driven in thought and style by personal and so sincere motives. In criticism and philosophy, beauty and its attendants—craft, feeling, sincerity, ethics, truth—have become permissible subjects again.

For the moment, though, beauty's most conspicuous return to the high arts seems to be in talk about art. In art itself, beautiful imitations still take a back seat to clever concepts, or to other aesthetics like the sublime

and the abject. When beauty does surface, it's still as grist for the concept, the target of a well-educated irony. There is of course room for disagreement about this—one MFA's irony is another's beauty—but not nearly as much we've been taught by a century of seeing beauty anywhere. Almost by definition, beauty is what you know, instantly, to be beautiful. Beauty *stands out*, both from other aesthetics and from lesser versions of itself. Prolonged exposure can deepen or wither your perception of beauty, in a poem or a person, but not the beauty itself, the beauty you saw then. We're not always ready for it, but beauty is immediate.

In the spring of 2007, I taught one of those new graduate seminars on beauty at the University of Toronto. For our final class I asked the students—myself and twenty MA and PhD candidates from the English, philosophy, and fine art departments—to find beautiful art by a contemporary artist. Looking back, we didn't come up with much. Andy Goldsworthy, the well-known British sculptor who makes ephemeral outdoor pieces from natural materials like rocks, leaves, and snow. A young Canadian sculptor, Cal Lane, who cuts delicate, lace-like patterns into everyday metal objects like shovels, oil cans, a wheelbarrow. Recent semi-abstracts by two British painters, Howard Hodgkin and Cecily Brown. In architecture, Studio FAM's glass memorial for the Madrid train bombing, and Foster and Partners' glass-covered court at the British Museum.

We saw others, but these are the few that immediately convinced us of their beauty, that stood out. It's possible that we found so few because we were too ignorant or too educated: that we knew too little about contemporary art, or too much about the pitfalls of beauty. But even granting those problems, I think we found little beautiful art in the real and virtual galleries of the West because there is still little to be found. The month our seminar began, the designer Bruce Mau wrote in *The Walrus* that "Today the talent to make beautiful paintings is a bus pass to the suburbs of art discourse."[13] Add beautiful sculpture and beautiful buildings, and that's pretty much what it took us three months to find out.

In a sense, Mau was wrong. Beauty is closer today to the centre of art *discourse* than it has been for decades. But in another and more important sense, he's right, more right than I think he realized. Beauty has returned to art, not just to talk about art. It's just that its most vital return hasn't been to the galleries, it's been outdoors, to the walls and streets of public space—to, quite precisely, the suburbs of art. Today, beauty is using that bus pass.

Dan Witz is one of several artists who have been called the godfather of street art.[14] Witz grew up in Highland Park, a suburb on Chicago's affluent North Shore. He studied at the Rhode Island School of Design in the mid-1970s and in 1980 received his BFA from the prestigious Cooper Union in New York's East Village. As Witz tells the story, he began doing street art while at Cooper, because of Cooper. Rebelling against the school's elitism—"the postmodern architecture, the chilly art snob students"—he got drunk one night and painted fires up and down its back stairway.[15]

Ironically, students at highbrow Cooper taught Witz the lowbrow skill for which he's become known, his ability to paint hyperrealistic images that "trick the eye," trompe l'œils.[16] Witz began fooling New York's eye in 1979 with his first large-scale street project, *The Birds of Manhattan*. Working with tiny brushes and acrylic paint, he painted over forty hummingbirds on walls and doors in Lower Manhattan. Besides the trompe l'œil illusion of three-dimensional realism, Witz used a technique called scumbling—thin layers of one colour over another—to capture the iridescent shimmer of a hummingbird's colours. The birds are not actual species: Witz let each adapt to its environment, taking its colour cues from the surface on which it flew.[17]

Street art grew from graffiti, but it uses a wider range of techniques and styles. It's more educated: graffiti with a BFA, as its detractors say more often than its defenders. It's less about asserting the self than addressing the world, sometimes through political content, more often through inclusive aesthetics. The most striking difference, the shift Witz anticipated by over a decade, is street art's new permissiveness towards the cute and the beautiful, aesthetics as off-limits in graffiti as in the galleries.

In retrospect, *The Birds of Manhattan* was street art avant la lettre, two years before Blek le Rat pioneered stencil graffiti in Paris, a decade before Shepard Fairey launched his *Obey Giant* campaign out of a Rhode Island skateboard shop. But at the time, Witz's birds were less street art than art taking to the streets, like Jenny Holzer's *Truisms* of two years before and Keith Haring's subway drawings two years later. Witz assumed his outdoor art would be for him what it became for Haring, Lee Quiñones, Jean-Michel Basquiat, and other artists working the New York streets at the same time: a step on the way to the galleries.[18] Throughout the 1980s he worked both sides of the fence, concentrating on studio painting in the winter and occasional, mostly lighthearted street pieces in the summer.

In the early 1990s, a motorcycle accident together with Witz's persistent misgivings with the dollar-driven gallery scene forced him to reassess his place in art.[19] In 1994, he recommitted himself to street art with his first major project since *The Birds of Manhattan*, a series of grim, hooded figures postered on walls overlooking heroin spots in his Lower East Side neighbourhood.

Since then, Witz has returned to the streets every summer with a new project. His dominant style remains trompe l'œil realism, though to reduce his exposure to increasingly anti-graffiti New York police he stopped hand-painting on site in the early '90s, working instead in the studio with a photograph printed on vinyl sticker paper and painted to add dimension. On site, Witz airbrushes shadows around the sticker, a process that gets him off the street in under five minutes.[20]

Witz employs several aesthetics. *Hoodies* is as dark as its content, heroin and HIV in the Lower East Side of the early '90s. Street art's affection for the cute surfaces in his humour, street pranks like a house he turned into a face by adding a red weather balloon for a nose. But his driving aesthetic is beauty. In 2000, when Witz left his Ludlow loft for Brooklyn, he revived his birds as a farewell to his old neighbourhood. Once again hummingbirds flew in Lower Manhattan, on Madison, on Henry, in Freeman Alley. Back in 1979, Witz looked for clean canvases for his birds, untagged walls and doors. In 2000, he let them fly over old graffiti, announcing the relation and the difference between the two aesthetics, tradition and departure.

The summer after September 11th, Witz stuck candlelit shrines on the bases of light poles radiating out along sightlines from Ground Zero into midtown, Jersey, and Brooklyn.[21] The pieces began as photographs of the votive offerings left in Union Square Park after the attacks, painted in Witz's way to light the night again. New beauty, for an old end: consolation.

The *WTC Shrines* is Witz's favourite work to date, his best marriage of form and function. Mine is *Floating*, a series from 2005 of tiny rowboats set afloat on the sides of dumpsters, trains, tractor-trailers—anything that moved. The boats all have the same name: *Lonesome*. In context, and nowhere else, they are a near perfect image of urban pathos, transient Prufrocks for the twenty-first century. They hear the mermaids sing, but not for them.

For Witz, public art should be publicly accessible.[22] "My small goal is to give pause, to say art is around, that it is a possibility. I want

ordinary people to know that places like this street aren't always what they seem."[23] His aesthetic follows from that goal: beauty is naturally accessible to "ordinary people," which is one reason high art spurned it and the main reason commerce embraced it. Witz's medium might be new, in other words, but his methods are old, pre-urinal. Trompe l'œil dates to the Greeks, to the dawn of beautiful imitations. Scumbling is an Old Masters' technique last used extensively in Impressionism, beauty's last gasp.

Conservative methods do not necessarily make conservative art. Accessibility matters to Witz as a starting point, a way in for all, but he uses beauty not to please but to provoke. In an art world that values concepts over aesthetics, Witz says he chose beauty as "a calculated punk reaction, a form of rebellion, an artist's line-in-the-sand manifesto rejecting boring, elitist, intentionally exclusivist art practices. Beauty as sedition."[24] Outside the art world, Witz's street art is equally radical for the simple, courageous reason that it's free: a public beauty that costs nothing to see and has nothing to sell.

Witz is not alone. The young New York street artist known as Swoon wheatpastes fragile paper cut-outs of her family, friends, and city characters—beauty caught and left to rot. In Montreal, Roadsworth spray-paints ivy along the painted lines on streets, or did until he plea bargained mischief charges in 2006.[25] Sometimes the beauty of street art is in the content more than the form, as in the hundred-plus "I Love You" tags someone sprayed across Toronto in 2001.[26] Sometimes it's not even in the street: the Wooster Collective, street art's online conscience, claims Andy Goldsworthy as one of their own.[27]

At the moment the amount of beautiful art is about the same on the streets as in the galleries: very little. But the crucial difference is that while beauty is still largely excluded from or treated ironically by the art world, it's being welcomed on the streets, by Witz's ordinary people. Witz, Swoon, and Roadsworth are not typical street artists, not yet. They're exceptional—and exceptionally admired. And though it's no guarantee, history gets made by exceptions. In 1917, urinals weren't typical art either.

Street art isn't the only artistic suburb to welcome beauty back in recent years. Beauty's back with heels and humour in the neo-burlesque, the revival of American burlesque that began in the mid-1990s.[28] It's back with a tear in its eye in indie music, in the explosion of sensitive singer-songwriters we would have beat with a bat in the crotch-rock '80s.

It's back as a child in so-called Outsider Art, both the unskilled folk art brought inside and the skilled folk art left outside, like the painter Thomas Kinkade calls "America's most collected living artist," that is, Thomas Kinkade.[29] It's back as craft in border-crossing extensions of punk's DIY aesthetic to the rebirth of vinyl, the Lowbrow movement, Martha Stewart, sculpture's turn to homemade materials, poetry's return to meter and rhyme, art's return to paint.

Some or all of these will disappear, passing with fashion or swallowed whole by art dealers and advertisers. The internal backlash against street art has already begun, with accusations flying in paint and words of artists selling out to galleries and corporations as well as charges of white artists stealing a black art, the tired and tiring Elvis story. The New York street art news was dominated in the summer of 2007 by the Splasher, an anonymous artist who vandalizes the vandals, Pollocking house paint on street pieces by crossover successes like Swoon and Fairey. The Splasher's manifesto quotes Dada scripture, demanding the destruction of all bourgeois art.[30] Old toilets die hard.

Beauty will survive the passing of street art, of any art. If it could endure all we threw at it in the twentieth century, it can handle a little house paint in the twenty-first. In art, beauty is just one aesthetic choice among many. But as Arthur Danto has said and Plato before him, it's the only aesthetic that is essential to life as we would prefer to live it.[31] In the last century, we got our public beauty fixes from nature and commerce, not art. Nature is too far away now, and commerce has another agenda. Beauty's return reveals an enduring hunger for nearby beauty that's not for sale. Kant was wrong: billboards can be beautiful. But they're not enough.

Beauty hasn't returned to these scattered fields ironically. It's back sincerely, for its own merits. Beauty is susceptible to irony, a point twentieth-century art proved repeatedly. But beauty is not itself ironic. If you see irony in the beautiful, you brought it there. The incompatibility of beauty with the late twentieth century's affection for irony is one reason it stayed away from the high arts as long as it has. As psychologist James Hillman has said, to bring beauty back, we'll need "the courage to abandon irony."[32]

For Danto, beauty has returned to the post-9/11 world because beauty eases pain. It's the appropriate aesthetic for our elegiac mood: candles in the parks, soft ballads by pop gods, Witz's street shrines, the Madrid memorial. We convinced ourselves that beauty was subjective, in the eye

of the beholder. But when we needed to come together in the communal rites of mourning and elegy, we chose beauty all the same.[33]

But beauty's use as consolation after September 11 wasn't a movement so much as a moment, one we'd shared many times before in the long litany of twentieth-century pain. We may have snubbed beauty, but we made sure to keep some around for experiences too intense for avant-garde theory to relieve. There are no Damien Hirst reproductions in hospital gift shops.

Beauty isn't back just to help us deal with the past. It's back to help change the present and create a different future. In a poster by Britain's best known street artist, Banksy, a masked graffiti artist in black and white pulls his arm back to throw a bouquet of flowers in living colour. In one of Witz's street illusions, a hand punctures a metal utility box to clutch a single rose. These are not beauty as consolation—they're beauty as provocation, as deliberately seditious as Duchamp's urinal was in 1917. Strange, how far we've come: that flowers could be rebellious.

Beauty has much to offer, starting with the pleasure of seeing it. I enjoy the intellectual delights of conceptual art as much as the next PhD, but after a while (say a hundred years) they can become predictable. Challenging the viewer's definition of art, check. Deconstructing the white cube, check. Exposing the politics of representation, check. Art cannot be blamed for having few new ideas: the number of ideas entering the world at any given time is exceedingly small. But it's not unreasonable to ask it to recognize this limitation, and to aim once in a while at pleasure instead. It's not as easy as it looks, or as simple.

Many of the people who are talking about beauty again are doing so because they believe that besides giving pleasure, pleasurable art can change the world. For the art critic Wendy Steiner and the philosopher Elaine Scarry, for instance, beauty engenders crucial political virtues. For Steiner, beauty invites communication between the beholder and the beheld, the self and the other—the beginnings of empathy and equality. For Scarry, beauty's fragility fosters the desire to protect it, and so might teach us to extend our care from the extraordinary artwork to the ordinary person.[34]

Scarry goes further, standing on Plato's and Kant's shoulders to argue that beauty points the way toward justice itself. It's more than a coincidence, she says, that we describe both beautiful objects and just outcomes as "fair." Beauty's main attribute is justice's main goal: harmony.

But unlike justice, which is necessarily general and abstract, beauty is present to the senses, particular and concrete. In answer to the question "What does a just society look like?" Scarry says we might answer, "like the sky."[35]

I'm not sure beauty can achieve what we could not, or that we should expect it to. In *Only a Promise of Happiness*, Alexander Nehamas is also doubtful, arguing that beauty offers no moral or social value beyond itself—only the uncertain promise that my life will be better for the time I spend with it. But even Nehamas ends up saying that in an uncertain world, "the promise of happiness is happiness itself."[36] His beauty gives the individual what Scarry's gives the world, a better life for you and me that presumably adds up to a better life for all.

If beauty offers anything beyond pleasure, it's to be found in its much contested universality. Perhaps we need a safer word: Nehamas suggests "communal."[37] But hopefully universal or cautiously common, long experience and recent science show widespread agreement on beauty and its appeal. If it isn't universal, it's the most universal aesthetic we've got. Maybe it's time to admit again what Friedrich Schiller said more clearly than Kant, that "Beauty alone makes the whole world happy, and each and every being forgets its limitations while under its spell."[38]

Beauty's magic can of course be used for unhappy ends. Mass culture's embrace of beauty doesn't necessarily make its products good for us. Beauty works as well to foster the warrior spirit as it does to lament its leftovers, from Rupert Brooke's beautiful poems in WWI to Silvia Pecota's beautiful pin-ups for the Canadian troops in Afghanistan.[39] But in a time scarred by the differences among us, anything that can remind us of our similarity without erasing our differences has tremendous political potential for good. Beauty doesn't get to decide for whom it works. But we do.

In his defence of beauty back in 1994, Peter Schjeldahl suggested that maybe we banished beauty because we couldn't forgive it for not saving the world.[40] But we never gave it a chance: we hid its survivors in museums and mansions and sold its public space to the advertisers. We don't actually know what an ethical beauty could do if we let it loose in the world, because we haven't tried. As Dan Witz says of his form of public art, "Not for sale is the most radical thing to happen in art since abstraction."[41]

Some believe ethics must come before beauty, the no-poetry-after-Auschwitz school. Duchamp, for starters: no more beautiful art for an ugly

world. The Splasher, for another: "OUR STRUGGLE CANNOT BE HUNG ON WALLS. DESTROY THE MUSEUMS, IN THE STREETS AND EVERYWHERE."[42] Less typographically excited but just as certain, Arthur Danto says beauty cannot return to art until politics ends injustice, while Peter Schjeldahl calls beauty "a necessity that waits upon the satisfaction of other necessities."[43]

They're probably right. Art isn't water, it's wine. But I like wine. The problem with putting politics before beauty is that it makes beauty contingent upon utopia, and I can't wait that long. Until the Marxists make the world perfect, perhaps the rest of us can make it a little better, a little fairer and a little happier—with the help of Dan Witz and Swoon, and, yes, Martha Stewart and Thomas Kinkade.

Beauty is not all there is or should be. I don't want to live inside one of Kinkade's bucolic paintings, and not just because I'd burn in his utopia. The human range of emotions deserves a range of aesthetics: it would be a mistake to abandon everything art learned in the twentieth century, just as it was a mistake to abandon everything it learned about beauty in the centuries before, the skills we replaced with theories. Nor is the beauty of the beautiful the end of the story: to call an artwork beautiful does not say all there is to say about it, any more than it says all there is about a person. And nor, finally, are beautiful shoes without their pleasure or virtue. Soweto's new malls are better than its old shanties—not perfect, just better.

But while we're waiting on utopia, beauty could do this imperfect world some good. Especially in public spaces, beauty could bring us together, remind us of what we share—in times of joy as well as grief. It could win our attention back from commercial beauty, showing us other pleasures besides shopping, other ways to see and think about our bodies, our values, our cities. Maybe, just maybe, it could point the way toward a fairer politics as well as a fairer home. And even if beauty can't do those things—even if it can't make the world we want—it can certainly make it easier to live with the world we have.

We don't just like beauty, we need it. Life is pain eased by the comforts we scratch on the walls. In beauty's service, Keats lied. Truth is a moving target, but beauty we can see, touch, and hold. It can't return because it never left us: we left it. The twentieth century made beauty that's not selling us something hard to share and rare to see, but it's still here, ready whenever we are.

NOTES

1 Dan Witz, "Sending a Message through Hummingbirds and Hoodies," *Public Art Review* (spring/summer 1995). Archived at http://www.danwitzstreet art.com/essays.html.

2 Charlotte Higgins, "Work of Art That Inspired a Movement: A Urinal," *The Guardian*, December 2, 2004, http://www.guardian.co.uk/arts/news/story/ 0,11711,1364123,00.html.

3 Barnett Newman, "The Sublime Is Now," *The Tiger's Eye* 6 (1948): 52. For Newman, the rejection of beauty began with the Impressionists' "insistence on a surface of ugly strokes" and was completing itself in America with artists like himself "by completely denying that art has any concern with the problem of beauty and where to find it" (ibid., 52–53).

4 Arthur C. Danto, *The Abuse of Beauty: Aesthetics and the Concept of Art* (Chicago: Open Court, 2003).

5 Clement Greenberg, "Review of Exhibitions of the American Abstract Artists, Jacques Lipchitz, and Jackson Pollock" (1946), rpt. in *The Collected Essays and Criticism: Clement Greenberg*, vol. 2, ed. John O'Brian (Chicago: University of Chicago Press, 1986), 74.

6 Jean Baudrillard, *The Spirit of Terrorism* and *Requiem for the Twin Towers*, trans. Chris Turner (London & New York: Verso-New Left, 2002), 52.

7 Walter Kirn, "Notes on the Darkest Day," *The New York Times*, September 8, 2002, http://query.nytimes.com/gst/fullpage.html?res=9503EED7173FF93 BA3575ACoA9649C8B63.

8 For instance, Naomi Wolf's *The Beauty Myth: How Images of Beauty Are Used Against Women* (New York: Morrow, 1991).

9 Neal Benezra, "The Misadventures of Beauty," *Regarding Beauty: A View of the Late Twentieth Century*, by Benezra and Olga M. Viso (Washington, DC: Hirshhorn Museum, 1999), 17.

10 For a summary of the research and a sliver of the bibliography, see Alexander Nehamas, *Only a Promise of Happiness: The Place of Beauty in a World of Art* (Princeton, NJ: Princeton University Press, 2007), 64–66 and notes.

11 Dave Hickey, "Enter the Dragon: On the Vernacular of Beauty," rpt. in *Uncontrollable Beauty: Toward a New Aesthetics*, ed. Bill Beckley and David Shapiro (New York: Allworth, 1998), 15.

12 Peter Schjeldahl, "Notes on Beauty," *Art Issues* 33 (May–June 1994), rpt. in Beckley and Shapiro, *Uncontrollable Beauty*, 55. Schjeldahl's essay was reprinted in *The New York Times Magazine* of September 29, 1996.

13 Bruce Mau, "Imagining the Future," *The Walrus* (December 2006–January 2007): 33.

14 Chris Osburn, interview with Dan Witz, *Juxtapoz Arts and Culture Magazine Online*, April 10, 2007, http://www.juxtapoz.com/index.php?option=com_content&task=view&id=843&Itemid=121. The two other main claimants to the title are Shepard Fairey and Blek le Rat.

15 Witz, "5 Tips," Wooster Collective (March 2003), http://www.danwitzstreet art.com/essays.html.

16 Mikal Saint George, interview with Witz, *Trigger Magazine*, May 5, 2005, http://www.triggermagazine.com/archives/2005/05/dan_witz.html.

17 Hummingbird technique from Witz's account at http://www.danwitzstreet art.com/birds1.html. Witz later used an NEA grant to publish a monograph on the series called *The Birds of Manhattan: Street Paintings by Dan Witz* (New York: Skinny Books, 1983).

18 Pitchaya Sudbanthad, "Roundtable: Street Art," *The Morning News*, March 23, 2005, http://www.themorningnews.org/archives/personalities/roundtable _street_art.php.

19 Noah Levine, "Multiplicity: The Secret Lives of Dan Witz," *Juxtapoz Arts and Culture Magazine* (September 2006): 74.

20 Sticker technique from http://www.danwitzstreetart.com/tromp1.html. See also Witz's "Artist Statement" for his 2000 Fellowship from the New York Foundation for the Arts, http://www.nyfa.org/nyfa_artists_detail.asp?pid=507.

21 See installation map at http://www.danwitzstreetart.com/lightpolesindex.html.

22 Brian Katz, interview with Witz, *Bozack Nation* (April 2003), http://www.dan witzstreetart.com/essays.html.

23 Dan Witz, "Sending a Message through Hummingbirds and Hoodies," *Public Art Review* (spring/summer 1995), http://www.danwitzstreetart.com/ essays.html.

24 Dan Witz, email message to Nick Mount, October 27, 2007.

25 Allison Hanes, "Graffiti Artist Free to Paint—But He Has to Ask First," *The Gazette* (Montreal), January 19, 2006, http://www.woostercollective.com/2006/ 01/roadsworth_resolves_court_case_against_h.html.

26 See Sharon Harris's partial collection of the "I Love You" graffiti at http:// www.iloveyougalleries.com. Harris's collection has since expanded and no longer makes its origin clear.

27 "When most people first hear the words 'street art,' they immediately think of urban settings and industrial locations. But some of the most interesting and exciting street art is being done in the most unlikely of places and far from city centers. We consider Andy Goldsworthy a 'street artist,' yet his work is almost never found on the street and is most often placed in extremely remote and rural settings" (Wooster Collective, quoted in Pitchaya Sudban- thad, "Roundtable: Street Art," *The Morning News*, March 23, 2005, http://www.themorningnews.org/archives/personalities/roundtable_street_art .php. Witz and Roadsworth both cite Goldsworthy as a key influence, Roadsworth on his name as well as his art (Dan Witz, artist interview, Addict Galerie, Paris, http://addictgalerie.com/lng_FR_srub_24_idc_1-texte-et -interview.html); Reid Cooper, "When the Stencil Hits the Road," *The Globe and Mail*, January 6, 2005, R3, http://www.goodreads.ca/reidcooper/.

28 A revival pointed out and explained to me in a paper by one of the students in my graduate seminar on beauty, Andrea Charise's "On with the Show!

Beauty, Sincerity, and the Neo-Burlesque," unpublished ms., April 20, 2007, University of Toronto.

29 For the return of beauty in Outsider Art see Wendy Steiner's *Venus in Exile: The Rejection of Beauty in 20th-Century Art* (2001; Chicago: University of Chicago Press, 2002), ch. 5. The description of Kinkade as "America's most collected living artist" is his own, from his website at http://www.thomas kinkade.com/. He's probably right.

30 See Sam Anderson, "The Vandalism Vandal," *New York*, May 28, 2007, http://nymag.com/news/features/32388/.

31 Danto, *Abuse of Beauty*, 160.

32 James Hillman, "The Practice of Beauty," *Uncontrollable Beauty: Toward a New Aesthetics*, ed. Bill Beckley and David Shapiro (New York: Allworth, 1998), 272.

33 Danto, *Abuse of Beauty*, 111–12.

34 Wendy Steiner, *Venus in Exile*, xiii–xxv; Elaine Scarry, *On Beauty and Being Just* (Princeton, NJ: Princeton University Press, 1999), 67.

35 Scarry, *On Beauty*, 93–101.

36 Alexander Nehamas, *Only a Promise of Happiness: The Place of Beauty in a World of Art* (Princeton, NJ: Princeton University Press, 2007), 138.

37 Ibid., 81–82.

38 Friedrich Schiller, *Letters on the Aesthetic Education of Man* (1794), Letter 27. Rpt. in *Aesthetics: The Classic Readings*, ed. David Cooper (Oxford: Blackwell, 1997), 135.

39 See Pecota's pin-ups at http://www.silviapecota.com/pages/1_Salute_troop .html. I'm indebted for this example to another student in my graduate seminar on beauty, Allison Crawford, who interviewed Pecota at Kandahar Airfield in 2007. (Allison Crawford, "'The face that launched a thousand ships' or 'Canada's Secret Weapon': The Return of Beauty to War," unpublished ms., June 25, 2007, University of Toronto.)

40 Schjeldahl, "Notes on Beauty," 59.

41 Dan Witz, email message to Nick Mount, October 27, 2007.

42 Qtd. in Anderson, "Vandalism Vandal."

43 Danto, *The Abuse of Beauty*, 123–24; Schjeldahl, "Notes on Beauty," 59.

PROTECT THE NET
The Looming Destruction of the
Global Communications Environment

RON DEIBERT

SK MOST CITIZENS WORLDWIDE WHAT THE MOST PRESSING issue facing humanity as a whole and they will likely respond with global warming. However, there is another environmental catastrophe looming about which citizens are only just beginning to learn: the degradation of the global *communications* environment. The parallels between the two issues are striking: in both cases an invaluable commons is threatened with collapse unless citizens take urgent action to affect environmental rescue. The two issues are also intimately connected: solutions to global warming necessitate an unfettered planetary communications network through which citizens can freely exchange information and ideas; the loss of the latter will undoubtedly impact the former. To protect the planet, we need to protect the Net.

The Internet has long been seen as a radical new medium of communication that breaks through the barriers that prevent wider public participation in local and global public policy. And certainly there is ample evidence to support such claims. From political blogging during elections in the United States to mass mobilization using cellular phones in the "coloured revolutions" of the former Soviet Union, to coordination of transnational advocacy networks of all political stripes, the Internet has become the de facto global public communications space. To be sure, issues of class, gender disparities, and other inequalities of access have always presented challenges to its full realization. Most foresee

these challenges being gradually overcome as connectivity expands. However, today a more far-reaching and comprehensive set of challenges are emerging that are major powerful social forces affecting not just relative access to the Internet but the very constitutive features of the Internet itself. Left unchecked, these social forces could transform the character of the Internet altogether, quash whatever gains are made in overcoming digital divides, and undercut hopes for the emergence of a democratic global public space.

Over the last eight years, in collaboration with colleagues spread across several universities and numerous countries, I have helped direct research and activist projects whose aim it is to unearth, expose, and confront these threats to the Internet: the OpenNet Initiative, the Information Warfare Monitor, and the psiphon censorship circumvention software system.[1] The first two projects share a common methodology: the combination of traditional contextual research and advanced technical means of interrogating networks from within countries under investigation. Together, they have helped expose a troubling degradation, from the inside out, of the global communications environment. In the first part of the chapter, I offer a summary of these threats, drawing in part from these projects. Fortunately, just as there are ways to check and constrain global warming and protect the planet, so too are there steps that can be taken to check and constrain the degradation of the communications environment. The psiphon circumvention project falls squarely in this domain. In the final portion of the chapter, I outline several steps that can be taken to protect the Net, including the contribution of psiphon and other tools like it.

The Internet as a Public Space

The Internet has had a long and often uncomfortable history with the notions of "public space" and the "public sphere." From the outset, while holding out seemingly endless examples of great promise, the Internet has also exhibited contradictory characteristics. Although the motivating technical principles behind the early development of the Internet were largely technical and functional and driven by military needs, the developers were inspired by aspirations about the free exchange of knowledge that, in turn, shaped the Internet's basic architecture.[2] Core to that architecture has been the "end-to-end" principle, in which the network is organized with a very simple, neutral, and

shared communications protocol at the core (TCP/IP) that in turn allows for innovation, diversity, and complexity at end points.[3] The strong resilience and capacity for unlimited expansion of this system has been borne out over the last several decades, during which time the Internet has exploded from an experimental, mostly U.S.-based network to the heart of the global communications system.

As the Internet migrated out of the laboratories and into the popular and commercial domains, the tensions between promise and reality persisted. Seemingly endless waves of technological innovation, driven in part by public funding but also by ever-encroaching commercialization, empowered more and more individuals to share information of their own choosing, often with unintended consequences. In the dot-com heydays of the 1990s and early 2000s, it was not uncommon to hear dramatic predictions of the democratization of mass media and the end of corporate and state control over the means of communication, even while corporate and state interests continued to shape, limit, and sometimes resist the medium's fundamental character. Today, millions of people around the world express themselves, debate, and share information through the latest wave of social networking media, such as blogs, video streaming sites, and tools of instant messaging. Throughout it all, the basic architectural principles of the Internet have remained intact, though increasingly challenged as will be outlined below.

Inspired by the writings of Jürgen Habermas and others, and informed by the promises and tensions alluded to above, a growing number of social scientists and political philosophers have critically probed the Internet as a global public space.[4] While most of these valuable contributions focus on gender, class, and other disparities that limit access and prevent its full realization, there are far more comprehensive and far-reaching challenges occurring that are not as often addressed. These challenges are not as well understood because they exist "beneath the surface" of the Internet, often shrouded in secrecy and largely invisible to the average user. They tend to operate within the realm of code, at a foundational or infrastructural level, and impacting the core architecture of the Internet. As a consequence, they have much broader and long-term implications for the Internet as a global public space.

Degradation of the Internet Commons

Just as evidence of threats to the global natural environment can be found in seemingly unrelated local events—deforestation here, a loss of wetlands there—so too can threats to the global communications environment. In Belarus, for example, access to opposition websites was disrupted during 2005 presidential elections, and then restored immediately afterwards with no explanation. In response to images and videos of demonstrations being uploaded to blogs and news sites, the Burmese government shut off the Internet entirely, except during the period of curfew when Internet users could be more effectively tracked. In Cambodia, the government quietly disabled the use of text messaging over cellular networks two days prior to national elections. In Pakistan, inept attempts to block access to streaming videos containing imagery satirizing the Prophet Muhammad resulted in the collateral filtering for several hours of the entire YouTube service, not just for Pakistanis, but also for most of the entire Internet population around the world.[5]

During the late 1980s and through the 1990s, the widespread conventional wisdom held that states were powerless to control Internet traffic. It was widely believed that because of its distributed character and the rapid pace of technological change, efforts by government to regulate content would fail. Some went so far as to suggest that authoritarian governments, for whom information control is vital, would wither in the face of the Internet.[6] Over the last decade, however, governments have shown a growing propensity to block access to information across a wide spectrum of topics, using a variety of regulatory and technical means often implemented in secrecy and without public accountability.

The most authoritative source of data on Internet content filtering comes from the research of the OpenNet Initiative, a collaborative project involving Harvard University and the Universities of Toronto, Oxford, and Cambridge.[7] The ONI employs a unique combination of contextual and technical interrogation research methods to determine what content is being filtered, by whom, and using what technologies. The ONI's interrogation methods are employed in-country across an extended period of time and through a variety of access points. Like an MRI of the Internet, they reveal what goes on "beneath the surface" of the Internet.

When the ONI was founded in 2003, only a handful of countries were known to engage in content filtering. In global tests conducted in 2006, the ONI found evidence of content filtering in 26 of 41 countries

tested. As evidence of the growing problem, it is presently conducting tests in 71. Several of the countries tested by the ONI—China, Burma, Vietnam, Tunisia, Iran, Saudi Arabia, Uzbekistan—are classified as *pervasive* filterers of the Internet, meaning they block access to content across every category in which the ONI tests, from websites of political opposition groups to human rights information, news, and online services such as streaming media or VOIP. Dozens of other countries routinely block access to one or more categories of content under the guise of protecting "public values" or "national security."

A disturbing trend highlighted by the ONI has been the emergence of "just-in-time" filtering, whereby countries leave the Internet more or less open except in special periods, such as during elections or public demonstrations, when access to websites are strategically filtered or otherwise disabled and then subsequently restored.[8] The ONI has documented cases of just-in-time filtering during elections and/or public demonstrations in Kyrgyzstan, Belarus, Tajikistan, Cambodia, Uganda, Burma, China, Pakistan, Thailand, and Malaysia. Unlike first-generation filtering, which is based on fixed (if secret) lists of banned websites that are made permanently unavailable, second generation "just-in-time" blocking methods are temporally fixed and often employ offensive computer-network attacks or other extra-legal means to "take out" adversarial information resources at their source point.

Furthermore, many of the countries tested showed a significant lack of transparency, with most instances of Internet content filtering being done in secret. Although in some countries block-pages inform users that they have requested banned content, in many cases users receive only an "error" message or are redirected to different websites and services than those requested. In China, users making requests for banned information receive a packet that effectively "penalizes" their computer from making further requests to the same server for an indefinite period of time. Although some of the countries tested employed their own "homegrown" filtering technologies (typically at either the backbone or Internet Service Provider (ISP) levels), a market for filtering technologies has blossomed, with some countries using Western commercial filtering technologies originally marketed for corporate environments.

More evidence of degradation can be seen by examining the changing roles played by Internet services companies, ISPs, and the other various "intermediaries" that stand between individuals and the Internet. One of the Internet's defining features has been that the companies and

other organizations that provide Internet connectivity maintain a neutral attitude towards the traffic that they support. Closely related to the "end-to-end" principle and known as "network neutrality," this principle has defined the relationship between the providers of the network and the information that flows through it.[9] Today, however, Internet intermediaries are digging deeper into Internet traffic flows, for political, social, and economic reasons, either at the behest of governments in which they operate or of their own accord.

The starkest example is "bandwidth throttling," which refers to the practice of limiting the speed of information flows based on the type of application or protocol being used. In the United States and Canada, it was revealed that several companies had been engaged in secret practices of bandwidth throttling, discovered after the fact by customers and purchasers of wholesale services. The discovery touched off a major controversy around network neutrality in both countries, with ISPs defending their practices and arguing that the norm of network neutrality was overstated and irrelevant to modern Internet service delivery. Whether that market rationale is legitimate or not, if ISPs are given discretion to discriminate on the basis of the nature or content of communications flowing through the networks they support, the public space of the Internet could be seriously jeopardized. For example, ISPs could favour content that falls only within the corporate family, or limit the speed of information related to competitors. The prospect of throttling for political content, especially in light of state filtering practices noted above, becomes even more ominous. ISP throttling practices and state content filtering identified by the ONI differ only in terms of intent. Indeed, it is now routine in places like Iran, Uzbekistan, Vietnam, China, and elsewhere for ISPs to be mandated to filter access to or remove politically sensitive information.[10]

These threats to network neutrality are amplified by the trend towards cloud computing and the growth of software-as-a-service (SaaS) models of communication, in which an increasing proportion of users' information and communication is dependent on third parties' hosting.[11] Google, for example, has transformed itself from a basic search engine to an email and data storage service company. As more and more user information is deposited into the hands of intermediaries such as these, certain questions—under what conditions will this information be shared or turned over to authorities? when will intermediaries do the bidding of government policy?—become increasingly vital.[12] An ominous example of what

this may portend can be seen in the case of Western firms operating in China. Studies by the ONI and its partners have shown how the U.S.-based service companies Yahoo!, Microsoft, and Google, have all engaged in various forms of self-censorship of their services in order to comply with local Chinese laws and regulations. These include the removal of contentious search terms from search engine results; deletion of offending posts, terms, and other entries from services; and in one egregious case involving Yahoo!, the disclosure of confidential user information to the Chinese State Security Bureau leading to the arrest and sentencing to ten years in prison of journalist Shi Tao.[13]

Not all of the changes to the functions of Internet intermediaries come as a result of pressures from censoring governments. Others arise from market pressures or voluntary self-regulation. For example, many ISPs in the industrialized world have begun implementing filtering systems to block access to pornography that relates to the sexual exploitation of children. In Australia and the United Kingdom, governments have mandated the filtering, whereas in Canada and the United States they have been implemented voluntarily by the ISPs themselves. While few would argue that child pornography is an acceptable form of speech, it is fair to question the *process* by which these filtering systems have been implemented, which in turn could set a dangerous precedent for the filtering of access to other, not-so-clear-cut content categories. In all of the cases mentioned above, the responsibility to determine which websites should be filtered falls largely in the hands of ISPs themselves, with little or no public oversight, transparency, and accountability. As more of the Internet's communications rests with third party intermediaries such as these, and as the principles of end-to-end functionality and network neutrality lose strength and vitality, the threats to freedom of speech and access to information online grow.

From Censorship to Cyberwar

Further degradation of the Internet as a public space comes from the troublesome encroachments of military and intelligence agencies into the global communications commons, developments that have been tracked by the ONI's sister project, the Information Warfare Monitor (IWM).[14] Around the world, states' armed forces are developing sophisticated doctrines for cyber warfare that include everything from computer network attacks to psychological operations. The U.S. Pentagon's recently

launched strategic command for cyberspace, operating under the air force, is perhaps the most formidable, ominously talking about "fighting and winning wars" on the Internet. Although much of this doctrine is classified, a recent article in *Armed Forces Journal* may give a glimpse, making the case for the U.S. armed forces to develop the capacity for "carpet bombing in cyberspace."[15] Although the sheer size and scope of the U.S. military makes its cyber warfare capabilities perhaps the most significant, it is not alone. Dozens of states have developed similar doctrines and methods as part of standard military practice, and numerous non-state actors and even individuals are now capable of launching disruptive electronic assaults.

What this may mean in practice can be fathomed by the recent distributed electronic assault on Estonia, which disrupted the country's 911, banking, and telephone systems for a period of time after that government decided to move a Soviet-era statue. Evidence gathered by the IWM about the assault suggests that although it was likely a spontaneous uprising of patriotic hackers sympathetic to Russian concerns, the event appears to have been at least partially "seeded" by the Russian state, whose actions spiralled out of control like a cyclone in cyberspace. The Estonian case was shortly followed by a similar incident involving Russia and Georgia in 2008. A multi-layered cyber warfare campaign, impacting and involving several countries internationally, accompanied the violent military conflict over the disputed South Ossetia region. The campaign included Georgian information filtering of Russian websites, denial-of-service attacks against government and media sites in several countries with Georgia being the most affected, Web defacements, and telecommunications and cellular phone service disruptions. Although there are unconfirmed suspicions of Russian government seeding here as well, there is evidence that malware commands were posted to Russian blogs and forums that provided codes for Russian individuals to participate in the attacks against Georgian government servers.

The implications for public space of an arms race in cyberspace are profound. Cyber warfare legitimizes the taking down of information sources at their source, denying others deemed strategically threatening the capacity to speak. It opens up a dangerous militarization of the online public sphere of the Internet by permitting state military and intelligence organizations to spread disinformation and propaganda disguised as civil discourse.[16] Although psychological operations in warfare are certainly not unprecedented, today's cyber warfare operations

are of a much larger scale, operating during times of peace as well as during war, and implicating civil society to a much larger degree than in the past through the targeting of civilian infrastructures.[17]

Surveillance: The Silent Strangler

While censorship and cyber warfare eat away at the Internet's infrastructure, a silent encroachment is taking place in the area of surveillance. States' intelligence and law enforcement agencies are increasingly extracting precious information flows through the installation of permanent eavesdropping equipment at key Internet chokepoints, such as Internet exchanges, ISPs, or at major international peering facilities, and combining such information with new tools of reconnaissance drawn from data sources such as CCTVs, satellite imagery, and powerful systems of geolocational mapping.[18] To be sure, electronic surveillance is nothing new, having a long history shrouded with secrecy. Throughout the Cold War, both superpowers assembled globe-spanning electronic surveillance systems that operated in the most highly classified realms.[19]

Today's surveillance systems are much more extensive and penetrating, however, given the permeation of electronic communications in all aspects of modern life.[20] Moreover, as the surveillance systems come out from the shrouds of secrecy, they are being legitimized by permissive anti-terror legislation that removes previous operational constraints. In many parts of the world involving non-democratic states where no such restraints exist in the first place, of course, surveillance is a matter of routine. However, today it is being underpinned and amplified by Western technology companies feeding an ever-growing market for surveillance technologies.[21]

Surveillance weakens the Internet as a democratic public space by creating a climate of fear and self-censorship. It undermines individuals' right to choose what information about themselves is made available to the wider public, casts a chilling pall over public discussions, and in doing so strangles vitality out of the global public sphere.

Protect the Net

Like any other commons, the global communications environment is a finite public good whose maintenance as a valuable resource depends on sustained contributions of individuals worldwide. And yet citizens are

having their legitimate contributions stifled by fickle governments and corporations who are threatened by freedom of speech and access to information. Fortunately, there are many ways to begin to rescue the global communications environment.

The first step is to recognize that the Internet does not have some mysterious magical property that invariably supports democratic communications, access to information, and freedom of speech. Like all technologies, the Internet is not fixed but malleable. It morphs in response to new technological developments and the policies and institutions that govern it. The initial foundation of the Internet was laid with the principles of end-to-end functionality and network neutrality. However, these constitutive features are now under threat. If the Internet as a global public space is to be protected, citizens must recognize that it cannot be taken for granted.

Protecting the Internet can happen at multiple levels, from international regulations down to the writing of code. Too often today software companies who once made their names by wiring the world and connecting individuals are now directing their considerable talents to shutting off those connections, eavesdropping on individuals, and colluding with regimes that violate human rights. Innovation needs to be redirected to technologies that support rather than detract from human rights and that shore up the Internet's distributed architecture. The Citizen Lab has produced one of the more prominent of these tools, the censorship-evading software system called "psiphon"—released as a free and open-source tool on December 1, 2006, and now used by hundreds of thousands of individuals worldwide.[22] Psiphon works by connecting friends and family members across national jurisdictions through social networks of trust and encrypted channels to allow citizens in censored jurisdictions to surf the Internet over an encrypted channel as if they were in an uncensored location. Psiphon is part of a family of such tools, like the anonymity network Tor or the encryption system PGP, whose aim is to protect and preserve human rights online.[23] While these tools hold out great promise, they tend to be underfunded and sustained only by the initiative of grassroots organizations and individuals. Tools that sustain the Internet as a global public space need to be supported by public and other funding mechanisms.

We live in a world deeply saturated by new information and communication technologies; these are the sinews through which power is exercised. In order to not accept such technologies at face value, and to

understand how they work beneath the surface, we need to revise and encourage the original notion of "hacking" as a positive experimental ethic, encouraging citizens—especially youth—not to accept technologies shrink-wrapped and locked down. Today "hacking" is nearly synonymous with criminality, but it was not always so. Originally the term meant someone enthusiastic about technology, experimental in outlook, opening things up and understanding how they work. Unfortunately, stringent intellectual property laws that demonize the experimental ethic have actively discouraged such instincts. The term "hacktivism" refers to the combination of the experimental ethic and explicit political goals.[24] Although some self-described hacktivists promote denial-of-service attacks and Web defacements that are contrary to principles of freedom of speech, the term needs to be reclaimed and properly defined as a bulwark in support of human rights. Hacktivism is as essential to liberal democracy today as was literacy in previous eras. Protecting the Net requires skilled individuals who are able to lift the lid on what happens beneath the surface.

We need to revive, promote, and extend the Internet's original culture of sharing, as represented by Creative Commons, or the free and open-source software movement, as an epistemic bulwark against the possessive and exclusionary instincts of the profiteering motive and the ethos of secrecy.[25] At the heart of these movements is the notion that the infrastructure of the Internet, whether the code contained in a CD or the instructions in a router, should be made as transparent as possible in order to ensure oversight and accountability. Such notions are particularly important in light of the extent to which power is increasingly exercised "under cover," hidden from the communications environment. Open-source software can be likened in this regard to a constitutional check on abuse of power operating at the infrastructural level.

We need to put pressure on governments that censor and the companies who assist them, promoting laws and norms from the domestic to the international spheres that restrain their short-sighted motives and hold them accountable for their actions. Today, the regulatory tide is definitively in the opposite direction, as a suite of legislative initiatives around the world in the national security and copyright domains have broadsided protections for human rights online. However, work by the ONI and others like it has pressured governments and corporations to account for their actions. Instructive in this regard is the so-called Multi-Stakeholder Initiative involving major Internet service

companies and rights groups (including ONI members) that would have Internet service companies adopt a code of conduct that protects free expression and access to information online. So too are efforts to promote global and local charters of Internet governance that enshrine network neutrality as foundational principles.[26]

Lastly, we need to raise global awareness that if we, citizens of the earth, are ever to solve our many shared problems successfully, we need an unfettered planetary communications system with which to do so. For better or worse, the Internet is the foundation for such a system. The only way to ensure that the Internet fulfills its promise as a global democratic public space is to build laws, codes, and ethics that support and protect such principles from the ground up.

NOTES

1 Kim Hart, "A New Breed of Hackers Tracks Online Acts of War," *The Washington Post*, August 27, 2008.

2 L. Kleinrock, "History of the Internet and its Flexible Future," *IEEE Wireless Communications* 15, no. 1(2008): 8–18.

3 Lawrence Lessig and Mark Lemley, "The End of End-to-End: Preserving the Architecture of the Internet in the Broadband Era," *UC Berkeley Law and Econ Research Paper* (October 2000).

4 Jürgen Habermas and Thomas Burger, *The Structural Transformation of the Public Sphere: An Inquiry into a Category of Bourgeois Society* (Cambridge, MA: MIT Press, 1991); L. Dahlberg, "Cyberspace and the Public Sphere: Exploring the Democratic Potential of the Net," *Convergence* 4, no. 1 (1998): 70–84; Diana Saco, *Cybering Democracy: Public Space and the Internet* (Minneapolis: University of Minnesota Press, 2002); and J. Dean, "Cybersalons and Civil Society: Rethinking the Public Sphere in Transnational Technoculture," *Public Culture* 13, no. 2 (2001): 243–65.

5 Ronald Deibert et al., eds., *Access Denied: The Practice and Policy of Global Internet Filtering* (Cambridge, MA: MIT Press, 2008).

6 John Perry Barlow, "A Declaration of the Independence of Cyberspace," *The Humanist* 56 (1996): 18–22.

7 http://opennet.net/

8 Ronald Deibert and Rafal Rohozinski, "Good for Liberty, Bad for Security? Global Civil Society and the Securitization of the Internet," in Deibert et al., *Access Denied*.

9 Paul Ganley and Ben Allgrove, "Net Neutrality: A User's Guide," *Computer Law and Security Report* 22, no. 6 (2006): 454–63.

10 Deibert et al., *Access Denied*.

11 Jonathan Zittrain, *The Future of the Internet and How to Stop It* (New Haven, CT: Yale University Press, 2007).

12 Jonathan Zittrain and John Palfrey, "Reluctant Gatekeepers: Corporate Ethics on a Filtered Internet," in Deibert et al., *Access Denied*.

13 Ronald Deibert, written testimony, "Panel III: Access to the Internet and the Participation of U.S. & Western Firms in Chinese Internet Controls," in *U.S.–China Economic and Security Review Commission* (Washington, DC: U.S. Government, 2008).

14 http://www.infowar-monitor.net/

15 Col. Charles W. Williamson III, "Carpet Bombing in Cyberspace," *Armed Forces Journal* (2008).

16 Ronald Deibert, "Black Code: Censorship, Surveillance, and the Militarisation of Cyberspace," *Millennium* 32, no. 3 (2003): 501–30.

17 A. M. Lungu, "WAR.com: The Internet and Psychological Operations," *Joint Force Quarterly* 28, no. 13 (2001); and Jeffrey T. G Kelsey, "Hacking into International Humanitarian Law: The Principles of Distinction and Neutrality in the Age of Cyber Warfare," *Michigan Law Review* 106, no. 7 (May 2008): 1427–51.

18 Lee S. Strickland, David A. Baldwin, and Marlene Justsen, "Domestic Security Surveillance and Civil Liberties," *Annual Review of Information Science and Technology* 39, no. 1 (2005): 433–513; and Deibert, "Black Code."

19 Jeffrey Richelson, *America's Secret Eyes in Space: The U.S. Keyhole Spy Satellite Program* (New York: Harper & Row, 1990).

20 David Lyon, *The Electronic Eye: The Rise of Surveillance Society* (Minneapolis: University of Minnesota Press, 1994).

21 Naomi Klein, "China's All-Seeing Eye," *Rolling Stone*, May 29, 2008.

22 http://psiphon.ca/

23 Nart Villeneuve, "Evasion Tactics," *Index on Censorship* 36, no. 4 (2007): 71.

24 Deibert, "Black Code."

25 Lawrence Lessig, *The Future of Ideas: The Fate of the Commons in a Connected World* (New York: Vintage, 2002).

26 Milton Mueller, John Mathiason, and Hans Klein, "The Internet and Global Governance: Principles and Norms for a New Regime," *Global Governance* 13, no. 2 (2007): 237–54.

THE CITY AS PUBLIC SPACE

PATRICK TURMEL

CITY IS FULL OF EXTERNALITIES. NOISES AND SMELLS, CONgestion and pollution, loitering and littering, fear and excitement, the everyday encounters with strangers and strange behaviours, the shared use of public spaces and the clash of activities—all produce or result in various forms of uncompensated costs individuals impose upon one another. This ubiquity of externalities, I want to suggest, is in fact part of the essential nature of the city. Indeed, trying to eliminate the gap between the private cost and the social cost of all these activities, or to *internalize* all those externalities—even trying to imagine a hypothetical world in which they are all internalized—would represent a denial of the type of interactions that define the urban environment. City life means never being able to completely retreat from the multiple effects of other people's action and behaviour. This is another way of saying that a city is by definition a public space.

As it has so often been argued, the notion of public space is essentially an urban notion. Inversely, the city is itself the public space par excellence. As Kingwell suggests, "Urban life is public life, the courtyard is the city, and proximity inevitably creates the complicated shared gazes of the unprivate private—which is to say, the always already public."[1] One can read this contribution as an interpretation of this insight, based on the notion of ubiquitous urban externalities.

I

When people litter in a park or drive a car, they produce *negative* externalities: they impose the cost of their action on other users of the park or on anyone stuck in traffic or breathing the polluted air. Inversely, a person's decision to bike to work produces *positive* externalities in the form of cleaner air and more road space for others. Everyone will enjoy the benefits of cleaner air and less congested roads, but the lone cyclist has no way to charge them for providing those benefits.

Externalities are problematic for economists, as they often lead to market failures. When a factory disposes of its waste by discharging it into the atmosphere, imposing the cost of its action on anyone breathing the polluted air, the market is not the solution but the problem. An important condition of an ideal market is that people assume the cost of their action. But under externalities, prices are not optimal. People can do things that make themselves better off, at the expense of others, without compensating them.

But externalities are also problematic for political philosophers. In a just society, citizens should bear their fair share of burdens, but they also have a right to their fair share of the benefits produced by social co-operation. A problem, however, is that a large part of these benefits are *free*. Social co-operation usually works if nearly everyone does their part, but this condition also entails that some can enjoy the benefits of the co-operation freely, without assuming their share of its burdens.

This is why some political philosophers argue, explicitly or implicitly, that justice requires that the norms of social co-operation should be immunized against externalities, that is, against the uncompensated costs that individuals impose upon one another. In other words, the norms governing a just society should not be the result of exploitation, either by free riders enjoying the benefits of positive externalities or parasites imposing negative externalities. Co-operation on terms affected by such externalities would certainly be neither rational nor fair, but would be the result of an exploitive agreement.[2] The idea behind all this is, I believe, easy to grasp: any past injustices should be eliminated in order to secure a *fair* or *just* social scheme.

The problem, when one takes this framework and tries to apply it to urban institutions, is that it is hard to imagine the possibility of internalizing every externality produced in the city. Consequently, and despite a common desire to get rid of them, both economists and political

philosophers still have to come to grips with the idea that externalities are essential to what a city is. Following Jane Jacobs, economists like Nobel Prize laureate Robert Lucas have started to recognize that externalities explain the development of cities, or at least, that they account for their social and economic vitality. As Jacobs explains in *The Economy of Cities*, cities don't have economic power despite their inefficiencies, but thanks to their inefficiencies.[3]

Theorists interested in questions of justice now need to come to the same realization. The question of urban justice is not that of a compromise between justice and the presence of externalities, but that of the conditions of justice given the ubiquity of urban externalities. Trying to eliminate or internalize all urban externalities would be to ignore what a city is, but it would also be to undermine the resources it needs to thrive socially, culturally, and economically. In the remaining of this contribution, I will discuss these two claims and will close on the importance in a just and democratic city for citizens to gain control of urban externalities—that is, of public space.

II

What is a city? This is by no means an easy question. Early in the twentieth century Louis Wirth, founding member of the Chicago School of sociology, proposed a now-classic definition of the city as "a relatively large, dense, and permanent settlement of socially heterogeneous individuals."[4] This is an important definition, one which had an overwhelming influence on generations of urban scholars. Many failed to realize, however, that these criteria can easily mislead if taken separately. For instance, many students of the city have taken density as the best way to define their subject. But, as Louis Wirth had already made clear, density alone is a completely arbitrary criterion if it is not correlated with other social characteristics of the city.[5] A town can be very dense, but not large nor heterogeneous enough to count as a city.

The interesting question, then, is this: what is so special about this complex combination of density, size, and heterogeneity? I want to suggest that this complex mixture expresses itself primarily through an intensification of the effects of individual actions or behaviours on others. It is reflected not only in more important variations between groups and individuals, and between their potential and actual interactions, but, more significantly, in an environment highly welcoming to externalities,

to the point that they become ubiquitous and inescapable. Indeed, the result of having a great number of different people in a relatively dense environment is that the possibilities of getting in each other's way—of *producing externalities*—are almost limitless. In a city, everything is affected by everything else, to the point in fact that its very existence depends on these spillover effects of individual actions and private transactions. The very presence of these ubiquitous externalities, produced by this complex relation between density, size, and heterogeneity, is *the* urban condition. Without such external effects, there is just no city.

To make the point clearer, think about the classic argument in favour of private property. Individuals often find themselves in situations where they can improve their own condition in a way that imposes a cost upon others. But when everyone does this, the accumulated costs may easily outweigh the advantages, leaving everyone worse off than they were to start with. These situations are what we have come to call, following Garrett Hardin, tragedies of the commons, situations where individuals pursuing their own interests undermine a collective good. The original example comes from England, at a time when land was held in common to graze sheep. The problem was that, when people grazed their sheep in the commons, they had an incentive to overgraze, which benefited themselves at the expense of everyone else, and which also wound up generating a collective action problem. This phenomenon occurs every time individuals have an incentive to produce negative externalities but no incentive to produce positive externalities. The classic solution is to break up the commons into private properties, thus, in the original scenario, restricting grazing to each farmer's lot. In eliminating the opportunistic strategy that generates the tragedy in the first place, it fully internalizes the externalities and resolves the collective action problem. An important role of the state is to create institutional mechanisms aimed at securing this kind of agreement or to secure through other means (regulation or taxation, for instance) the internalization of externalities.

The problem is that if one tries to apply this model to urban institutions, it is difficult to imagine that it is possible (or even desirable, as I will try to show later) to internalize every externality produced in the city, that is, to break down the city as public space into multiple private spaces. The ubiquity of externalities—or the impossibility to internalize them entirely—is indeed what defines the urban environment. Thus, by contrast with a classic tragedy of the commons, which does not depend

on the number or on the density of people affected, and which can be neutralized with the help of various institutional techniques without modifying the nature of the social environment in question, urban externalities, characterized by their being the product of this complex combination of density, size, and heterogeneity, cannot be completely neutralized without altering the social entity in question, that is, without simultaneously eliminating the conditions of possibility of the city.

My attempt here is primarily to theorize or to systematize an intuition expressed in various ways by many authors that have written on the city. Indeed, this relation between cities and externalities can help us understand why Rem Koolhaas, in his major work on New York—his "retroactive manifesto" as he calls it—defines urban culture as a "culture of congestion" and describes the built environment of Manhattan as "a paradigm for the exploitation of congestion,"[6] or why Michel de Certeau sees the *real* city—in contrast to that of utopian and urbanistic discourses—as an improper space.[7] I will argue in a later section that one can also interpret Jane Jacobs's work in this vein.

III

The idea that externalities are an essential characteristic of cities should be understood to mean not only that people are always getting in each other's way, but that it is neither possible nor desirable to neutralize all these spillover effects, that is, to internalize all the externalities that cities generate. The point is not simply that individual actions are not isolated and that they affect other people's lives. This would be a rather banal claim, and not one that is particularly specific to cities. The claim here is that the existence of the city depends on the presence of externalities and that urban institutions might even sometimes have to intervene to protect them.

The reason urban externalities are not only a condition of cities, but can also be desirable, is that they account for cities' social, cultural, and economic vitality. Urban externalities are what make great cities. They give cities their atmosphere, their creative and innovative burst—think of Richard Florida's idea of a creative class whose members are basically looking to take advantage of other people's presence, actions, and behaviours.[8] These qualities of the city can never be the direct result of planning. The atmosphere of a neighbourhood, for instance, cannot be the product of someone's intention. It is always the result of uncoordinated

actions. But even if this can't be planned directly, urban institutions and the built environment of the city will necessarily play a major role in how urban externalities thrive and the directions they take. Thus, instead of aiming at internalizing all externalities, an important function of urban institutions might be to secure or even encourage the production of some *urban* externalities, while minimizing their negative effects (or what can be perceived as such).

This conclusion can look surprising, since the city is usually associated with numerous *negative* externalities: car horns and neighbours' music, congestion and pollution, crowds of people walking, shouting, bustling, littering, shoving, and so on. A popular and largely shared vision of the city is that of a polluted, dangerous, noisy, and alienating place; thus, the role of good urban institutions should first be to fight these evils and to protect individuals against other people's actions, instead of encouraging these spillover effects.

My point is not that externalities found in cities have a different structure than those we usually find in collective action problems. Cities are indeed full of these situations where individuals have an incentive to produce negative externalities but no incentive to produce positive externalities. Consequently, it is possible to solve many localized collective action problems or to internalize various externalities in the city through a classic institutional mechanism such as regulation or taxation. Road taxation, for instance, was proven in many places to be an efficient means of dealing with congestion.

Historically, cities have accomplished a great deal in the elimination or internalization of negative externalities. We too often forget that the air in large cities is much cleaner today than it was just a few decades back. The urban quality of life in general is also without comparison to what it was centuries ago. One should not forget that up until the development of sewage systems in the nineteenth century, it was normal for inhabitants of a city to throw their garbage and excrement out on the street. What people experienced on a daily basis would seem to us simply unbearable, but for them, these smells and sights were part of urban life. As Paul Seabright writes with regard to ancient Athens, this city "was remarkable for the contrast between the grandeur of the Acropolis and the squalor of its residential streets, but only by a very modern eye would the squalor even have been noticed."[9]

The evolution of cities goes hand in hand with a constant striving to solve these various collective action problems, to get rid of all sorts

of negative externalities. And there is no doubt still plenty of room for improvement (think about urban sprawl). But it is impossible to control or to trace the effects of all types of externalities in cities. It is difficult, for instance, to imagine that the institutional mechanisms we can resort to in order to internalize externalities would really solve all collective action problems specific to cities and their various public spaces. The problem with urban externalities is that they tend to escape objective evaluation. It is hard to determine whether they are positive or negative. Indeed, the evaluation of these externalities largely depends on the subjective preference of the urban dweller or on the context in which he or she experiences the externality.

One can think about neighbourhoods that will be given up and avoided by the general public but that will often attract and be valued by artists and bohemians, who will bring life, and value, back. Trying to "clean" these places, to eliminate what is seen by many as nests of negative externalities, would undermine important resources for the social and economic vitality of cities. The same goes for "aesthetic externalities." For instance, what some people consider architecturally pleasing others see as an insult to the eye. These externalities are not peculiar to the city, but many urban externalities certainly take this form. Think about the kind of public controversies generated by urban-renewal projects of the postwar years and onward, such as public housing or revitalization of old industrial districts. These large-scale urban projects always seem to impose a controversial vision of the good neighbourhood, the good public place, or the good city. Examples of such controversies abounded in the last few decades, but the classic of the genre remains the destruction by Baron Haussmann in the nineteenth century of numerous old, and mostly slummy, Paris neighbourhoods, in order to impose a highly controversial plan of urban renewal centred around the Grands Boulevards, a plan which still raises passions today. Dutch architect Rem Koolhaas shows a clear understanding of the nature of these controversies in writing that "the Zoning Law is not only a legal document; it is also a design project."[10] A design project, or an aesthetic proposition more generally, by its very nature rarely generates unanimity.

The evaluation of externalities, however, does not only depend on preferences. It can also vary for an individual, in function of the context in which he or she experiences these externalities. When I was a graduate student, I lived in a neighbourhood filled with frat houses. Living in such a neighbourhood can be bothersome, especially on those nights

when I wanted to go to bed early. But I always benefited from animated, and therefore safer, streets when coming home late. Thus, even though one generally associates cities with a series of negative externalities, many of these are intertwined with all sorts of positive externalities, that is, with a series of resources essential to what a "good" city is. Indeed, among other reasons, one comes to the city in order to take advantage of these "free" benefits, these positive externalities produced by diverse and lively streets, by artists and various cultural resources, by numerous sources of excitation and surprises that can also generate their fair share of negative externalities, depending on the perspective one adopts.

This Janus-faced feature of urban externalities is, according to Iris Young, a virtue of city life. She calls it the eroticism of city: "the pleasure and excitement of being drawn out of one's secure routine to encounter the novel, strange, and surprising."[11] This "virtue" of city life captures the idea I'm trying to put forth here, according to which negative and positive urban externalities are often nothing more than the two faces of the same coin. It explains why the city attracts people and scares them away at the same time. There is something threatening in city life that puts into question the stability of our identity, but there is also something exciting about the experience of difference it offers. Each neighbourhood, for instance, proposes a unique experience, with people from different horizons, origins, or cultures constantly bringing us to face realities that are not ours. For Young, this virtue of the city is also the product of its built forms, of the variety of its architecture, the juxtaposition of ages, styles, and uses. In all of these cases, it is almost always impossible to attempt an objective evaluation of the externalities thus produced, that is, to determine, independent of context or individual preferences, whether they are positive or negative.

Cities are thus defined by externalities, but also by the fact that positive and negative externalities are intertwined and blurred. For this reason, success in eliminating negative externalities could very well carry with it the unintended effect of also eliminating positive externalities, the very group of resources that accounts for the social, cultural, and economic vitality of the city. A great city depends on the grace of its problems.

IV

Nineteenth-century French writer and humorist Alphonse Allais proposed to move cities to the country in order to free them from all of these nuisances that they are commonly associated with—noise, smells, crowdedness, pollution, stress—and to bring them closer to the *plaisirs champêtres*, the joys of country life. Of course, we understand that the city is all of these things. These problems are what distinguish the city from the country. But even in jest, Allais did capture something important about the zeitgeist. A common hatred of the city and a romantic desire for open space was indeed the order of the day.

This anti-urban trend was made most explicit in the works of modern architects and urbanists, who had been profoundly marked by their experience of the dirty and unhealthy industrial cities of the turn of the twentieth century. Ebenezer Howard with his Garden City, Le Corbusier with his *ville radieuse*, and Frank Lloyd Wright with his Broadacre City were all in one way or another trying to free the city from all its externalities: by bringing nature back into the city through the creation of large urban parks or green belts; by getting rid of, or at least in hiding, the streets; and by preventing mixed-use neighbourhoods, making sure that residential areas would not be contaminated by commerce or industry. There was also the assumption that other people are necessarily evils and that we should limit exposure to these others through strategies of isolation or protection of private life. Most importantly, the common purpose of these architects and urban planners was to achieve or impose a rational and unadulterated *order* on the city. Among the great figures of modern urban planning, Le Corbusier is probably the one who pushed this rationale the furthest, offering a radical rejection of history and architectural traditions, even proclaiming the death of existing cities, which offer an image of chaos, Le Corbusier writes in *La Charte d'Athènes*.[12]

So, their aim was primarily to eliminate a series of negative externalities associated with cities—noises and smells, invasion of private life, congestion, urbanistic and architectural chaos. In many ways, their intentions were praiseworthy. Most cities at the time were insalubrious. The problem is that the hope of modern urban planners to reach their goal by the neutralization of spillover effects, by a strictly functional division of space, and by the efficiency of circulation, was based on a complete ignorance of the role played by externalities in urban dynamics. The development of externality-free cities would have the indirect and negative

consequence of eliminating numerous positive externalities that are central to city life.

Jane Jacobs's forceful criticism of modern urban planning in *The Death and Life of Great American Cities* seems to be grounded in a similar intuition.[13] The strategies of modern urban planners who try to eliminate negative externalities that run through cities end up undermining a series of resources that are essential for the social, cultural, and economic vitality of cities. According to Jacobs, good neighbourhoods, like her own Greenwich Village, are densely populated and have many streets, not many parks, and a stock of old buildings; they mix together in a disorganized fashion residential units, businesses, and other working places. From the viewpoint of the modern planning curricula, they are slums and should be replaced by well-ordered neighbourhoods organized around the park, not the street. What Jacobs has helped us see, however, is that these "bad" neighbourhoods, with all their grit and mess, are socially, politically, and economically much more dynamic than the urban projects built according to the principles of urban modern planning. As Jacobs remarks, in these dense and diverse neighbourhoods people spend more time on the street, discussing, loitering, or just enjoying what she calls the "ballet of the street." One of the reasons, but also one of the consequences, is that the streets and public spaces are much safer and more welcoming in these neighbourhoods than in the well-ordered public spaces of suburbia or of large urban projects. The popularity and safety of these streets is a positive externality, a by-product of people's actions.

This idea was most famously captured by Jacobs's notion of "eyes upon the street." This is the now well-known idea that streets are safer when they attract people, when more people are on them. The intuition is that streets can be controlled and policed by the mere presence of people using them, with different purposes and at different times of the day. In this perspective, mixed uses (residential, work, leisure) secure frequent public encounters and thus become informal mechanisms of surveillance. Streets should therefore be organized in such a way as to encourage as many people as possible to use them, at nearly all hours, who will witness all activities, thus making it safer, attracting even more people, who will in turn police it. There are many ways to encourage this virtuous circle and the presence of eyes upon the street: by making sure that buildings are not offering a blind façade (that they are oriented toward the street, not the backyard); by making sure that residents witness and

care about what's going on outside, in public; by having places like shops and restaurants with active building fronts that also give people a reason to use the sidewalk.

In other words, we can't force people to use and police the street or to take responsibility for what's going on in public, but we can plan the public realm in such a way as to make sure that people will effectively be brought or encouraged to produce these positive externalities that not only make for safe and exciting streets, but also foster social networks, civic trust, and, potentially, a genuine sense of community life.

V

I discussed two claims in this contribution: that the ubiquity of urban externalities—the multiple effects of other people's actions and behaviours—is an essential part to what a city is, and that it accounts for what make cities great. But what does it all mean from the perspective of urban justice?

The first thing to notice is that the way we talk about justice should change when we take the city, rather than the state, as the subject of justice. It does not mean that the city is not affected by more traditional problems of social justice. It is. But it is important to draw a distinction between issues of *social* justice, which are primarily concerned with questions of equality, and issues of *urban* justice, which are concerned with the city as public space. Theories of (distributive) justice often assume that it is possible to quantify everyone's share. Once everyone's situation is fair or just (according to our favourite principles), further costs and benefits are simply managed through exchange or consumption. In cities, however, "money" is neither the only nor the most important quantifier when determining the way people are treated, since an important number of essential costs and benefits don't take the form of exchange, but of (urban) externalities.

In this context, an important role of urban institutions can be understood as the attempt to secure and sometimes encourage the production of some urban externalities while minimizing their negative effects (or what could be perceived as such). Urban planning could then be thought of as a way to pursue and take advantage of the numerous positive externalities of the city. But, as I suggested, it can be very difficult to evaluate urban externalities—that is, to determine whether they are positive or negative. Since there is no objective and definitive answer

to the evaluation of urban externalities, it can be hard, and sometimes impossible, to eliminate negative externalities without eliminating the positive ones. Instead, the control and directions of externalities has to be constantly negotiated, making urban public space particularly conducive to conflict. Any urban planning decision will favour a certain pattern of externalities that quickly becomes entrenched and that will tend to remain stable, even though it will rarely generate unanimity.

The ubiquity and the ambiguity of urban externalities, then, pose a serious challenge for justice, but they do not in themselves undermine the possibility of a just and healthy urban public life. The threats arise when people lose control of the externalities, and the repeated complaints about surveillance, homogenization, domination, or commercialization of public space can all be in one way or another attributed to this symptom. In a just and democratic city, however, citizens need to be in control of urban externalities—that is, of public space. The negotiation of space and the control of any urban externality should not be left to a particular group—be it politicians, advertisers, or developers—and urban institutions should be organized in such a way as to prevent it. In other words, urban institutions should provide mechanisms to keep negotiation of the city as public space and the directions of externalities alive and fair.

NOTES

1 See Chapter 1 of this book for Mark Kingwell's "Masters of Chancery: The Gift of Public Space."
2 This way of wording things is due to David Gauthier, *Morals by Agreement* (Oxford: Oxford University Press, 1986). The basic intuition here is that it does not make sense to talk about justice if externalities are ignored. When it comes to the basic institutions of society, everything needs to fall within the scope of the social contract. Basically, rational contractors could not come to an agreement about the division of society's benefits in the presence of uncompensated externalities, since they would naturally demand that these external effects be included within the scope of the agreement.
3 See Jane Jacobs, *The Economy of Cities* (New York: Vintage Books, 1969), 85–121.
4 Louis Wirth, "Urbanism as a Way of Life," *The American Journal of Sociology* 44, no. 1 (1938): 8.
5 Ibid., 5.
6 Rem Koolhaas, *Delirious New York: A Retroactive Manifesto for Manhattan* (New York: Oxford University Press, 1978), 10.

7 Michel De Certeau, *L'invention du quotidian*, vol. 1, *Arts de faire* (Paris: Galli-
 mard, 1990), 139–42.

8 See Richard Florida, *The Rise of the Creative Class ... and How It's Transform-
 ing Work, Leisure, Community, and Everyday Life* (New York: Basic Books, 2002).

9 Paul Seabright, *The Company of Strangers: A Natural History of Economic Life*
 (Princeton, NJ: Princeton University Press, 2004), 114.

10 Koolhaas, *Delirious New York*, 107.

11 Iris Marion Young, *Justice and the Politics of Difference* (Princeton, NJ: Prince-
 ton University Press, 1990), 239.

12 Le Corbusier, *La Charte d'Athènes* (Paris: Éditions de Minuit, 1957), 95.

13 Jane Jacobs, *The Death and Life of Great American Cities* (New York: Modern
 Library, 1993).

... walks from the office for soft architecture
from *Occasional Work and Seven Walks from the Office for Soft Architecture*

LISA ROBERTSON

First Walk

NCE AGAIN THE PLAQUE ON THE WALL HAD BEEN smashed. We attempted to recall the subject of official commemoration, but whatever we said about it, we said about ourselves. This way the day would proceed with its humiliating diligence, towards the stiffening silver of cold evening, when the dissolute hours had gathered into a recalcitrant knot and we could no longer stroll in the fantasy that our waistcoats were embroidered with roses, when we would feel the sensation of unaccountability like a phantom limb. But it is unhelpful to read a day backwards.)

My guide raised the styrofoam coffee cup as if it were the most translucent of foliate porcelains. During the instant of that gesture morning was all recollection, vestige—something quite ordinary to be treated with love and intelligence. From our seat on the still, petal-choked street we re-conjured the old light now slithering afresh across metropolitan rooms we had in our past inhabited: rooms shrill and deep and blush and intermediate, where we had felt compelled to utter the grail-like and subordinated word "rougepot" because we had read of these objects in the last century's bawdish books; rooms with no middleground, differently foxed as certain aging mirrors are foxed; shaded rooms pleasure chose; shabby, faded rooms in which, even for a single day, our paradoxical excitements had found uses and upholsteries; rooms of

imbrication and elaboration where we began to resist the logic of our identity, in order to feel free.

And specifically we recalled the small pinkish room above the raucous market street, the room whose greenish sconces had seemed to transmit new conditions for an entire week. This was the room where, in first light, a rhythm was generating some sort of Greek Paris, the room where, still-too-organic, we discovered we could exude our fumbling as a redundant architecture.

My guide deliberately swirled the final sugars into the steaming fluid in the cup. "The fragile matinal law makes room for all manners of theatre and identity and description of works, the tasting and having, bagatelles, loose-vowelled dialects—lest we get none in paradise." We rose from the wooden bench. We felt limber and sleek and ambitious: Ready. We agreed to prepare the document of morning.

When we built our first library it was morning and we were modern, and the bombed windows admitted morning, which flowed in shafts and tongued over stone. Paper documents had been looted or confiscated; new descriptions became necessary. Twelve pixilated scenes from the life of a teenager replaced walls. The pigments were those of crushed weeds under skin and just for a moment we left our satchels leaning on the font.

The satchels, the pixilation, the confiscations: What actually happened was a deep split, deep in the texture of mortality. We had been advised in the morning papers that there was no longer a paradise. Hell also was outmoded. That is why we were modern. We built this library with an applied effort of our memory and its arches were the chic curvature of our tawdry bead necklaces turned up on end. We laced its hollowness with catwalks, to make use of our intellectual frivolity. We could survive on these catwalks, slung across the transept, the emptied stacks, the nave, the richly carved choir, dangling our little blight plastic buckets for earthly supplies, and the bombed windows served as passages for our smoke. Always we were waking suspended in this cold library, as our neighbours were waking on their own narrow scaffolds and platforms, performing their slow, ornamental copulations, and we called our matinal greetings like larks.

It was a preposterous reverie, borrowing several of its aspects from stolen engravings we had seen and coveted and surreptitiously slit from expensive books in order to furnish the numerous inner pockets of our coats. But we felt some sort of use had to be made of the abolished

heaven. Since it was redundant, now we could colonize it. Ours was a *fin-de-siècle* hopefulness, which bloomed in tandem with its decay.

The resting point of our long avenue was the shipyard with its jaunty assemblage of stacked containers. We talked of the bare co-mixture of stuff and life in the stacked hulls of freighters, strangers shipped anonymously in containers among their dying and dead. We had read of this also in the papers, how in the city's ports the wracked individuals had been prised or extruded as mute cargo, living or dead. They had attempted to migrate into experiment. The rhetorics of judgement and hope are incommensurate. We spoke of these rhetorics because morning is overwhelmingly the experiment of belief. We rise into the failed library of *civitas*. We agreed for the moment not to speak of the nature of the individual tether, the institutes and lordships and instituted shortages, and certainly this agreement marked our complicity with the administration of shortage. But we did not know any other way to go on. We in no sense expect to be excused from judgement because, our own ancestral arrivals having receded into the billboards and whitewash of public myth, we cannot fully imagine the terribly anulled waking of strangers buried in the lurching hulls of ships. We wished also to include in the document our willful ignorance and forgetting, not to ennoble them but because they exist in a crippling equivalence with the more doctrinal sentiments, such as pride and shame.

There we were, nudging the plentiful chimera of the foreground, maudlin and picturesque in our rosy waistcoats and our matinal etiquettes—please?—of course—if only—my pleasure—dawdling into the abstract streets. Or let us say that we were the scribbled creatures who received the morning's pronouns and applied them quixotically to our persons. Perhaps morning simply helped us to feel somewhat pertinent.

Clangour of the rising grates of shops, rattles of keys, the gathering movements in the clearer warming air, rhythmic drawl of trucks of stuff, skinny boys in aprons dragging bins of fruits, shut markets now unpleating themselves so that the fragile spaciousness leafed out into commodities. And this played out to the familiar accompaniment of the sub-melodic birds of our region, striving away in the boulevard trees. Yet we could in no way say that the hour was a development towards a phantom differentiation: already it contained everything, even those elaborately balanced sentences that would not reveal themselves until noon, even the long passivities, even the lilac suckers at night plunging

up. We consulted the morning as a handbook of exempla as outmoded as it was convivial.

And what did we acquire through the consultation? Was it dignity or the final limpid understanding of a fashion in love? Or was it a hint of that suave heaven made from Europe (slightly mannish, famous for violets and roses, extra-refined and commodious with stuff)? Obviously we were confectioners. At least we were not hacking with random anger at the shrubbery and the absences, dulling our instruments. Yet we envied that capacity for anger we witnessed in others. Our own passions often prematurely matriculated into irony or doubt, or most pathetically, into mere scorn. We consulted morning also because we wanted to know all the dialects of sparkling impatience, bloated and purple audacity, long, irreducible grief, even the dialects of civic hatred that percolated among the offices and assemblies and dispatches. We wanted knowledge.

We entered this turbulence in our document as a blotted, perky line, a sleazy glut and visual crackle in gelatinous, ridged, and shiny blacks, an indolent pocket where self and not-self met the superb puberty of a concept. We understood latency, the marrow. We watched girls with briefcases enter the architecture, the ones we had seen juggling fire in the alleys at night. Morning is always strategic.

Inextricably my guide and I were moving towards lunch, our favourite meal.

Second Walk

Habitually we walked in the park late afternoons. Slowly the park revealed to us the newness deep within banality. This was the city where the site oozed through its historical carapace to become a paradoxical ornament. In this way the emblem of the park could appear anywhere on our daily routes, insinuating itself deviously within the hairline cracks in capital as we ourselves were apt to do. Amidst persistently creeping foliage we would tease out wiry angers and saccharine tenderness mixed, in this manner both flaunting and secreting our souls. In any case we were radically inseparable from the context we disturbed. It was as if everything we encountered had become some sort of nineteenth century, this long century that encroached so splendidly on much of July. We would lean on its transparent balustrade, rhythmically adjusting our muted apparel, waiting somewhat randomly to achieve the warmth of an idea. But you should not assume that my guide and I were entirely

idle. Waiting was many-roomed and structured and moody and we meas-
ured, then catalogued, each of its mobile affects. We dawdled morosely
in the corners of waiting, resenting our own randomness. Or we gar-
nered our inherent insouciance towards the more subtle sediments of pas-
sivity. But it is hard to make remarkable faults in a spiritual diorama. Only
slowly did contrary dreamings appear. Only slowly did we come to see
our own strolling as a layered emergency: we recognized that we were the
outmoded remainders of a class that produced its own mirage so expertly
that its temporal disappearance went unnoticed. We found ourselves
repeatedly original. The diva, the waves, the hotel, aroma of apples—
these were structures in us. How like lyric we had been. Here, then, was
the warmth, here the awaited idea. We were equally maligned and arro-
gant, performing our tired doggeries against a sky inlaid with phrases.
We were of the lyric class.

Ours had been a rarified training—haute décor of dragonfly on cir-
rus, the crickets shriller. Our favourite objects were spoons. The eroti-
cization of a privileged passivity twisted, turned, passed, and remained.
Inexplicably both prim and sensuous, we drifted then and gamboled in
puffs of golden dust. We were meant to be starlets. But since that time
our grooming had undergone much revision. This rigged our vernacu-
lar also in a sort of lapsed trousseau. We now called our garments shifts
or shells or even slacks. As the lyric class indeed we pertained to all that
was lapsed or enjambed. Even our pathologies were those of a previous
century, as when beside the daily marital protocols, lovefights wake a
neighbourhood. Remember lovefights? Nor could we act and change
deliberately: although we desired fine clothes and freedoms on the patio
of late modernism, what our passivity achieved or attracted were the
fallen categories of experience—the gorgeous grammars of restraint,
pure fucking and secrecy and sickness, mixtures of unclassifiable actions
performed in tawdry décors, passional sincerities and their accompa-
nying dialectics of concealment and candour, cruelty and malice, the
long, ill-recalled choreographies of greeting and thanking, memory.
Our agonies were farcically transparent and public. Yet those fallen cat-
egories, seemingly suspended in some slimy lyric harness, came to ani-
mate and rescue our bodies' role as witness, witness to the teaching and
fading cognitions of the park.

Here, on the clipped margins of the century, in our regalia of mud-
freckled linens, and with our satchel of cold provisions, we needed to
prove to ourselves at least that although we had no doubt as to our lyric

or suspended status, we were eager to be happy. We wanted to be the charmed recipients of massive energies. Why not? Our naïveté was both shapeless and necessary. We resembled a botched alfresco sketch. Who could say that we were a symmetry; who could say that we were not?

Previously I mentioned the spiritual diorama. Just for the satisfaction, I'll repeat myself. "It is hard to make great and remarkable faults in a spiritual diorama." We knew our happiness was dependent on such faults—proportional errors, say, which expanded the point where the passional and the social meet, or the misapplied tests for chemical residues, which revealed only the critical extravagance of our narcissism. Yet our attraction was inexplicably towards the diorama. The glittering attires and airs of summer began to vitrify so that we felt ourselves on the inside of a sultry glass, gazing outwards towards an agency that required us no more than we required the studied redundancy of our own vocabulary. Hope became a spectacle, a decoration. Anger was simply annulled. All that we could experience inside the diorama was the fateful listlessness usually attributed to the inmates of decaying houses, or to the intolerable justice of betterment, the listlessness of scripted consumption. It was innocuous and pleasant, but it did not move.

Thus, the park. The bursts of early evening rain would thrust the foliage aside and shape a little room for us, promising truant privacies. Fragments of a hundred Utopian fantasies of one sort or another mingled with all the flicking and dripping. My guide would utter gorgeous nonsense limply to intrigue and tickle me, such as "Swinburne couldn't swim" or "Seeing is so inexperienced." Is it possible to persuade towards disassembly? For such a persuasion is what the park performed upon us, loosely, luxuriantly, but not without malice. If the park were a pharmaceutical, it would be extruded from the stick of an herb called mercury; if it were a silk, its drapery would show all slit-film and filament printed with foam. If it were a velvet (one of those worn ones that shrinks or adheres like a woman's voice with ruptured warp and covert intelligence); if it were a canvas (all ground and flayed beyond the necessity for permanence). We were meant to inquire "whose desire is it?" and we did inquire, of the lank dampness, the boulder tasting faintly of warm sugar, of the built surfaces also, such as benches and curbs—we inquired but we were without the competence to interpret the crumbling response. And the tattered cloud and leaf tatters transferred to us sensations that we did not deserve. In the park, our generous government had provided conditions for the wildest fantasy—but what we repeatedly released

ourselves into were the rehearsed spontaneities of poverty fables, the erotic promise of acts of disproportion and spatial discomfort, dramas of abandonment, the commodious weaving and bleaching of screen-like stories, as if we were to one another not amorous colleagues but weird sockets of uncertain depth.

"Our happiness" "our naïveté" "our attraction" "our regalia" "our humiliation" "our intention" "our grooming": this is the habitual formula I have used. While normally such a grammar would indicate a quality belonging to us, in this landscape the affects took on an independence. It was we who belonged to them. They hovered above the surfaces, disguised as clouds or mists, awaiting the porousness of a passing ego. By aethereal fornications they entered us. We had observed the images and geometries of such intercourses in the great galleries, print rooms and libraries of our travels, but here we ourselves became their medium. And as in those galleries, the affects that usurped or devised us were not all contemporary. The park's real function was archival. Dandering here, a vast melancholy would alight upon us, gently, so as not to frighten, and the pigmented nuance of a renaissance shadow eased its inks and agitations beneath our skin. Or we were seized by a desperate frivolity, plucked up, cherub-style, into marooned pastels and gildings. We foxed the silver mirrors up there and absorbed the nineteen meanings of the flexure of the human wrist. Or a fume would swathe us in the long modern monochrome of regret. I insist that we did not choose to submit to these alienations and languors. It was they who chose us. "No space ever vanishes utterly," said my guide.

If I have mistakenly given the impression that my guide and I were alone in this vast parkland, it is because our fractured emotional syntax rendered us solipsists. In fact the park was populated by gazes. They swagged the sites where desire and convention met. Now we found an advantageous perch on a marble kerb near the plashing of a minor fountain. We unfastened our satchel; we intended to nibble and observe and refract. We ate two champagne peaches. A gamine laced in disciplined Amazonian glitter strode past. Her trigonometric gaze persuaded us entirely. Clearly she was not mortal. We chose a fig and discussed how we approved of arborists—here the specifically Marxian arborist emerged from among branchwork like an errant connotation. With our pearly pocket knife we cut into an unctuous cheese and again the clouds tightened and the lilies curled and the little child ran cringing from us to its mother. We ate the cheese. "Hey, cobweb," a soldier called out, and the

light fluxed in patterns of expansion and contraction. Oh, and the long leonine gathering from the green eyes of the womanly boy, his essence feathering, his gestures swelling, his fabrics purely theoretical. No interpretation could extinguish this. When we methodically compared him to what we already knew of boyhood—the strange dialect, the half-finished sentences, the exorbitant yearning for certitude—we experienced the delirious bafflement of a double pleasure, a furious defiance of plausibility. But the plausible would never be our medium. And then the ranks of slender bachelors frantically propelling themselves in too-crisp suits towards the chemical alleviation of loneliness, so frantically that they could not glance, could not comprehend the invitation of the glance, so that to them we were naught. And then the merely dutiful glance of the courier, which halfheartedly urged us towards a bogus simplification, and then the she-theorist sauntering purposefully from her round hips, her heavy leather satchel swinging like an oiled clock. Her saturate gaze demanded secret diplomacy, public contrition, and intellectual disguise, so that we blushed and were flung among swirling canals, sleaze, simulated musculatures, collective apertures, gaudy symbols, kits of beautiful moves and paper parts, vertiginous scribbles and futurist hopes. The she-theorist knew something more crimson than place. We felt suddenly and simultaneously that we should hire a theorist to underwrite our fantasies, the thought communicating by the mutually nervous adjustments of our carefully tousled coifs. She passed and we became tenants of a dry season, professionless. Her hazel gaze had informed us that we merely frolicked in semblance. Our pencil spilled across the silent path. A black panting dog loped past. And so on.

The gaze is a machine that can invent belief and can destroy what is tender. In this way it is like an animal or a season or a politics, or like the dark bosco of the park. Our scopic researches aligned us, we liked to think, with the great tradition of the natural philosophers, for whom seeing was indeed and irrevocably inexperienced, and wherein the admission of such inexperience served as an emblem or badge of belonging. What can we claim about the park, about the sorrows that are and were not our own? Nothing. We simply sign ourselves against silence. But the gaze and our researches upon it might yield a medium for a passional historiography, building with their interpenetrations a latticework for civic thought. We remembered the free women moving from city to city eating fruits in their seasons previously. To be those women, their feminine syllables bristling, to be a modernist declining the spurious

hybridizations and pollutions that we intermittently adore and repudiate, to cup a superb expectancy in a sentence, to make with our hands a sensation that is pleasant and place in it then a redundant politics: this is not quite it. But as researchers we were bound to scrupulously visit each potential explanation for the scopic piety we so cherished. Admittedly it was a relief when we found the explanation lacking. For to continue with our researches was our strongest wish. The inevitability of failure became our most dependable incentive. And as we strolled through the park to accomplish our speculations always we wondered—were we inside or outside the diorama?

Sixth Walk

I feel I can look through the paintings and narrations, the sentences and devices of knowledge, the pleasure and melancholy, through the strange windows with their yellow light and shadows and curtains in the style of someone else's childhood. I can begin to see through another's technique of forgiveness or introspection.

When I started off towards my guide the bridge seemed to be made of astonishingly tawdry materials. Branches, twine, tiny mirrors, smashed crockery, wire, bundled grasses, living fronds, pelt-like strips, discarded kitchen chairs of wood their rungs missing, sagging ladders, bits of threadbare carpet, cheap shiny grating, rusted metal strips, gilded frames of nothing, lengths of fraying sisal rope, straw mats unraveling, limp silken roses on green plastic stems, tattered basketry, twisted papers, flapping plastic tarps lit from beneath, woven umbrella spokes, stray asphalt shingles, stained toile de Jouy curtains their wooden rings rattling, a ticking cot-mattress bleeding straw, swollen books stuffing the chinks of the swaying sounding structure, everything knit as if with an indiscernible but precisely ornate intention which would never reveal the complexity of its method to the walker. This was not a bridge I would have chosen to cross. I awoke already embarqued on the superb structure. There was nothing to do but continue. What the bridge passed over changed as I walked. At first, rivers of motor traffic hissing on a black highway, this with the skewed strangeness of a foreign highway, sulfur headlamps occasionally emblazoning the trembling bridge, which by then had become a cradle of slung planks, their wrist-wide gaps admitting blue-black silence of a forest, punctuated with the snapping and crashing of branches and odd whistlings in the wind, which rocked me also.

I believe that solitude is chaos. I believe that the bridge came to be swathed in undulating stuff, unknowable fibres that fluctuated like the dendrites of nerves, in response to the minute flickering of thought and light and things astral as well. My fingers stroked its pure oscillation. There was a sensation of cushioning, of safety, which at the same time was not different from chaos—as if unknowable varieties of experience would be held gently, suspended in an elastic breeze. What this experience was I can't say—it was held by the bridge the way sleep is contained by the person. Solitude and sleep are autonomous and festal. Gorgeous structures cradle them. We can approach the structures but not the substance, which is really more like a moving current. Then the rippling of fibres converted themselves again to foliage, as all speech converts itself to foliage in the night, and I felt this rippling simultaneously all over my skin. It was not necessary to differentiate the sensations of particular organs or leaves since this rippling unknit the proprieties and zones of affect—the entire body became an instrument played by weather and chance. We are so honoured to live with chance.

I wished for my guide to join me on this bridge. I dawdled and sauntered and loitered at its sultry interstices. In expectation I adjusted my maudlin garments and touched my hair. Everything around me unbuttoned. Did I cause this? Perhaps it was dawn, or something lucid. Animals were crossing. Mules and dogs and cattle. Children too. Bicycles with devilish horns. The bridge-urchins were at their card games and games of dice. Some of us were men and some were women. Some of us cheated. And in this matter also it was not necessary to differentiate. Some wore secular velvets and I touched them in passing, then uttered the velvet syllables. We carried wrapped packets. Some scattered papers. Some would sing. Maybe one was my guide. I called out not knowing if my voice would arrive. The harsh or worried sound simply blended with the frequency of motion. Was it a name? What could I hear or follow? The bridge was gently swaying; I wished to receive and to know my guide. But stronger and newer and more ancient than that wish was the barely recognizable desire to submit to the precocity and insecurity of the bridge itself.

Imagine a very beautiful photograph whose emulsion is lifting and peeling from the paper. There is no longer a negative. To preserve it you must absorb this artifact through your skin, as if it were an antique cosmetic comprised of colloidal silver. You must absorb its insecurity. Imagine the post-festal table, rinds and crusts and pink crustacean shells and

crumpled stuff smeared with fats and juices, the guests gone, for a moment the raw morning utterly silent, your shirt stained with the wine, your face pulsing with the specific sadness of something you won't know. Imagine a sound with no context. Only that emotion. It is not called doubt.

Context has become internal, rather than hovering as a theatrical outside. Like new cells speak us. We call itself a name. We call it change and beautifully it's swaying as the new electrical patterns fringe our sight. Everything is tingling. We forget about Europe. It won't hurt soon. Soon we will relax. We will walk above polders and marshes and roads. The clouds are real or painted.

Seventh Walk

We had been at our physical exercises. Now we entered into the late civic afternoon. The scissoring metres of the apparatus had left us lucid, distant, and extreme. Cool air parsed our acuity. Although we indeed sauntered in the street, through the grey discourse called human and concatenations of rain (in short, in the mode of the ordinary), my guide and I perceived as from a vast temporal distance an impertinently muttering tide of ambitions and ticks. It was our city. We recognized the frayed connective cables sketched by words like "went" and "pass," the sacral nostalgias fueling violence and the desiring apparatus of love. Utopia was what punctuated the hum of disparities. Utopia: a searing, futuristic retinal trope that oddly offered an intelligibility to the present. We saw that we could lift it and use it like a lens. We observed guys in their cities, guys in their cities and their deaths and their little deaths and mostly what we coveted was their sartorial reserve, so marvelously useful for our purpose. "The fact remains that we are foreigners on the inside," opined my guide; "but there is no outside." And it was true that inside any "now" there was the syllable by syllable invention and the necessity for the disappearance of faces and names. Therefore we wanted only to document the present. For example, women—what were they? Arrows or luncheons, a defenestration, a burning frame, the great stiff coat with its glossy folds, limbs, inner Spains ... Our hands forgot nothing. We searched for these pure positions to frame with our lens. Our foreignness was a precisely burdensome gift.

Make no mistake. Here I am narrating an abstraction. When I say "our lens" I do not intend to indicate that, like the master Atget, we hauled

a cumbersome and fragile equipment across neighbourhoods. I do not refer to an atelier made opaque by the detritus of use, the economy of repeated gestures trapped in the mended furnishings, vials of golden dusts, privacies of method, sheets of albumen. Nothing was known about that. And when I say "women" I mean nothing like an arcane suppleness or a forged memory of plenty. I'm painting the place in the polis of the sour heat and the pulse beneath our coats, the specific entry of our exhalations and words into the atmosphere. And when we pass each reflective surface, glimpsing our passage among sibylline products, what are we then if not smeared stars, close to it, close to what happens; the sequin, the syllable, the severance.

This is a manner of speaking; never fear hyperbole. In practise we knew intimately the inadequacy of means for discerning the intelligible. Given inevitable excess, irreversible loss and unreserved expenditure, how were we to choose and lift the components of intelligibility from among the mute and patient junk? We wished to produce new disciplines within the lexicon of the secular; we paid a ferocious piety to artifice. In a way we were just rehearsing.

We began to imagine that we were several, even many. In the guise of several we lounged dissolute on nonce-coloured couches, bold in conscious merit. What we were to ourselves: fabulously dangerous. We never performed the pirouette of privation. Dangerously we pulled our kneesocks up over our knees. We asked the first question and we answered. What is earth?—A haunt. A tuft. A garland. An empress. A mockery. Girlfriend. A violet. A milk. A cream. A hazardous trinket. A flask. A basket. A mimic. A wild ideal pageant in the middle of London. A plinth. A liking. A bachelor. A thickening. A military straggling. And the severance, utter. And so on.

As many or several we played other games as well. We would mottle our vernacular with an affected modesty because we enjoyed the noble sensation of bursting. Flippantly we would issue implausible manifestoes, seeking no less than to abolish the therapeutic seance of novelty. When there was a call for images we would fan through the neighbourhood constructing our documents. Our method was patience. We would slowly absorb each image until we were what we had deliberately chosen to become. Of course then we ourselves were the documents; we acquired a fragility. Hello my Delicate we would repeat when we met by chance in the streets under the rows of posters Hello my Delicate.

And we learned that as many we could more easily be solitary. As solitaries, this is what we would do. We would silently practise the duplicitous emotion known as anarchy or scorn. We would closely observe strangers to study how, in a manner, or in a touch, we might invent the dream of the congress of strange shapes. We would make use of their resistance; it showed us our own content. We were not at all pleasant. As I said, our intentions were documentary.

One of us was famished for colour; this one would lasciviously brush up on the paused automobiles as if it were somehow possible to carnally blot the knowledges locked in those saturate and subtly witty pigments. One of us would take eight days to write a letter describing the superb greyhound of the Marchesa Casati, as painted by Boldini; the sublime haunches of the slightly cowering creature, and the intelligence of its ears. One of us wanted only to repeat certain words: diamond, tree, vegetable. This was the one who would touch the street with the point of her toe to establish its irreality and this is the one who would scream through the filters of gauze to illustrate the concept "violet" and this is the one who remembered flight. This one remembered flight. This one remembered the smooth cylinders glimpsed at evening through the opened portals of the factory. What discipline is secular? This one remembered each acquaintance by an appetite. This one remembered each lie, each blemish, each soft little tear in the worn cottons of the shirts.

But now we needed to abandon our pastime. My guide and I found ourselves leaning into the transition to night. Everything had a blueness, or to be more precise, every object and surface invented its corresponding blueness. And the trees of the park became mystical, and we permitted ourselves to use this shabby word because we were slightly fatigued from our exercises and our amusements and because against the deepening sky we watched the blue-green green-gold golden black-gold silver-green green-white iron-green scarlet-tipped foliage turn black. No birds now; just the soft motors stroking the night. Stillness. We went to our tree. It was time for the study of the paradox called lust. Our chests burst hugely upwards to alight in the branches, instrumental and lovely, normal and new. It was time for the lyric fallen back into teeming branches or against the solid trunk gasping.

CONTRIBUTORS

JOE ALTERIO is a San Francisco–based illustrator, comic artist, and animator. He is best known for RobotsAndMonsters.org, a project that trades custom comic art for donations to a good cause. Joe's work has appeared both nationally and internationally, in editorial as well as in advertising. He is working on his first graphic novel, due out next year. More of his work can be seen at http://www.joealterio.com.

GEORGE BAIRD is dean of the John H. Daniels Faculty of Architecture, Landscape, and Design at the University of Toronto and partner in the Toronto-based architecture and design firm Baird Sampson Neuert Architects Inc. Author of *Alvar Aalto* (1968) and *The Space of Appearance* (1995), he is also the co-editor, with Charles Jencks, of *Meaning in Architecture* (1969) and, with Mark Lewis, of *Queues, Rendezvous, Riots: Questioning the Public in Art and Architecture* (1995).

ROBIN COLLYER has been exhibiting sculpture and photography since 1971. He is best known for his three-dimensional works that use industrial materials, found objects, and images from advertising and media. Photography and sculpture play equally important roles in his creative output, and in addition are his analyses of architectural forms, the urban landscape, and issues of representation. His photo work has included critical views of photographic content, urban and natural landscapes, and digital technology. Collyer has represented Canada in international exhibitions such as documenta 8 1987 and the Venice Biennale 1993. He has works in numerous public and private collections in Canada and

internationally. He is represented by Gilles Peyroulet et Cie., Paris, and the Susan Hobbs Gallery in Toronto.

FRANK CUNNINGHAM is a founding member of the University of Toronto's Cities Centre, Professor Emeritus of Philosophy and Political Science at the university, and former principal of its Innis College. He is the author of numerous articles and books on political theory, including *Democratic Theory and Socialism* (1987), *The Real World of Democracy Revisited* (1994), and *Theories of Democracy: A Critical Introduction* (2002).

RON DEIBERT is an associate professor of political science and director of the Citizen Lab at the Munk Centre for International Studies, University of Toronto. He is a co-founder and a principal investigator of the OpenNet Initiative, the director of the psiphon censorship circumvention software project, and co-founder and director of the Information Warfare Monitor. Deibert has published numerous articles, chapters, and two books on issues related to technology, media, and world politics.

Architect and urban designer **KEN GREENBERG** has played a leading role on a broad range of assignments in highly diverse urban settings in North America and Europe. Much of his work focuses on the rejuvenation of downtowns, waterfronts, and neighbourhoods, as well as campus master planning. In each city, with each project, his strategic, consensus-building approach has led to coordinated planning and a renewed focus on urban design. Current efforts include work on plans for Toronto's Lower Don Lands (involving reshaping the mouth of the Don River into an urban estuary where it enters Toronto Harbour), a strategic master plan for Boston University's Charles River Campus, plans for the renewal of Grange Park in association with the Art Gallery of Ontario, and plans for the Calgary Riverwalk along the Bow and Elbow Rivers.

MARK KINGWELL is a professor of philosophy at the University of Toronto and a contributing editor of *Harper's Magazine*. He is the author of twelve books of political and cultural theory, including most recently *Concrete Reveries: Consciousness and the City* (2008) and *Opening Gambits: Essays on Art and Philosophy* (2008). He is the recipient of the Spitz Prize in political theory and National Magazine Awards for both essays and columns, and in 2000 was awarded an honorary DFA from the Nova Scotia College of Art & Design for contributions to theory and criticism.

He is currently at work on a philosophical biography of the pianist Glenn Gould, to be published in fall of 2009.

LISA KLAPSTOCK is a Toronto-based artist who has exhibited her work extensively in Canada and Europe as well as doing residencies in Rotterdam, Helsinki, Copenhagen, and Banff. Her work is in the institutional collections of the Musée de la Photographie, Belgium; the Museet for Fotokunst, Denmark; the National Portrait Gallery of Canada; the Kamloops Art Gallery; the Winnipeg Art Gallery; the Art Gallery of Windsor; and the Art Gallery of Hamilton. She is represented in Canada by Jessica Bradley Art + Projects and Diane Farris Gallery. More information can be found at http://www.lisaklapstock.com.

SHAWN MICALLEF is a senior editor at *Spacing* magazine and co-founder of [murmur], the location-based mobile-phone documentary project. He writes about cities, culture, buildings, art, and whatever is interesting in books, blogs, magazines, and newspapers. *Stroll*, his monograph of Toronto from a flâneur's perspective, will be published by Coach House Press in 2010.

NICK MOUNT teaches Canadian literature at the University of Toronto. He is the author of *When Canadian Literature Moved to New York*, which won the 2005 Gabrielle Roy Prize.

JOHN PARKINSON is a senior lecturer in politics at the University of York, U.K., specializing in democratic theory and practice, and theories of the policy process. His book, *Deliberating in the Real World*, was published by Oxford University Press in 2006, while his Democracy and Public Space project will result in another book with OUP in 2010. He has also published articles on the House of Lords, restorative justice, and referendums in New Zealand and Switzerland.

ALBERTO PÉREZ-GÓMEZ is the Bronfman Professor of Architectural History at McGill University. He has lectured extensively around the world and is the author of numerous articles published in major periodicals and books. He is also co-editor of a well-known series of books entitled Chora: Intervals in the Philosophy of Architecture. His book *Architecture and the Crisis of Modern Science* (1983) won the Alice Davis Hitchcock Award in 1984. Later books include the erotic narrative theory *Polyphilo, or The Dark Forest Revisited* (1992), *Architectural Representation and the Perspective Hinge*

(co-authored with Louise Pelletier, 1997), and most recently, *Built upon Love: Architectural Longing after Ethics and Aesthetics* (2006).

LISA ROBERTSON is a poet and critic, previously based in Vancouver and now living in Oakland, California. Her books of poetry include *Debbie: An Epic*, nominated for a Governor General's Award in 1997; *The Weather*, winner of the Relit Award in 2001; and *Rousseau's Boat*, winner of the bpNichol Chapbook Award in 2005. Her collection of essays relating to architecture, urban design, and contemporary art practice, *Occasional Works and Seven Walks from the Office for Soft Architecture*, was published in 2003. Robertson has held residencies at the University of Cambridge; the University of California, San Diego; Capilano College; The American University of Paris; and the University of California, Berkeley, and she is now artist in residence at California College of the Arts. Her current work is centring on urban ambient sound recording and composing; she is constructing a prosody of noise.

OREN SAFDIE is a playwright-in-residence at La MaMa E.T.C. in New York and the interim artistic director of the Malibu Stage Company in Los Angeles, where *Private Jokes, Public Places* first debuted. Other plays include *West Bank, UK, The Last Word ..., Jews & Jesus, Fiddler Sub-terrain, Smother, Broken Places*, and *La Compagnie*, which he developed into a half-hour pilot for CBS. As a screenwriter, he scripted the films *You Can Thank Me Later* and *Bittersweet*. He has also written for *Dwell* and *Metropolis* magazines. His new play, *The Bilbao Effect*, will debut in 2009/2010.

RUSSELL SMITH's most recent novel, *Muriella Pent*, was nominated for the Rogers Fiction Prize and the IMPAC Dublin Award. He writes a weekly column on culture for *The Globe and Mail* and speaks frequently on CBC Radio in English and French. His new novel, *Girl Crazy*, will be published by HarperCollins Canada in 2010. He lives in Toronto.

PATRICK TURMEL is an assistant professor of philosophy at Université Laval in Quebec City. His main research interests are in moral and political philosophy. He has published articles and book chapters on ethics and political philosophy and on issues pertaining to cities and justice. He is also co-editor of *Penser les institutions* (Presses de l'Université Laval), due out in 2010.

INDEX

Agamben, Giorgio, 15, 20n11, 21n17, 22n21
Alexander, Christopher, ix–xi, xviin1
Allais, Alphonse, 159
Allgrove, Ben, 148n9
Alterio, Joe, xii
Althusser, Louis, 13, 17, 21n14
American Psycho (Ellis), 22n21
Anderson, Sam, 136n30, 136n42
Aragon, Louis, 53n6
Arcades Project (Benjamin), 11
architecture, xiii, 47–52, 53n4, 66, 78, 159; as event, 50–51; of parliaments, 78–79; and public space, 49–50, 52, 56; vocation of, 47–49. *See also* CIAM; Le Corbusier; modernist theory; urban design
Arendt, Hannah, xiii, 48, 56–57, 58, 60, 60nn5–7, 61n11, 84n3
Aristotle, 15, 93
art, 123–33; beauty of, xv–xvi, 123–33; high, 125, 129–30; modern, xv, 124; Outsider Art, 130, 136n29; public, 128, 130; in public space, 49–50; role of, xi; street, xvi, 127–31, 135n27
Astor, John Jacob, 10

Athens Charter. *See* Le Corbusier: *La Charte d'Athènes*
Atlantic, 35
Australia: and Internet filtering, 143
automobile. *See* car

Baird, George, xii, xiii
Bakema, Jaap, 30
Baldwin, David A., 149n18
Bale, Christian, 22n21
Banksy, 131
Barlow, John Perry, 148n6
Barthes, Roland, 97n6
Bartleby the Scrivener (Melville), xii, 10–15, 18, 21n13, 21n18
Basquiat, Jean-Michel, 127
Bataille, Georges, 21n13
Baudrillard, Jean, 14, 124, 134n6
Beauregard, Robert, 97n2
Beckett, Samuel, x
being-in-the-world, 57
Belarus: and Internet filtering, 140, 141
Benezra, Neal, 134n9
Benjamin, Walter, 11, 15; *Arcades Project*, 11
Bennett, Edward H., 42
Betsky, Aaron, 60n4

Beverungen, Armin, 20n11
Birds of Manhattan (Witz), 127–28,
 135n17
Blek le Rat, 127, 134n14
Body Double (De Palma), 21n22
Boldini, Giovanni, 177
Borges, Jorge Luis, 51
Boston, 31, 39, 45
Bound, Anna, 97n2
Breton, André, 53n6
Britain. *See* United Kingdom
Broadbent, Alan, 35
Brooke, Rupert, 132
Bruni, Carla, 9, 20n6
Buenos Aires, 42
built environment, 31, 38, 74–75,
 80, 151, 153–55, 156
Burger, Thomas, 148n4
Burma: and Internet filtering, 140,
 141
Burnham, Daniel, 42
Bush, George W., 22n21

Calgary, 21n16, 31, 39
Cambodia: and Internet filtering,
 140, 141
Cambridge (Mass.), 39, 45
Canada: demography, 35; federal
 government, 33; and Internet fil-
 tering, 142, 143
Canberra, 80
Candilis, Georges, 30
car, 32–33, 36, 40, 152
Caruso, David, 16
Casati, Marchesa Luisa, 177
CCTV (close-circuit television), 4, 145
Central Park Conservancy (New
 York), 37, 38
Centre for Urban and Community
 Studies (University of Toronto), 34
Charise, Andrea, 135n28
China: and Internet filtering, 141,
 142, 143
Christie Pits Park: riots, 88
CIAM (Congrès International d'Ar-
 chitecture Moderne), xii, 30–31
Citizen Lab, 146

citizenship, 71–72, 77, 96–97; on the
 Internet, 145–48
city: control over public places, 96;
 definition of, 153–55; democracy
 in, 41, 88, 96, 153, 161–62; eco-
 nomic development, 34–35, 157,
 160; functions of, 30; and iden-
 tity, 19; life, 30, 38, 98n11, 151,
 158–60; natural world and,
 37–41, 159; parks, 37, 80, 82; as
 physical space, 37, 86; as public
 space, 4, 19, 29–31, 35, 37–39,
 48–49, 65, 85, 94, 101–12,
 151–62; right to (H. Lefebvre),
 91. *See also* art: street; built envi-
 ronment; Le Corbusier: func-
 tional city; liminal space; *New
 Babylon*; suburbia; town squares;
 urban externalities; urban insti-
 tutions; urban justice; urban
 planning; urban trails
City on the Move Institute, 61n10
civil society, xiii, 37, 55, 72; as infor-
 mal public sphere, 76–77; and
 cyber warfare, 145
Cleveland, Horace, 39
close-circuit television. *See* CCTV
Cocteau, Jean, 60
collective action problems, 154,
 156–57. *See also* tragedy of the
 commons
collective resources, 73, 75
Collyer, Robin, xi
commodity, 9, 11, 93
common interest, 4, 6, 7, 81
Congrès International d'Architecture
 Moderne. *See* CIAM
consumerism, 93. *See also* consump-
 tion
consumption, xi, xiii, xv, 8, 13–14,
 16, 21n11, 47, 52, 58, 93
Cooper, Reid, 135n27
co-operation. *See* social co-operation
Crawford, Allison, 136n39
creative economy, 34, 36
Critique of the Gotha Programme
 (Marx), 98n8

CSI, 16
Cunningham, Frank, xiv–xv
cyberspace. *See* Internet

Dahlberg, Lincoln, 148n4
Danto, Arthur C., 124, 130, 133,
 134n4, 136n31, 136n33, 136n43
Dean, Jodi, 148n4
Debord, Guy, 98n7; *The Society of the*
 Spectacle, 20n3
De Carlo, Giancarlo, 30
de Certeau, Michel, 104, 155, 163n7
Deibert, Ronald, xv–xvi, 148n5,
 148n8, 148n10, 149n13,
 149n16, 149n18, 149n24
Deleuze, Gilles, 20n11
democracy, 16, 17, 21n19, 22n21,
 71–83, 86, 93; deliberative, xiv,
 71; on the Internet, 145–46,
 147; market, 79–81
De Palma, Brian, 21n22
Derrida, Jacques, 3, 21n19
design. *See* urban design
Deutsche, Rosalyn, 98n10
Dewey, John, 93
Dickens, Charles, 11
Duchamp, Marcel, xv, 123–24, 131,
 132
Dunne, Stephen, 20n11
Dziekanski, Robert, 59

Edmonton, 31
electronic surveillance. *See* surveil-
 lance
Ellis, Bret Easton. See *American Psy-*
 cho (Ellis)
environmental imperative, 33, 35–36
epokhé, 15
Estonia: and cyber warfare, 144
exclusion: in public space, 87, 95
externalities. *See* urban externalities
Eyck, Aldo van, 30

Facebook. *See under* social network-
 ing medias
Fairey, Shepard, 127, 130, 134n14
feminism, 124

festivals. *See* street festivals
Florida, Richard, 155, 163n8
Flusser, Vilém, 48, 53n1
Foucault, Michel: age of representa-
 tion, 48
free-rider problem, 75, 152

Gangs of New York (Scorsese), 12
Ganley, Paul, 148n9
Gans, Herbert, 31
Gauthier, David, 162n2
general will. *See under* Rousseau,
 Jean-Jacques
Georgia: and cyber warfare, 144
Geuss, Raymond, 84n3
Girard, René, 9
Glenn, Joshua, xviin3, 20n9
global communication environment,
 xvi, 137–40, 145–46
globalization, 52
Goffman, Erving, 73, 84n4
Goldsworthy, Andy, 126, 129,
 135n27
Goodsell, Charles, 78, 84n6
Google, 142–43
government: and Internet filtering,
 140, 142–44, 147; intervention
 in public space, 17, 33, 96–97
Greenberg, Clement, 124, 134n5
Greenberg, Ken, xii

Habermas, Jürgen, 57–58, 59, 60n8,
 139, 148n4
hacking, 147
hacktivism, 147
Hanes, Allison, 135n25
Hardin, Garrett, 5, 154
Hardt, Michael, 20n11
Hardwick, Elizabeth, 12–13, 15,
 20nn11–12
Haring, Keith, 127
Harris, Sharon, 135n26
Hart, Kim, 148n1
Haussmann, Baron Georges Eugène,
 157
Hegel, Georg Wilhelm Friedrich, 13
Hénaff, Marcel, 84n1

Hickey, Dave, 125, 134n11
Higgins, Charlotte, 134n2
highway, 32, 39, 173
Hillman, James, 130, 136n32
Hirst, Damien, xv, 124, 131
Hitchcock, Alfred, 18, 22n22; *Rear Window*, 18
Holly White. *See* Whyte, William H.
Holzer, Jenny, 127
homelessness, 14, 21n16, 33, 48
Homo faber: culture of, xiv, 89, 92
Homo ludens: culture of, xiv, 89–92, 94, 95, 96
Hong Kong, 80, 82
Hough, Michael, 38
Houston, 56
Howard, Ebenezer, 159
Huizinga, Johan, 89, 97n5
Hulchanski, David, 34
human rights: on the Internet, xvi, 146–47

Iceland, 78
identity, 12, 18, 19, 60; cultural, 4; in public space, 33, 48, 59, 60
Illich, Ivan, 51, 53n7
Impressionism, 129, 134n3
individualism: possessive, xv, 93–94, 98nn12–13; propertarian, 8
individual rights, 9, 12, 17
Information Warfare Monitor (IWM), 138, 143–44
Internet, xvi, 137–48; censorship, xvi, 138, 143, 146, 147; cyber warfare, 143–45; end-to-end principle, 138, 142, 143, 146; filtering, 140–43; network neutrality, xvi, 142–43, 146, 148; as public space, xvi, 71, 86, 137, 138–39, 145–48; surveillance of, xvi, 145. *See also* OpenNet Initiative; psiphon
Iran: and Internet filtering, 141, 142
Ishikawa, Sara, xviin1
IWM. *See* Information Warfare Monitor

Jacobs, Jane, xvii, 30, 36, 41, 58, 153, 155, 160, 162n3, 163n13
James, Henry, 13, 21n12
Jameson, Frederic, 55, 60n2
Jones, John Paul, III, 97n1
Justen, Marlene, 149n18
just society, xi, 7, 18, 132, 152. *See also* urban justice

Kafka, Franz, 14
Kandinsky, Wassily, 104
Kant, Immanuel, 130, 131, 132
Katz, Brian, 135n22
Keats, John, 133
Kelly, Grace, 18
Kelsey, Jeffrey T. G., 149n17
Kiev, 77
Kingwell, Mark, xii, xiii, xv, xviinn2–3, 20n3, 20n9, 55, 58, 60, 61n12, 151, 162n1
Kinkade, Thomas, 129, 133, 136n29
Kirn, Walter, 134n7
Klapstock, Lisa, xi
Klein, Hans, 149n26
Klein, Naomi, 149n21
Kleinrock, Leonard, 148n2
Kohn, Margaret, 97n2, 98n7
Koolhass, Rem, xvii, 47, 155, 157, 162n6, 163n10

La Charte d'Athènes. See under Le Corbusier
Lafargue, Paul, 91, 98n8
Lane, Cal, 126
Le Corbusier, xii, 159, 163n12; *La Charte d'Athènes*, 30, 159, 163n12; functional city, xii, 30
Lefebvre, Henri, 91, 98n10
Lemley, Mark, 148n3
Lessig, Lawrence, 148n3, 149n25
Levey, Ann, 21n16
Levine, Noah, 135n19
liminal space, city streets as, xv, 103, 105–6, 108, 111–12
London, 77
Lucas, Robert, 153

Lungu, A. M., 149n17
Lyon, David, 149n20

Macpherson, C. B., xiv, 93, 98nn12–13. *See also* individualism: possessive
Malta, 109–12
Manhattan, 13, 18, 155; Bridge, 123; Lower, 39, 127, 128; Waterfront Greenway, 39. *See also* New York
Mann, Steve, 17, 21n20
Mansbridge, Jane, 84n2
market society, xv, 93–94
Marx, Karl, 91, 92, 98n8; *Critique of the Gotha Programme*, 98n8
mass culture, 125, 132
Mathiason, John, 149n26
Mau, Bruce, 47, 126, 134n13
McHarg, Ian, 38
Melville, Herman: *Bartleby the Scrivener*, xii, 10–15, 18, 21n13, 21n18
Mexico City, 56, 57, 75
Miami, 56
Micallef, Shawn, xv
Microsoft, 143
Mill, John Stuart, 93
Miller, Kristine, 9, 20n7
Milton, John, 20n8
Minneapolis, 31, 39
Mitchell, Don, 97n1
modernist theory (architecture), 30–31
Molloy (Beckett), x
Montreal, 31, 49, 129
Moscow, 75
Mouffe, Chantal, 20n10
Mount, Nick, xi, xv–xvi
Mueller, Milton, 149n26
multiculturalism, 59, 124
Multi-Stakeholder Initiative, 147
[murmur] project, xii, 41

Negri, Toni, 20n11
Nehamas, Alexander, 125, 132, 134n10, 136n36

neighbourhood. *See* public space: neighbourhood as
New Babylon (Nieuwenhuys), 90, 91, 92, 97n6
Newman, Barnett, 124, 134n3
New York, 9, 12, 13, 16, 127, 155; Draft Riots, 12; Federal Plaza, 9; Five Points, 12; Times Square, 9, 96; Wall Street, 11, 12. *See also* Central Park Conservancy; Manhattan
Nietzsche, Friedrich, 52
Nieuwenhuys, Constant, 89–92, 97n6
9/11. *See* September 11th
1984 (Orwell), 4
norms. *See* public norms

Olmsted, Frederick Law, 39
Ong, Walter, 53n2
ONI. *See* OpenNet Initiative
Ontario: Conservative government of, 33
OpenNet Initiative (ONI), 138, 140–43, 147, 148
open-source software, 146, 147
Orwell, George. *See 1984*
Osburn, Chris, 134n14

Pakistan: and Internet filtering, 140, 141
Palfrey, John, 149n12
Paris, 127; Baron Haussman projects in, 157; Canal Saint-Martin, 39
Parkinson, John, xiv, 84n2
parks. *See* city: parks
Paz, Octavio, 53n3
Pecota, Silvia, 132, 136n39
Pérez-Goméz, Alberto, xii, 53n3
Perrault, Claude, 53n3
Picasso, Pablo, 124
Plan of Chicago (Burnham and Bennett), 42
Plato, 130, 131; *Symposium*, 125
Pollock, Jackson, 124
post-structuralism, 52, 124

privacy, 4, 9, 12, 13; rights to, 8;
 within public space, 64
private interests, 8, 9, 10, 17, 18, 86,
 93, 154. *See also* tragedy of the
 commons
private property, xv, 13, 93, 94, 154
private/public distinction, ix, xiii–xiv,
 xvii, 6–10, 12–15, 16–17, 18,
 18–19, 21n16, 21n19, 57–58, 66,
 72–73, 77, 79, 83, 86–87, 151,
 154, 159. *See also* public space:
 and ownership
Project for Public Spaces, 31
psiphon, xvi, 138, 146. *See also*
 Internet; OpenNet Intiative
public institutions. *See* urban institu-
 tions
public life, xi, 8, 19, 31–32, 35, 59,
 102, 151, 162
public norms, xv, 14, 21n16, 59, 82,
 101, 104, 170
public realm. *See* public space
public space: anonymity within, x,
 4, 8, 18, 33, 87, 89, 94, 95;
 beauty in, 132, 133; democracy
 and, x, 34, 41, 71–72, 76–81,
 82, 86, 137–38; neighbourhood
 as, 37, 41, 58–59, 157–58, 159,
 160; ownership and, 5, 9–10,
 32, 57–58, 72–75, 77, 78,
 86–87, 93, 95–96; physical, xi,
 xiv, 73, 86; politics and, xiv–xv,
 3–4, 48, 49, 71; as public good,
 xii, xv–xvi, 4–10, 14, 16–17, 19,
 58, 60, 73, 74–75, 145–46, 154;
 public order and, x, xiii, 7, 12,
 17, 82, 159; rebirth of, xii,
 29–41; as site for intersubjec-
 tive meaning, 48; sports cele-
 brations in, 106–9; street as, x,
 xii, xiii, xv, xvi, 4, 8, 11–13, 16,
 30, 31, 33, 37, 56, 59, 74, 88,
 101–12, 126, 158, 160–61; and
 subversion, 86–93, 97; virtual,
 xvi, 32–33, 71, 76, 81, 86. *See
 also* architecture: and public
 space; art: in public space; city:
 as public space; civil society: as
 informal public sphere; exclu-
 sion: in public space; govern-
 ment: intervention in public
 space; Habermas, Jürgen; iden-
 tity: in public space; Internet:
 as public space; privacy: within
 public space; private/public dis-
 tinction; Project for Public
 Spaces; Toronto Public Space
 Committee
Public Space Committee. *See*
 Toronto Public Space Committee
public sphere. *See* public space

quality of life, 34, 35, 81, 156
Quiñones, Lee, 127

Radiant City, 32
Rahder, Barbara, 98n11
ratchet effect, 5, 6
Reader's Digest, 19
Rear Window (Hitchcock), 18
Remnick, David, 9, 20n6
representation, age of. *See under* Fou-
 cault, Michel
Richelson, Jeffrey, 149n19
right: to anonymity, 4, 8, 18; to
 gather, 7; to privacy, 4, 8; to
 property, 93
Roadsworth, 129, 135n27
Robertson, Lisa, xvii
Rogers, Betsy Barlow, 38
Rohozinski, Rafal, 148n8
Rosen, Jonathan, 20n8
Rousseau, Jean-Jacques: general will,
 7; will of all, 7
Russell, Devlin, 21n18
Russia: and cyber warfare, 144

Safdie, Oren, xiii
Saint George, Mikal, 135n16
Saint Paul (Minn.), 39, 40
San Francisco Bay, 43
Sarkozy, Nicolas, 9, 20n6
Saudi Arabia: and Internet filtering,
 141

Scarry, Elaine, 125, 131–32, 136nn34–35
Schiller, Friedrich, 132, 136n38
Schjeldahl, Peter, 125, 132, 133, 134n12, 136n40
Schmitt, Carl, 20n10, 21n19, 22n21
Scorsese, Martin. See *Gangs of New York*
Seabright, Paul, 156, 163n9
Sennett, Richard, 52, 53n8
September 11th, 22n21, 124, 130, 131
Shanghai, 56, 57
Shi Tao, 142
Silverstein, Murray, xviin1
Simmel, Georg, 8, 20n4
Singapore, 80
situationists, 89, 91–92, 97n6, 98n7, 98n10. See also Debord, Guy; Nieuwenhuys, Constant; Vaneigem, Raoul
Smith, Russell, xv
Smithson, Alison, 30
Smithson, Peter, 30
social co-operation, 92–93, 152. See also collective action; tragedy of the commons; urban externalities
social networking medias, 9, 139; Facebook, 9, 32; YouTube, 140
Sonne, Wolfgang, 84n7
Sorkin, Michael, 60n3
Speaks, Michael, 60n2
Spirn, Anne Whiston, 38
Splasher, 130, 133
square. See town square
Steiner, Wendy, 131, 136n29, 136n34
Stevens, Ray, 124
Stewart, James, 18
Stewart, Martha, 130, 133
street festivals, xv, 101–12
Strickland, Lee S., 149n18
Strong, Tracy, 84n1
suburbia, xii, 30–35, 37, 160
Sudbanthad, Pitchaya, 135n18
surrealist writers, 51

surveillance, x, 8, 16, 55, 58–59, 60; cameras, 4; society, 4. See also *under* Internet
Swoon, 129, 130, 133

tragedy of the commons, 5, 7, 75, 87, 154. See also collective action problems; private interests
Taylor, Charles, 9
Team 10, 30
Toronto, 31, 34, 39, 41, 43, 44, 56, 57, 59, 88, 101–2, 129; Caribana Festival, 106; Pride Festival, 102–6, 111. See also [murmur] project
Toronto Public Space Committee, 4, 8, 9, 17
town squares, 37, 56, 74, 77, 82, 89
trusteeship, culture of, xiv–xv, 92–96
Tunisia: and Internet filtering, 141
Turmel, Patrick, xv–xvii, xviin2

United Kingdom, 4, 80; and Internet filtering, 143
United States, 82; and Internet filtering, 142, 143
urban design, 51, 55–56. See also architecture
urban environment. See built environment
urban externalities, xvi–xvii, 8, 151–62
urban institutions, 16, 50, 152, 154, 155–56, 161–62
urban justice, xvii, 152–53, 161–62. See also just society
urban planning, 31, 36, 159–60, 161–62
urban trails, 39–45
Uzbekistan: and Internet filtering, 141, 142

Vaneigem, Raoul, 91, 98n9
video surveillance. See surveillance
Vietnam: and Internet filtering, 141, 142

Villeneuve, Nart, 149n23
Vitruvius, 49–50, 53n5

Waldron, Jeremy, 84n5
Wall Street. *See under* New York
Washington (D.C.), 77
Wharton, Edith, 13, 21n12
Whyte, William H., 31
will of all. *See under* Rousseau, Jean-
 Jacques
Williamson, Col. Charles W., III,
 149n15
Wirth, Louis, xvii, 153, 162n4
Witz, Dan, 127–29, 130, 131, 132,
 133, 134n1, 134n14,
 135nn15–17, 135n20,
 135nn22–24, 135n27, 136n41;
 Birds of Manhattan, 127–28,
 135n17; scumbling, 127, 129

Wolf, Naomi, 134n8
Wood, Patricia, 98n11
Woods, Shadrach, 30
Wooster Collective, 129, 135n15,
 135n27
Wright, Frank Lloyd, 159

Yahoo!, 143
Young, Iris Marion, 97n6, 158,
 163n11
YouTube. *See under* social networking
 medias

Zittrain, Jonathan, 148nn11–12
Žižek, Slavoj, 8, 13, 15, 20n5, 20n11,
 21n15

Books in the Canadian Commentaries Series
Published by Wilfrid Laurier University Press

Uneasy Partners: Multiculturalism and Rights in Canada by Janice Gross Stein, David Robertson Cameron, John Ibbitson, Will Kymlicka, John Meisel, Haroon Siddiqui, and Michael Valpy. Introduction by the Hon. Frank Iacobucci • 2007 / xiii + 165 pp. / ISBN-10: 1-55458-012-9 / ISBN-13: 978-1-55458-012-5

Rites of Way: The Politics and Poetics of Public Space Mark Kingwell and Patrick Turmel, editors • 2009 / xviii + 192 pp. / illus. / ISBN: 978-1-55458-153-5